Planetary Echoes

Edited by
Lukas Feireiss and Michael Najjar

Exploring the Implications
of Human Settlement
in Outer Space

Spector Books

Table of Contents

Chapter 1
From Earth to the Universe

Chapter 2
Future Trajectories of Space Travel

Chapter 3
Imagining Habitats in Outer Space

Chapter 4

Mars and Beyond

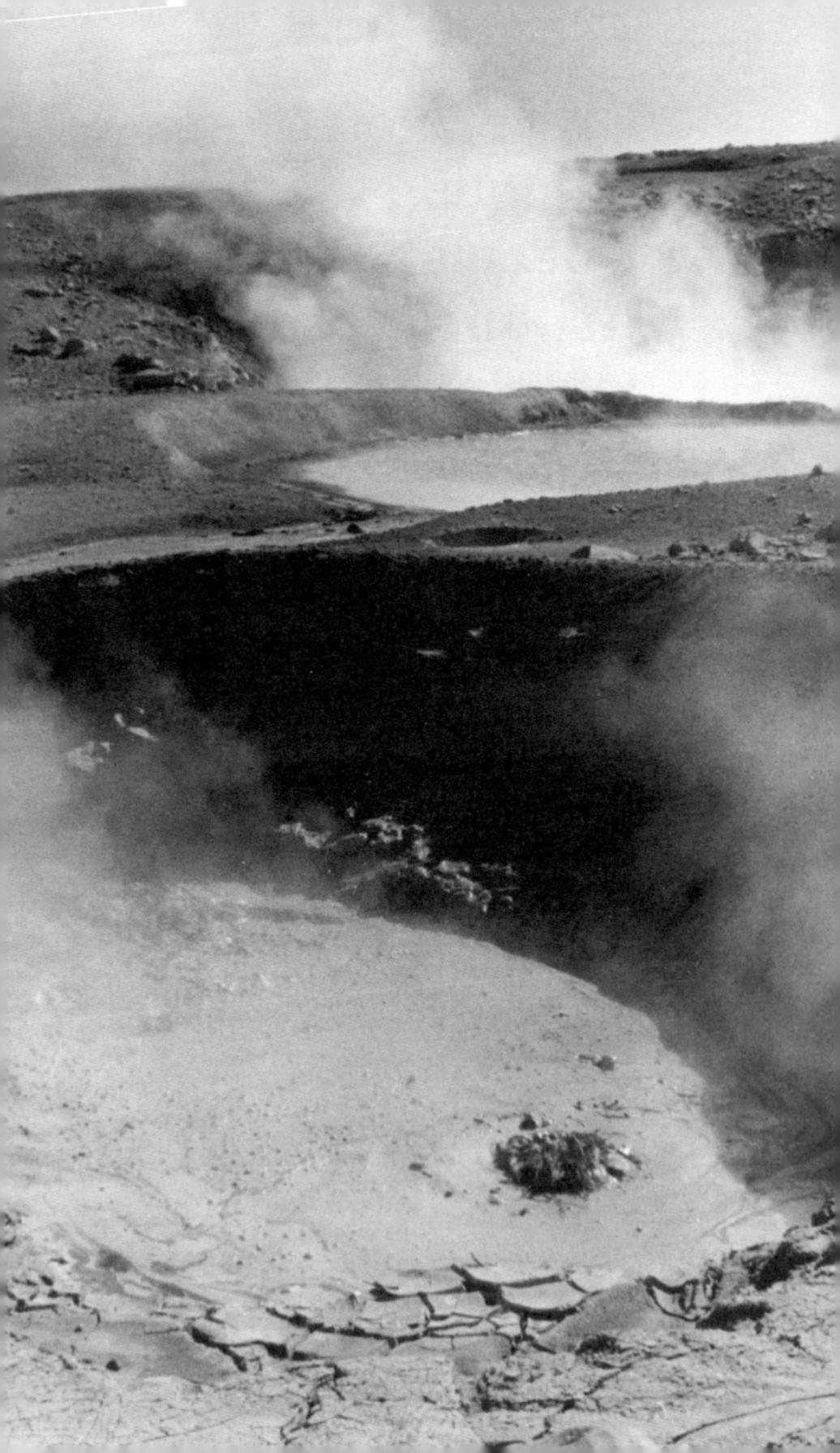

Foreword

Christiane Stahl
Director, ALFRED EHRHARDT STIFTUNG Berlin

The ALFRED EHRHARDT STIFTUNG has been committed to presenting contemporary photography and media art for the past fifteen years. The foundation's exhibitions have a dialogue-based approach which provides an encounter between contemporary positions addressing themes intrinsic to Ehrhardt's work—nature and the construct of the natural—and original photographs and films by Alfred Ehrhardt. This dialogue is then continued in the form of events and discussions and recapitulated in accompanying publications.

The photo and video compositions of the internationally renowned, Berlin-based artist Michael Najjar suggest formal and thematic similarities between our own home planet and other Moons and planets in the solar system. The various levels of similarity between terrestrial and extraterrestrial environments shown in his work correspond perfectly with the focus of the ALFRED EHRHARDT STIFTUNG exhibition program. The cosmic laws postulated by Ehrhardt and his contemporaries, who were inspired by German *Lebensphilosophie* (a philosophical tendency rejecting rationalism and emphasizing human experience), identified congruencies between the microcosm and the macrocosm—a theme that echoes in the visionary dimensions of Najjar's compositions. For example, in his work titled "interplanetary landscape" he combines the surface structure of Earth and Mars, while "waves of mars" shows a Martian landscape that could just as easily stem from the sand dunes in the Curonian Spit as documented by Ehrhardt. And in the work "europa" the icy surface of Jupiter's Moon Europa merges with glacial regions in Iceland to create a new hybrid world.

The recent artworks photographed in Iceland in early 2017 bridge Najjar's and Alfred Ehrhardt's practice, driven by a typological approach to the landscape and employing an abstract, avant-garde visual vocabulary. In 1938 Ehrhardt went for a two-month photo and film expedition in Iceland, leading him to the untouched "primal landscape" shaped by glaciers and volcanoes where he hoped to "gain insights into the origins of the Earth." Najjar photographed many locations that Alfred Ehrhardt had visited almost a century ago.

Furthermore, Najjar draws on an interdisciplinary understanding of art whereby science, art, and technology are fused into utopian visions of future social orders spawned by cutting-edge technologies. It is no coincidence that there is a correspondence between the range of interests pursued by the artist and the programmatic orientation of the ALFRED EHRHARDT STIFTUNG which includes the exploration of overlapping concerns in science and art. These border areas between disciplines are often the most fertile in terms of innovation. An interdisciplinary linking of ideas expands the terrain, enables interaction, and transports certain values beyond their given boundaries—enabling a view of the situation from an elevated perspective, as in the "overview effect" described by Frank White which takes hold when one views our blue planet from space.

For these reasons we are very happy and proud not only to present Michael Najjar's solo exhibition *Planetary Echoes* but also to contribute to the realization of this publication which brings together a range of leading experts on the forefront of studying the implications of future human settlement in space. We would particularly like to thank Michael Najjar and Lukas Feireiss for their initiative and for giving us the benefit of their exceptionally rich knowledge and expertise without which this publication would never have seen the light of day.

Planetary Echoes

Exploring the Implications of Human Settlement in Outer Space

Lukas Feireiss and Michael Najjar

The human species now faces multiple growing threats on planet Earth from overpopulation and climate change to diminishing resources, and shortages in the energy, food and water supply. Consequently, colonization of our solar system might be the ultimate solution to guarantee survival of our species. We therefore need to extend our existential framework of references from one that is purely Earth-bound to one which includes Earth orbits, other planets and outer space in general. Even though many long-term technical challenges still need to be resolved to support the creation of a permanent, self-sustaining human presence on another planet, imagining humans as a multi planetary species is not a mere fantasy anymore.

Against this backdrop, the book at hand focusses on the idea of space exploration and future human settlement in space. It attempts to interweave this discourse into the very fabric of today's society by connecting artistic practices with the abstract theoretic sciences on an international level. Dedicated to offering an inspiring overview of exemplary topical positions from scientists, researchers, astronauts, architects and artists that illustrate the potential of human settlement in space, this book is divided in four partially coinciding chapters that thematically move from Earth to Orbit and further into Outer Space.

The first chapter "From Earth to the Universe" brings together various essays that gaze from the depth of the earth towards the limitless skies. Whilst Sir Tim Smits, philanthropist and founder of Eden Project, the largest indoor rainforest in the world in Cornwall, England, reflects upon a meteorite's cosmic origin, Nelly Ben Hayoun, critical explorer and experience-designer, engages in biological archeology with scientists at NASA and at the SETI Institute in order to understand how to build a habitable future far away from earth. Pierre Cox, Director of the ALMA Observatory in Chile's Atacama desert, introduces us to this remarkable facility that will probe the very first stars and galaxies, and directly image exo-planets, possibly discovering the first traces of life. Curator, theoretician and Director of ZKM Center for Art and Media Peter Weibel helps us understand the full meaning of defying gravity and the dawn of the orbital age. Frank White, author of the seminal book *The Overview Effect: Space Exploration and Human Evolution*, takes us on a personal and intellectual journey of discovery of the human implications of settlements in Space, and artist Michael Najjar reflects upon the existential questions and technological forces implicit in future space exploration in the 21st century from an artistic perspective.

The second chapter entitled "Future Trajectories of Space Travel" is dedicated to understanding the possibilities of space exploration from the hands-on perspective of both a number of astronauts as well as from both a robotics expert and an entrepreneur. Opening up the chapter with an inspiring contribution by former astronaut and Lunar Module Pilot on Apollo 11, Buzz Aldrin, who was one of the first two humans to land on the Moon, has a critical look at the past and offers a unified space vision for the future of space travel. Space Shuttle and International Space Station veteran Michael López Alegría contemplates the evolution of commercial spaceflight, and the life-changing experience of spacecraft launches and spacewalks.

Anousheh Ansari, the first self-funded female space traveler to fly to the International Space Station shares her thoughts on how the cost of access to space could be cut along with the improvement of new technologies in the future. Professor of Robotics at the University of Edinburgh Sethu Vijayakumar explains the future of humanoid robots in out of this world missions such as the NASA Valkyrie. In another contribution by Sir Tim Smit, he speculates about the future role of plants in sustainable space travel. Sir Richard Branson, investor, philanthropist and founder of the Virgin Group, closes off the second chapter with his vision of Virgin Galactic, as the world's first commercial spaceline, created with the goal of democratizing access to space for the benefit of life on earth.

The contributions to the third chapter "Imagining Habitats in Outer Space" look at various infrastructures and architectures in outer space. Cultural-scientist Alexander Geppert starts off by sketching a brief cultural history of the space station in the 20th century as permanent outposts circling planet Earth. Pritzker Prize winning architect Sir Norman Foster generally envisages the challenges of creating comfortable, reassuring environments in zero gravity space. Fellow architect Xavier De Kestelier, who previously co-headed the Specialist Modelling Group at Foster+Partners where he lead several projects with both ESA and NASA, each project focused on how Moon and Mars habitats could be 3D printed with local regolith, further explores human-centered design for human habitats in outer space. Renowned architect and educator Greg Lynn presents his New Outer Atmospheric Habitat and New City which directly engages the theme of Space Architecture as the new frontier for design research in terms of the spatial character and navigation of environments with alternative gravities. Ostap Rudakevych and Masayuki Sono of Clouds Architecture Office, who recently won the NASA Mars Habitat contest, rethinks the skyscraper typology and proposes a hanging skyscraper above Planet Venus.

The fourth and final chapter "Mars and Beyond" draws particular attention to the possible colonization of our neighboring planet Mars. Beginning with an excerpt of Andy Weir's best-selling novel *The Martian*, about an astronaut who becomes stranded alone on Mars in the year 2035, the chapter continues with Lukas Feireiss's general exploration of Martian speculations, aspirations and imaginations in popular culture. Ulrich Köhler of the DLR, The German Aerospace Center, critically questions the options for becoming a multi-planet species within our solar system. Last but not least, independent scholar Thore Bjørnvig raises the issue of the equally complicated and relevant relation between space exploration and religion in past, present, and future.

All in all, we hope that the eclectic publication in hand will inspire its readers to further engage in the idea of future space exploration and for a deeper insight of what's already happing today. The vision and desire of calling more than one planet our home is paired to the most existential question of the 21st century: saving the Earth's future.

Lukas Feireiss and Michael Najjar

Chapter 1

"Man must at all costs overcome the Earth's gravity and have, in reserve, the space at least of the Solar System. All kinds of danger wait for him on the Earth... We have said a great deal about the advantages of migration into space, but not all can be said or even imagined."

Konstantin Tsiolkovsky, *The Aims of Astronautics*, 1929

From Earth to the Universe

Dancing Lessons from God

Tim Smit

It's accidents that change the world. I met a man once who on hearing my story said, "Random meetings are dancing lessons from God." I've never forgotten that. So, myself, Dave, and his son Sam, are walking in the full glare of the desert sun, it's Palm Springs and desperate for some respite, we duck into a mineral shop exhibiting dinosaur eggs and excrement in the window. Fascinated, I waited to let my eyes adjust to the gloom inside. Cabinet after cabinet of curiosities tempting me, tempting me, and finally, at the darkest end of the room I see what I didn't know I'd come for, but… the moment I saw it… I knew. Over there, glinting darkly, scoured by the years, rough edged, and unknowable… was a meteorite. This was a big sucker… Just under 4 kg. It had crashed down in Argentina in 1956, but now a widow was selling a much-loved collection on and here it was, this planetary orphan, looking for a home. How do you haggle for a meteorite, especially one so big and how do you know it's not a fake? Pacing up and down and then outside, Dave checked eBay, but no help there, only small meteorites. Let me lift that thing I say, Jesus it's heavy. How could something the size of a baseball weigh so much? Compressed iron ore and nickel says the man. How much? HOW MUCH!!! That's what you gotta pay… they're uncommon and this big… very uncommon, says the man.

I try to haggle. Cash may be king, but this guy is unimpressed. It's rare he repeats. Hold it one more time. I buy it and the adventure begins. How do you explain something you can't X-ray through security at LAX?

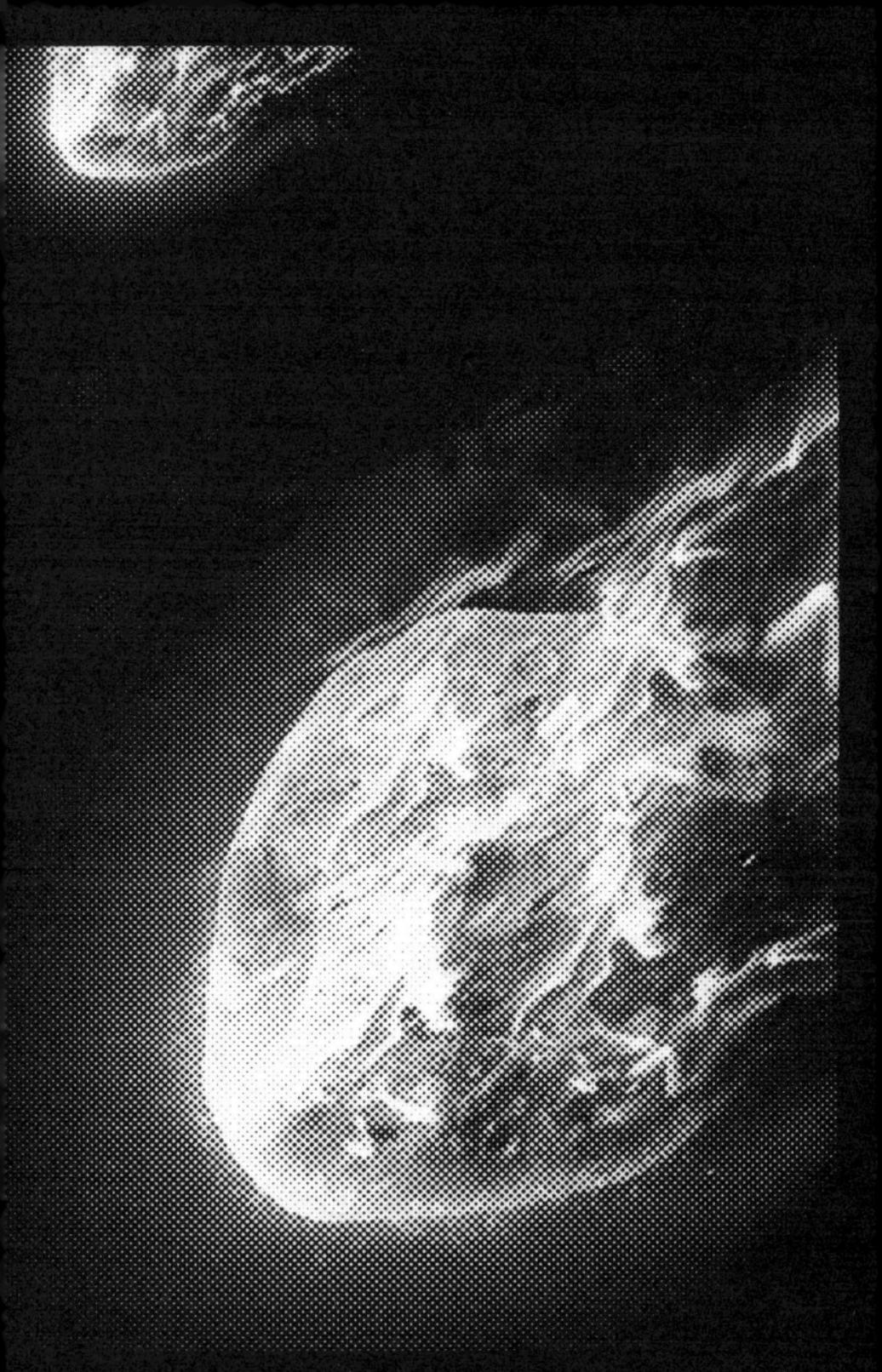

Over there, glinting darkly, scoured by the years, rough edged, and unknowable…

We fly back to Heathrow and I need to travel onwards so I ask a friend to take the meteorite with him to save me the weight in my rucksack. I meet him two days later and he tells me that every single man, woman and child wanted to touch the meteorite. They would hold it and smile, pass it on, then ask whether they could hold it once more. The whole train, he said, awestruck, the whole damn train fell in love with your meteorite. He had told his mother on the phone and she asked him whether he could keep the meteorite for one more day and come and see her with it. He did. She loved it and, was happy holding that great metal ball.

I returned to Cornwall, to Eden. We were closing for two days for our 450 staff to get together and hear about plans for the coming year. I walked on stage with my backpack and took it off, then dropped it to the floor. Bang it went. So loud everybody fell silent and looked at me strangely. They were paying attention. I looked out at this familiar audience of friends and colleagues and told them of our need for awe, how we needed to fall out of love with ourselves and our creations and instead allow awe to flood through you at the wonder of the world and the Universe in which it exists. I told them that they would soon be introduced to awe and lifted my meteorite from the backpack and handed it to a person at the end of the front row and said pass it down the line until everybody has held it. One by one they held it, jealously, amazed at its weight, surprised by its warmth (for it had taken on the temperature of all the many hands who'd held it). I finished speaking, but would not see my meteor for another three hours. Never ever have I felt so many people interested in something. It's older than planet Earth I said. My brain is exploding just thinking of the terrible loneliness of forever. Later, I told the story of meeting Buzz Aldrin at Buckingham Palace at a party hosted by Her Majesty the Queen. When we were introduced I told him that he was one of my heroes and that although I never get nervous, I could hardly speak. He put me at ease with small

She loved it and, was happy holding that great metal ball.

talk and then I asked him if he had ever been terrified. I was thinking how I'd feel sitting on top of a bomb, or left on the Moon, a "can you hear me Major Tom" sort of thing? No, he said, I'm an engineer and I know the risks, I know how stuff works. Then he fell silent and said, well actually yeah, once. Walking in space... concentrating on doing my thing when suddenly a thought ambushed me and I couldn't get it out of my head. What? It's a funny thing... that beneath me was forever. I'll never forget him saying that, possibly the loneliest thing the imagination can hold onto. Beneath him was... Forever.

So, I write this while looking onto my table where the meteorite resides. Whenever I am home I look at it and think about where it may have come from. I know, it is silly, but my son Sam opened up the Hubble web-site with its gallery of extraordinary pictures. So beautiful, so large, so unknowable like a peep show of heaven only there are dozens upon dozens of them, an infinity for all I know, your breath feels thin inside you and you feel your heart pounding as you think and when you really really think, the hair stands up on the back of your neck and then you wonder, where did my meteorite come from, am I looking at home?

I read Michio Kaku because I wanted to feel clever, but it made me feel lonely again; black holes and ice and strings and things and infinity made simple. The Nano and the techno and the love affair with physics. Gene Rodenberry rocks, he says, Warp Factor 9 could be real. Oh yes, Nathaniel Hawthorne, Edgar Allen Poe, H.G. Wells, Asimov, Clarke, Dick, and... Rodenberry, were heroes and script-writers for the Quantum physicists.

You see, when you hold the meteorite, my meteorite, you hold a memory and a thing. We do not know its origin, but we know that it is something to do with origins and, when speaking with my colleagues so many of them mused... how did we get here, did we come like that? A ball of flame

and a hard landing in some desert somewhere, but were there passengers? Are we passengers?

As we look up into the night sky and watch the satellites trace their path across the fathomless void, like fingerling fish at the edge of a great ocean wherein lurk giants. Your thinking is feeling and the tension in the core of your being is awe. It is both awe at what you perceive and the awe of destiny, for you know deep inside yourself that what makes humans human is the curiosity that conquers fear and leads us to new frontiers. Holding that meteorite reminds you of the impossibility of understanding time, except for its reminder of the shortness of our existence. Humility in the face of such, allows you to think perhaps for the first time, of hundreds and thousands of years into the future and behind it all the biggest question. What is life? And what dancing lessons lie in wait.

The Life, the Sea, and the Space Viking

Nelly Ben Hayoun

This TV series documents a submersible expedition and an encounter with our own biological archaeology. The expedition which ranges from the Icelandic fissure in the Earth's crust to the deep gold mines of South Africa, from the deep sea abyss to the giant Universe, consists of pioneering scientists at NASA and the SETI Institute who are considering how to colonize and build a habitable future far away from Earth.

In the deep sea abyss lie incredibly resistant biological species—extremophiles or sulfur-eating bacteria. Living inside hydrothermal vents in the core of the Earth's fissures, these organisms have made us reassess our knowledge of living mechanisms and the origins of life on Earth.

A developing field of research has emerged: "Astrobiology," or biology in outer space. The NASA Kepler Mission revealed a thousand potentially habitable planets (exoplanets) in the Universe. Exoplanets might have already developed life and some pioneer scientists are now considering how to colonize them and build a habitable future far away from Earth.

THE
LIFE

THE
SEA

THE

SPACE VIKING

NATHALIE CABROL
SENIOR RESEARCH SCIENTIST
AND DIRECTOR OF THE CARL SAGAN CENTER

LIZ TAYLOR
PRESIDENT, DOER MARINE

KÁRI STEFÁNSSON
PRESIDENT AND CO-FOUNDER OF DECODE GENETICS

Exoplanets might have already developed life and some pioneer scientists are now considering how to colonize them and build a habitable future far away from Earth

Nelly Ben Hayoun

Earth's Gravity and the Orbital Age

Peter Weibel

"Let us prepare ourselves to escape, to continue life and rebuild our cities on other planets: we shall not be long on this earth."

Ray Bradbury to Oriana Fallaci

Gravity makes all things fall down to the ground as they are attracted by the Earth which means that we humans cannot take off from the ground through our own strength alone. So why do the Moon and the stars not fall down to Earth? Because they are revolving around one another in elliptic or circular orbits. The fundamental principle on which the movement of the planets is based is the law of attraction by gravity which is a universal law that holds true for the entire Universe.

The fact that the planets (Mercury, Venus, Earth, Mars, Jupiter, Saturn, Uranus, Neptune, Pluto) do not plummet into the Sun but revolve around it in elliptical orbits—just as the Moon doesn't fall to Earth but orbits around it—is due to the forces of attraction exercised by gravity in accordance with a simple law discovered by Sir Isaac Newton (1643–1727). This states that the attraction between two bodies is proportional to the product of their mass and inversely proportional to the square of their distance (1687). This means that the force of attraction between two bodies decreases with increasing distance and smaller mass. Yet if gravity's force of attraction keeps a planet moving in a circular orbit, what keeps the planet moving in the first place?

An initial push (the Big Bang at the origin of the expanding Universe) was followed by an equilibrium of centrifugal force and gravity. And by the way centrifugal force increases with the radius and the mass of the object and the number of revolutions it makes per second. After Johannes Kepler (1571–1630) had formulated the basic law of planetary movement that the planets revolve around the Sun in elliptical orbits (with the Earth at a distance of 150 million kilometers), Newton could start to investigate why this should be so. The explanation for this "Mysterium Cosmographicum" (to cite the title of Kepler's book published in 1597) could not be given by assuming a universe of spheres, cubes, pyramids etc., but only by assuming the

Peter Weibel

existence of a law of gravitation which would balance centrifugal force.

Calculation of the centrifugal force of a planet has been possible since Kepler who first discovered its distance to the Sun, its orbit and time of revolution and so on. And when we calculate the centrifugal force of an orbit, we have also calculated its gravitational force, since this is known to be equal to the centrifugal force. Planets and stars attract each other on the basis of the law of gravitation and by so doing balance the escape force of the Big Bang which set everything in motion. Just as Moons revolve around planets and planets themselves revolve around the Sun, the stars revolve around the center of the galaxy and the movement of the galaxies themselves is governed by gravitation. So it should be hardly surprising that Newton was the first to envision the possibility of sending an artificial satellite into orbit around the Sun. Two vital discoveries have radically changed our way of thinking of the Earth: firstly that the Earth is not the stationary single center of movement in the Universe but just one of a number of planets that move around the Sun (1543). And secondly, Newton's discovery that this movement is governed by the law of universal gravitation.

Kepler's law of planetary orbits opened the way for the discovery of the law of gravitation. Both these laws are at the heart of the orbital issue. Thus the man who discovered the laws of orbits is one of the founders of orbital thinking which seeks to reflect the consequences of three scientific discoveries (by Copernicus, Kepler, and Newton) on which modern astronomy is founded and which have led to the development of astronautics and manned space flights.

The movement of planets in (elliptic or circular) orbits governed by the law of gravitation has unleashed a powerful imaginative phantasy in humans in their desire to overcome gravity, to be free from the gravity of the Earth and

to launch out into the cosmic choreography of planetary movement. The revolutionary idea that the Earth itself is in movement, that the Earth is only one planet revolving on its own axis and moving in a given unchanging orbit, and that the whole Universe consists purely of planetary orbits, has fuelled our desire to move into this planetary movement and to become an orbiter (an object moving on an orbital path). We soon discovered that knowledge of the laws of falling and gravitation could be used not merely for overcoming the pull of Earth's gravity but critically for the creation and control of such orbits. In such "human" orbits, mankind could for the first time determine the size of an orbit and the length of time an object would stay in a given orbit. Imagine a stone being thrown from an immensely high tower: If we threw the stone horizontally into space, and there were no gravity and no atmospheric friction, the stone would continue to fly into the infinite expanse of the Universe. However, the gravitational pull of the Earth bends the flight path of the stone according to Newton's law of gravitation and the stone lands on the ground far away from the tower.

However, if we catapult the stone towards the horizon and up to a certain height with a certain machine power, it might happen that the curve of the descending stone becomes equal to the curve of the sphere of the Earth. In this case the stone would never reach the ground because each time the path of the stone bent earthwards the surface of the Earth would bend to the same degree. If, by virtue of the initial force, the stone were to reach a certain height and speed, making the curvature of its fall equal to the curvature of the Earth, it would never reach the Earth but rather revolve around it as a satellite. What we see here is how the falling movement of an object can become an orbital movement around the Earth if the object receives a strong enough horizontal push or thrust (through rocket motors). What we see here is how the orbital movement is related to the laws of gravity and centrifugal force. The horizontal

velocity required for making the curvature of the fall mirror the curvature of the Earth is some 5 miles per second. At this juncture we should remember the fourth precursor of orbital thinking, the man who discovered the laws of fall, Galileo Galilei (1564–1642).

The principle of launching a satellite rocket into space is similar to that of throwing the stone. The first rocket explosion takes the rocket beyond the atmosphere, the second rocket explosion pushes the satellite into horizontal motion. Satellites are artificial manmade planets placed in their orbit by humans which means that humans can control both the orbit's size and its duration. We can also direct such a satellite-planet away from the Earth and steer it on a new orbit by means of further tiny explosions similar to the way we used to steer sailing ships across the sea. These artificial planets offer humankind the means of embarking on a voyage beyond the gravity of Earth through the weightless expanses of space. Thus the Big Bang at the beginning of the Universe is comparable to a first rocket explosion. The Big Bang put the planets in their paths of motion whose orbital form is set by the law of gravitation. And now we use rocket explosions to put our satellites in orbital motion. We lift off from the Earth, we invoke the laws of gravity to escape from the gravitational pull of the Earth. This conquest of orbital gravity allows us to see that the Earth itself is but a satellite. The man-controlled launching of satellites into orbit around the Earth, where they quietly sail between the balancing forces of attraction of Earth and Moon which keep them in their orbits, these artificial orbits (the orbital paths of planets) are extraordinary interventions in the natural order of orbits, in the natural order of planetary and stellar orbits.

Orbits determined by humankind, on which man-launched objects are moving, constitute the beginning of life in space, life beyond the Earth. Accordingly, the conquest of the orbital sphere as the beginning of a new way of life

beyond the Earth is perhaps just as important as the beginning of life on Earth millions of years ago. Because the beginning of the Orbital Age marks nothing less than the beginning of the transfer of life from Earth into space, and eventually into the cold black deserts of the Universe. After all, who or what says that the surface of the planet Earth must forever remain the sole dwelling place for an expanding technological civilization? Who says this except the law of gravity? For millions of years the gravitational pull of the Earth made us think that the surface of the Earth was the only place to live. It was from the depths of the Earth that we mined materials and pumped up energy resources, not from the depths of space. Staggeringly vast new spaces far beyond the Earth have been opened up for human life by the new opportunities for joining the stellar orbit, for joining the orbital dance of cosmic choreography ourselves as an artificial planet with a satellite as its core. In this sense the Moon landing may well be one of the most important events in the history of humankind, in the history of human life. Indubitably, it is a watershed, a consummation and a departure, a radical break from a cast of mind prevalent for hundreds of thousands of years and from an old form of life dominant for a million years—from life as the prisoner trapped by the gravity of our globe.

The force of gravity was the most elementary aspect of evolution on Earth for billions of years. Living beings were tied to the Earth with their feet pointing down towards the center of our planet. From this perspective, the break with this rule, represented by our entry into the zero gravity orbital sphere, is perhaps the most important event in the history of humankind.

400 million years ago when the first vertebrates appeared and fish populated the sea, millions of years later when the first amphibians crawled onto dry land, 50 million years ago when the first primates appeared and the continents began their drift and separated—in all of these immense

periods of time, life was tied to the Earth. Even the journey of life to various earthly habitats—from water to land and the air—was a journey that took millions of years to accomplish. Compare this to the 2000 year history of orbital awareness and the length of the journey to extra-terrestrial habitats, and not only is the journey away from Earth incredibly accelerated when compared to the trajectory of life on Earth (from water into the air) but also to a good extent the natural continuation of the movement of human-kind, of the ascendancy of living beings. The movement of the continents took millions of years, the movement beyond continents took only 500 years to realize. For three billion years all of life had taken place within the Earth's atmosphere. For 60 years now an attempt has been made to carry or launch life into space outside the Earth's atmosphere. When a satellite is put into orbit, this is an attempt to launch life into space beyond the Earth. If we compare this fraction of a second of life on Earth (and 60 years are really nothing more) with the evolution of life on Earth which spans many millions of years, we have grounds for optimism and an inkling of what could come in the millions of years before us…

Within less than 50 years the Orbital Age has taken shape as people began to work and live in orbital space. These people can surely be compared to the pioneers who set sail from England to America in the 17th century or with those prehistoric people who populated the islands of the South Pacific. Yet these people will not use slaves, will not exploit people in tackling the difficulties of the start-out phase. Their slaves will be robots. And consequently, robotics, along with computer and automata theory will be the key media of the Orbital Age after the law of gravitation. At the same time the comparison with the Pilgrim Fathers reminds us that the colonization of America did not happen without wars, and that indeed nearly all human expansion has a bellicose character. In orbital space too, the dark depths lurking in the concept of progress will not remain sealed.

EDITED EXCERPT AND TRANSLATION FROM THE GERMAN ARTICLE BY PETER WEIBEL "JENSEITS DER ERDE: DAS ORBITALE ZEITALTER" IN: ARS ELECTRONICA, EXHIBITION CATALOGUE, BD. 1, LINZ,1986

All this confers added importance to the second dimension of space travel—the orbital view of the Earth itself—because from this perspective spaceship Earth (Buckminster Fuller) is discernible for the first time as a unity. The promise to see the Earth itself as a single nation, as United Earth instead of the united states of various nations is like the promise of a coming golden age.

Even so, orbital consciousness is not the same as planetary or global consciousness although it is closely related to the unifying orbital view in the idea of the essential unity of the Earth. Orbital consciousness is more complex and well aware of the negative dialectics in the human idea of progress. For sure, a united world is both necessary and inevitable—yet it is so precisely because we wish to stay alive in a nuclear age. Social progress is possible but only under the condition of the logic of diversity and heterogeneity. New thoughts, new forms of life, new views on human co-existence, human relationships and our relationship with the Earth and the Universe that spurn traditional thinking are needed and must be tolerated as part of the process of adaptation we must embrace in order to survive.

The cloned Earth

The history of the human body
as the history of the prosthesis
converges with
the history of the Earth
as the history of the prosthesis.
The Earth becomes the human
body.

The tools and the technical culture
derive from externalization
(exteriorisations)
of the human body.
The tools and technical products
are artificial limbs (prostheses) and
complete human organs:
hand – hammer, lever
foot – wheel

Modelling of the body led to
technology
as a culture of prostheses,
to the cloned body.
Computational modelling and
cloning
are the most advanced forms of
prostheses.
Humans become prostheses gods,
masters over their bodies,
over the Earth and the Universe.

The conquest of the Universe
continues the externalization of the
body.

Satellites and spaceships are
not only externalizations of the body
but also exteriorization of the Earth.

This is the aim of tools,
of prostheses and technology.
satellites are the eyes, ears
and cameras of the human Earth
of the Earth become Man's body.
After the cloning of the body
comes the cloned Earth.
Spaceships are the
first cells of cloned Earth.
The mothership and the master
tape Earth
will release countless copies
into space.
Just as each cell of an individual
organism
Through cloning can become
The stomach of an identical
individual
so can the Earth become the

eye – glasses, microscope,
telescope, television
ear – telephone, radio
memory – writing, photography,
record
brain – computer
mother's womb – house and home,
Earth.

The inherent quality of the
prosthesis is its replacing
of natural organs by man-made
artificial ancillary organs:
the technomorphic transformation
of the Earth
as part of the human body.
Technology is the make-up of the
Earth.

The places of dwelling and the
sources of energy
the organs and tools
of Earth are put out in the Universe.
The Earth as the maternal womb is
externalized in the space age.
Like the inside of Earth
the human subconscious
is placed on the outside.
The Earth becomes the human brain
of Man the Prosthesis God.
The Earth becomes a prosthesis,
a tool of Man.

The Earth as Brainwork:
self-made reality
self-generated world.
The Earth becomes Man:

stomach for identical Earth stars
and Earth cells.

In the space age
we replace parts of the Earth,
until the Earth itself is replaced.
A replaceable cloned Earth
is infinitely reproducible.
The Earth transforms itself
into an immortal
gigantic prosthesis.

The ALMA Observatory and the Future of Astronomy

Pierre Cox

The Atacama Large Millimeter/submillimeter Array, or ALMA for short, is an international partnership between Europe, North America and East Asia in cooperation with the Republic of Chile, and the largest astronomical project in existence. ALMA is a single telescope of revolutionary design, operating at millimeter and submillimeter wavelengths and composed of sixty-six high-precision antennas located on the Llano de Chajnantor, a plateau at an altitude of 5,000 meters (16,404ft) in the Atacama Desert in Northern Chile. Inaugurated in March 2013, the observatory is now transitioning to full operations. Full availability of all the antennas and their equipment as well as implementation of all the observing modes of ALMA will still take a few years before completion. This period of time is in a sense unique as this multinational project, conceived and planned nearly two decades ago, will gradually become a dream come true.

The ALMA project is the culmination of an extraordinary global endeavor, combining three projects originally envisioned in North America, Europe, and Japan and ultimately brought together in the ALMA project. This combination has pushed a leap in observational power, both in terms of sensitivity and the ability to distinguish small details in celestial sources, corresponding to a tenfold improvement over current radio observatories operating at similar wavelengths. Observing at millimeter and sub-millimeter wavelength levels allows astronomers to study the coldest

and densest regions of the Universe, such as the opaque clouds of gas and dust where stars are born, and the regions where galaxies were formed when the Universe emerged from its dark ages. Furthermore, exploring this part of the spectrum, which is very rich in emission lines from a vast number of molecules, has opened up the field of astrochemistry. The information collected by ALMA is complementary to the data obtained with optical telescopes, as the visible light probes the hot Universe dominated by stars and tenuous interstellar gas.

The clear skies and the exceptional conditions found in the deserts of Northern Chile are the primary reasons why some of the largest observatories have been built in these remote locations. ALMA is the highest observatory on Earth, at about mid-distance to the edge of space. Its antennas are spread over a remarkable plateau surrounded by volcanoes and a landscape of fascinating and constantly changing hues and colors. In the Kunza language of the Atacamenos, "Chajnantor," means "The Place of Departure," a name which perhaps foreshadowed, centuries ago, the long journey that ALMA started with the goal of exploring the cold Universe. At 5,000 meters (16,404ft) altitude, the air of the Atacama Desert is so dry that this site becomes transparent to radio signals with wavelengths in the millimeter range or below. Furthermore, the remarkable flat nature of the broad plateau is well suited for moving the antennas to large distances, many miles apart.

ALMA is a telescope composed of an array of sixty-six antennas that receive and combine radio waves from the same astronomical source. Based on the technique of aperture synthesis, it works as an interferometer. This technique enables us to achieve high resolution by making a single virtual telescope with a diameter equivalent to the maximum distance between two antennas. ALMA functions as a zoom array of antennas, moving from a compact configuration where the antennas are located close-by to

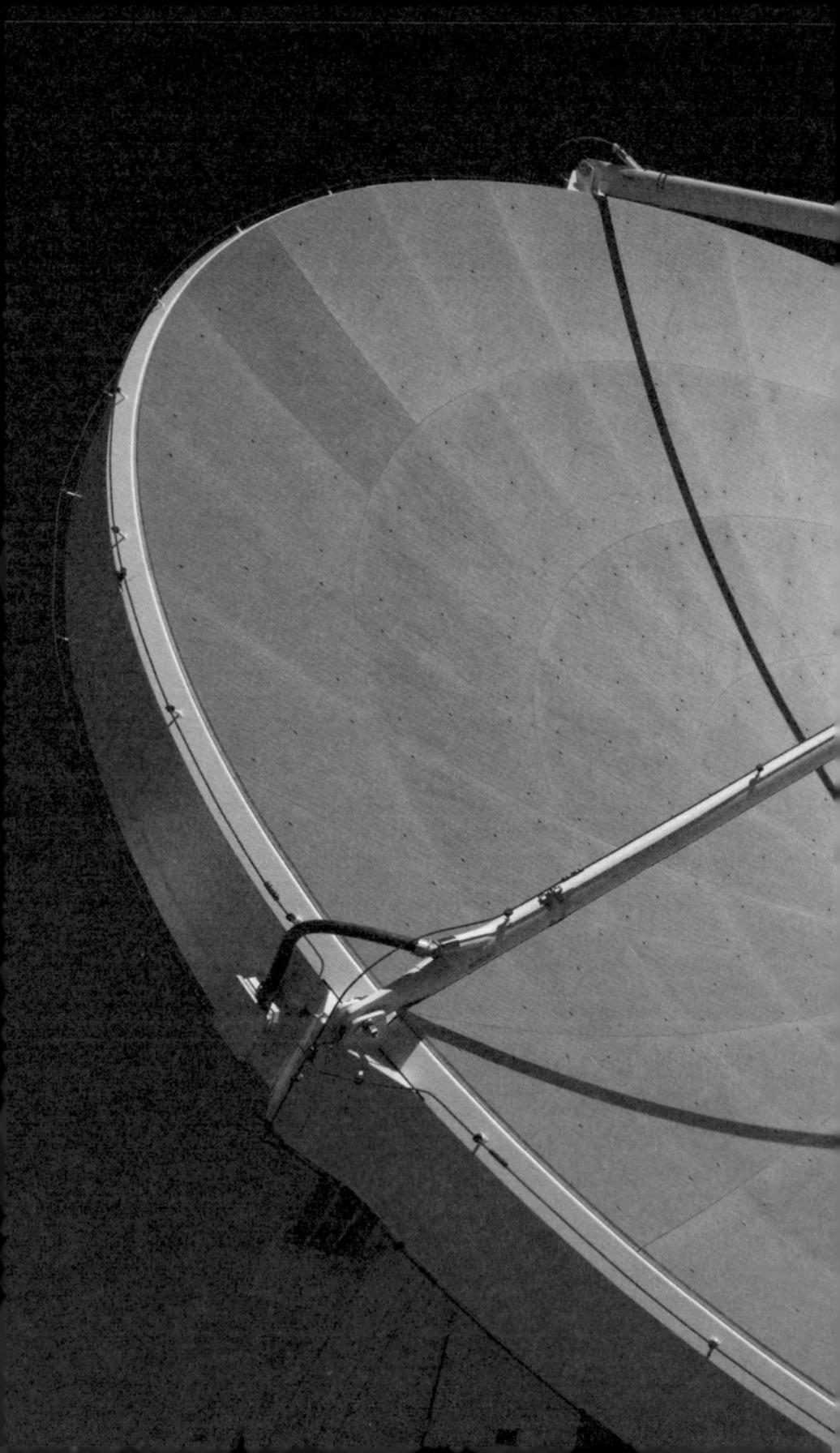

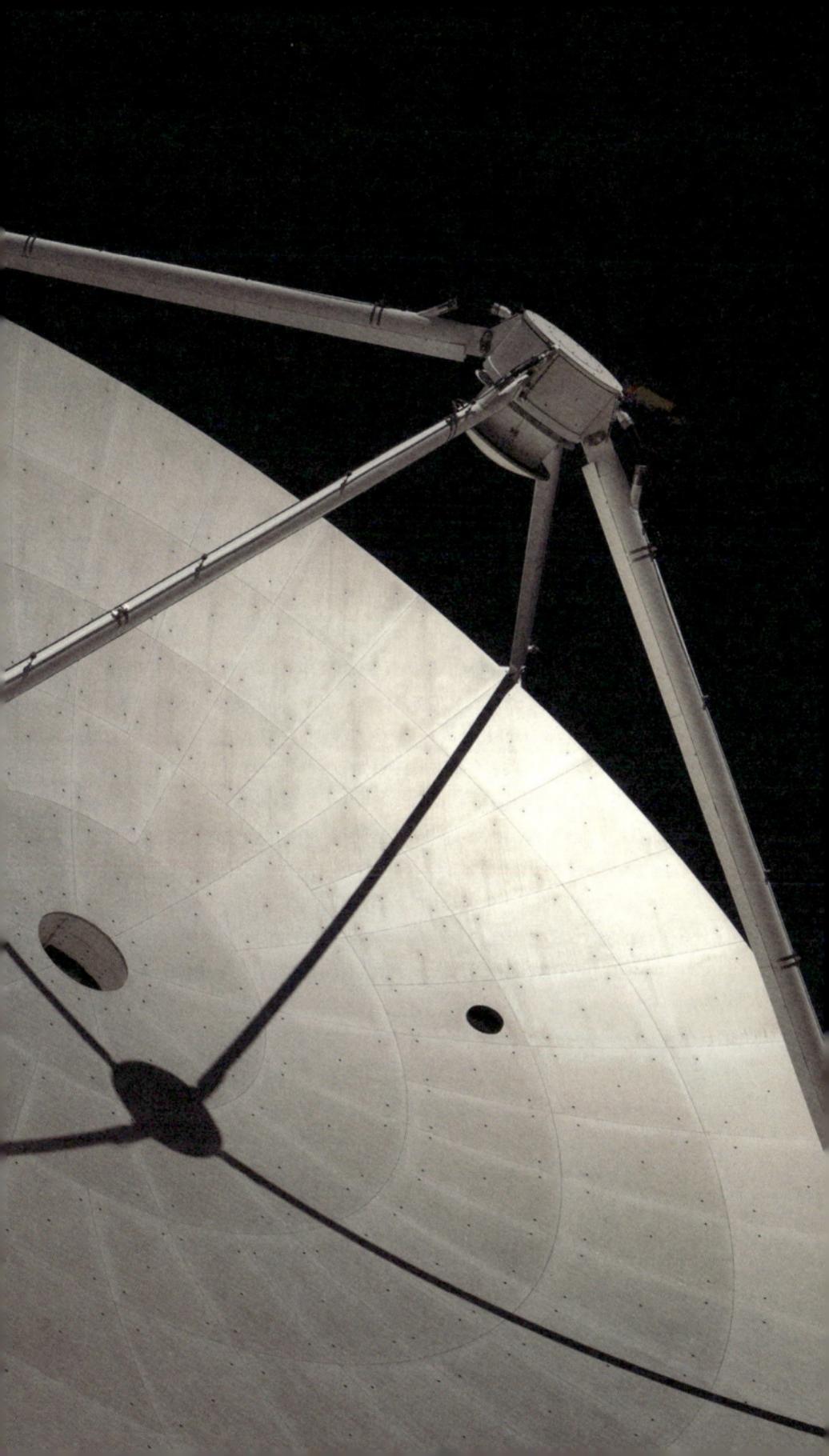

an extended configuration with a maximum distance of 16 kilometers (10mi) between the antennas, offering the highest angular resolution. The frequency and strength of the radio signal of the astronomical source are measured at each individual antenna. Since the antennas all have different positions, each antenna receives the signal at different times and measures slightly different strengths. As the Earth rotates, the antennas change their relative positions with respect to the source. By combining the information recorded over the time of the observation, it is possible to reconstruct the image of the astronomical source. To do this, the antennas and the electronics have to work in perfect synchrony, to a precision of one millionth of a millionth of a second, and the distances between each of the antennas and the central computer must be known to an accuracy finer than the diameter of a human hair (or better than one hundredth of a millimeter).

ALMA will revolutionize our understanding of a vast variety of topics. The first observations have already demonstrated its amazing power (even with a limited number of antennas) with spectacular results obtained on galaxies in the early Universe, colliding galaxies, and evolved stars or disks around young stars. It is clear that ALMA will bring about transformational science encompassing nearly all the major fields of astronomy and providing answers to fundamental questions such as the detailed processes leading to star formation; the formation of planets in a disk surrounding a young star; understanding how matter becomes ever more complex leading to life with the detection of prebiotic molecules; the properties of the nuclei of galaxies close to the central black hole; and the first generation of galaxies a couple of billions years after the Big Bang. Unexpected results will undoubtedly emerge from the data collected by ALMA, and the observatory is well positioned to have a profound scientific impact, pioneering new fields of research.

Pierre Cox

The photons collected by telescopes today have been emitted by sources so far away that we are literally looking back in time. For the most distant objects known, light has traveled for twelve billion years. By comparing observations of objects at these immense distances astronomers can compare conditions and measure changes over the lifetime of the Universe. With its high sensitivity, ALMA will probe even deeper into the Universe, observing normal galaxies and providing a better understanding of how matter was assembled and how galaxies evolved. Observation at millimeter wavelength levels also provides a window onto the earliest ages of the Universe, as the cosmic microwave background—a glow that fills the entire Universe with leftover radiation from the Big Bang—emits at those wavelengths. It formed about 380,000 years after the Big Bang and carries fluctuations that are traces of the seeds from which the stars and galaxies we can see today eventually formed. Recently, remarkable measurements made from the South Pole have detected a polarization signal in the cosmic microwave background that is related to the primordial gravitational waves that are thought to have abounded when the Universe was very young, a mere 10 – 35 seconds after the Big Bang, during the epoch of inflation. These recent discoveries and the prospects offered by ALMA open a new era for exploring the history of the Universe.

Although ALMA will become a unique facility of unmatched performance, it still remains important to foresee and articulate future technological developments which will occur during the thirty-year lifetime of the facility. This will, of course, directly depend on the availability of development funding. But it is only by outlining plans with strong scientific arguments that one can hope to convince the funding agencies and gradually implement new features that will make ALMA even more powerful and versatile.

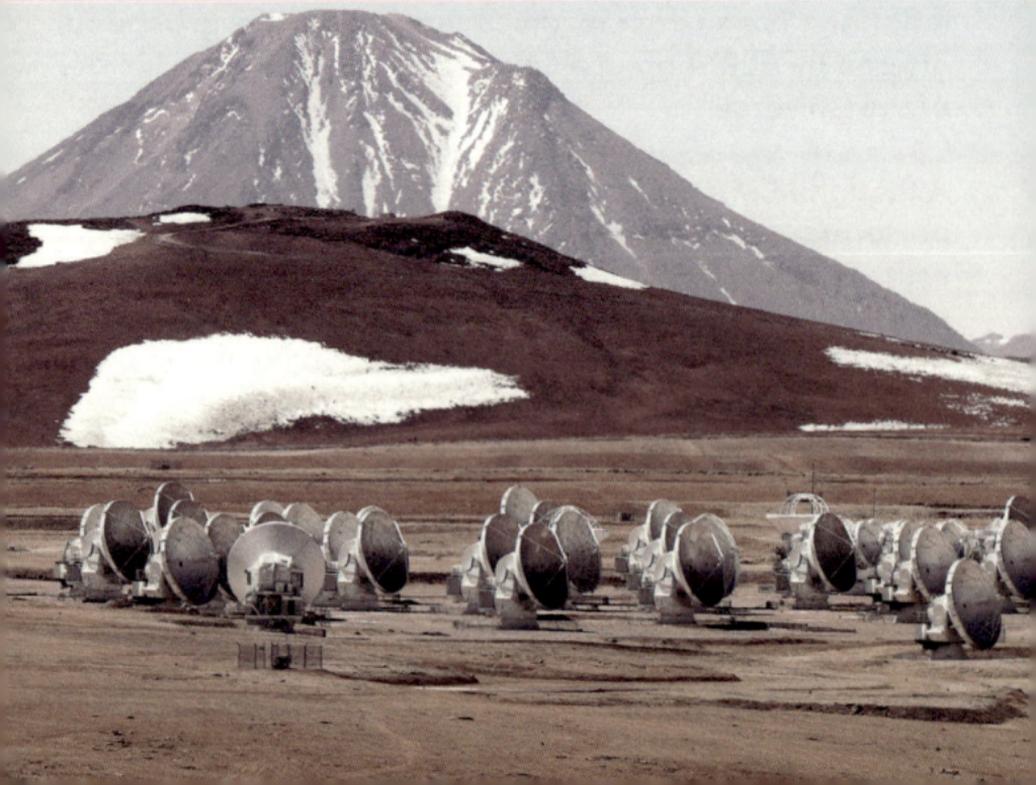

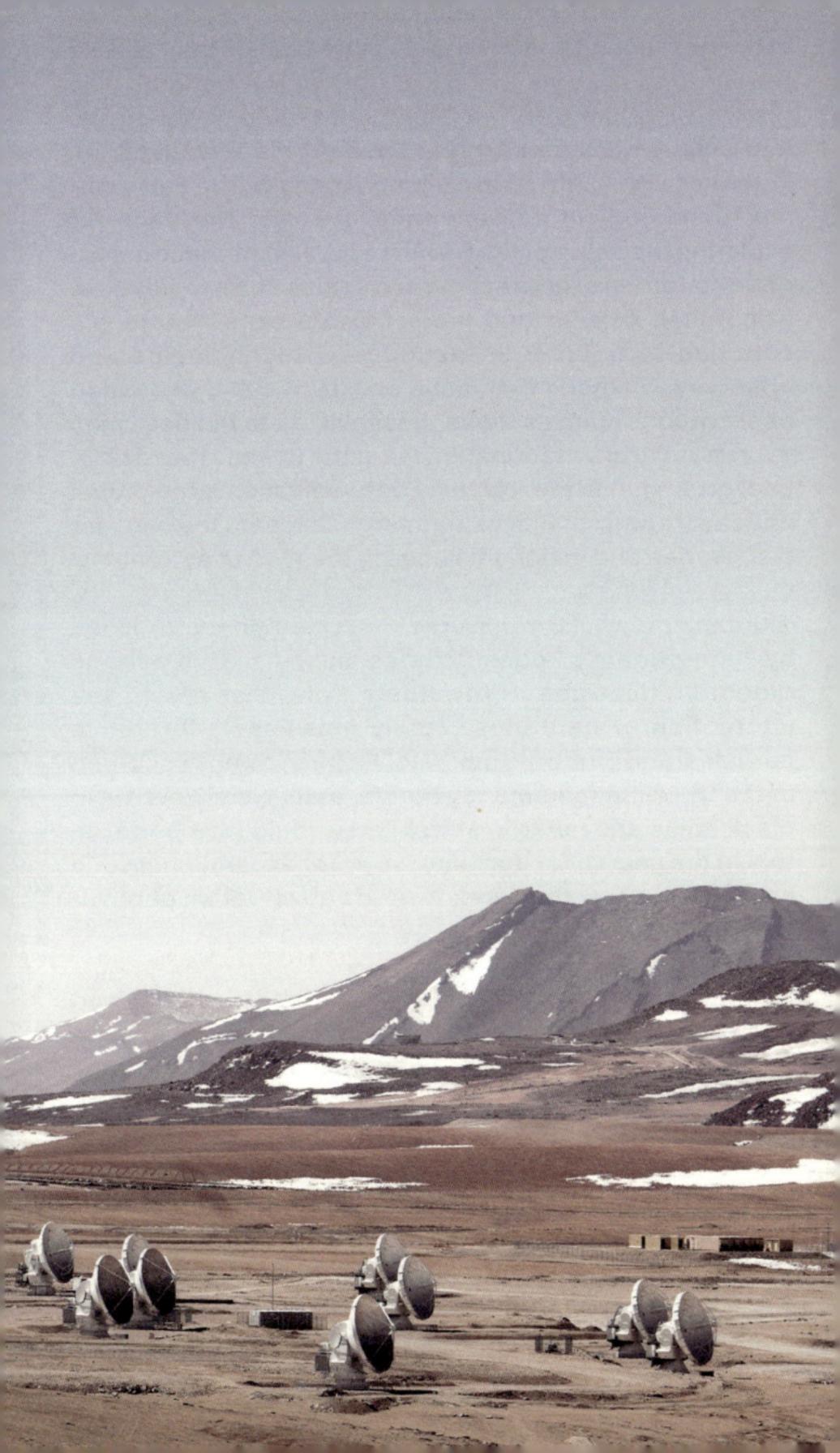

In the next decade, very large facilities will be built across the world to observe the sky at optical wavelengths (like the E-ELT or the LSST in Chile) or at radio wavelengths (the Square Kilometer Array in South Africa and Australia). Together with ALMA, these observatories will be outstanding technological achievements that set the pace for exploring the depth of the Universe across the electromagnetic spectrum at unprecedented scales and sensitivities. In parallel, smaller and more flexible experiments will continue to flourish in testing new technologies and observing methods that focus on specific and dedicated observations such as those that have led to the detection of primordial gravitational waves in the cosmic microwave background. It is the interplay between such large global endeavors and smaller experiments that sets the pace for discoveries and major advances in the field of astronomy.

The exploration of the Universe has recently been enriched by "non-photonic" observatories, such as large particle detectors (IceCube at the South Pole) that record the interaction of neutrinos (nearly massless sub-atomic particles) and probe the most violent phenomena occurring in the Universe (gamma ray bursts, cataclysmic events in black holes and neutron stars). They could be a powerful tool in the search for dark matter, or for experiments such as VIRGO in Italy that work towards observation of gravitational waves.

Over the past century astronomy has been revolutionized by the use of new technologies that enable us to explore the Universe beyond visible light. Each time a new region of the spectrum was opened, new discoveries have been made that could not have been made otherwise. In the near future, the coexistence of large observatories exploring the Universe from radio to optical wavelengths, and experiments looking for information from sources other than light will lead to an unprecedented view of the Universe and a better understanding of the world we live in.

THIS TEXT BY PIERRE COX WAS ORIGINALLY WRITTEN IN 2014 FOR THE PROJECT "VISIONARY STATEMENT 2046" AS PART OF MICHAEL NAJJAR'S *OUTER SPACE SERIES*

Pierre Cox

The Overview Effect and the Human Implications of Settlements in Space:

Frank White

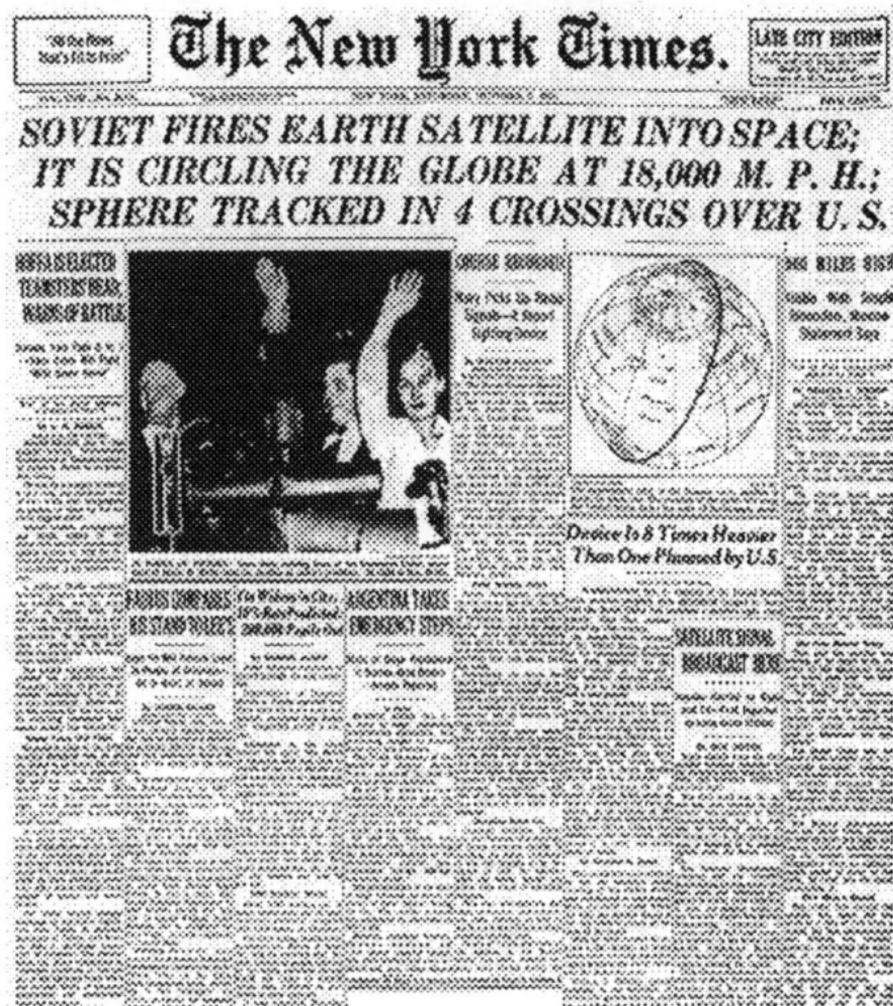

The New York Times.

SOVIET FIRES EARTH SATELLITE INTO SPACE;
IT IS CIRCLING THE GLOBE AT 18,000 M. P. H.;
SPHERE TRACKED IN 4 CROSSINGS OVER U.S.

A Personal Journey of Discovery

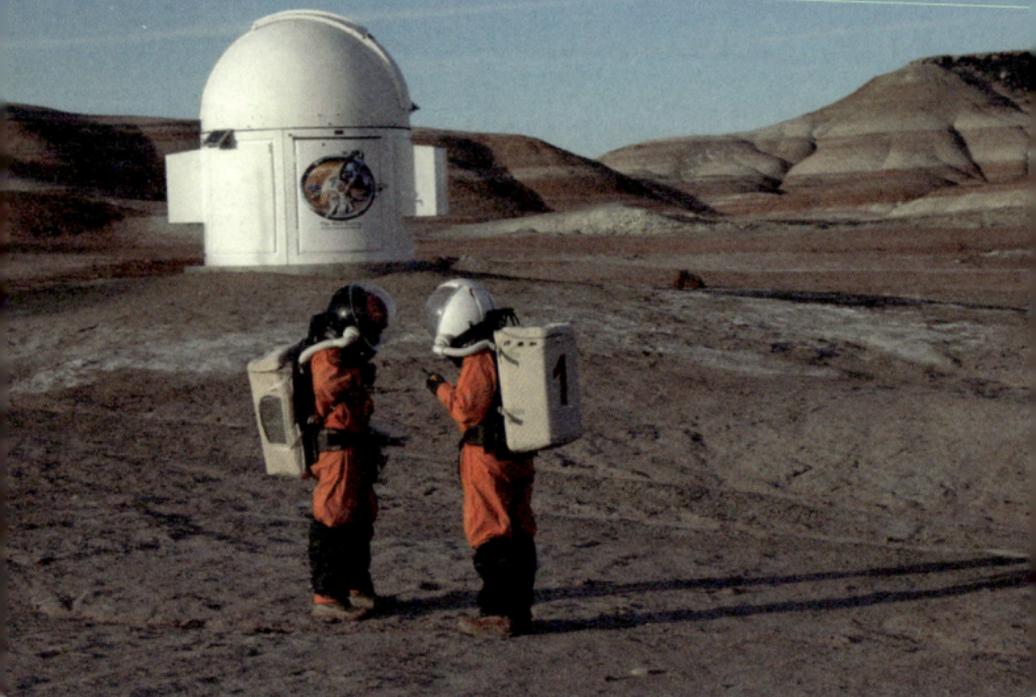

Space is open to us now; and our eagerness to share its meaning is not governed by the efforts of others…

US President John F. Kennedy, Address to a joint session of Congress, May 1961

Frank White

Why... should man's first flight to the Moon be a matter of national competition? Why should the United States and the Soviet Union... become involved in immense duplications of research, construction, and expenditure? Surely we should explore whether the scientists and astronauts of our two countries—indeed of all the world—cannot work together in the conquest of space, sending someday in this decade to the Moon not the representatives of a single nation, but the representatives of all of our countries.

President Kennedy, Address to the United Nations, September 20, 1963

Just before I joined the "space advocacy movement" in the late 1970s, I wrote a paper called "The Stars Our Home: Exploring the Human Implications of Colonies in Space." This essay continued a long intellectual journey that began when I was very young.[1]

From the beginning of the First Space Age in 1957 with the launch of Sputnik, my primary interest has been in understanding what President Kennedy called "the meaning of space," or the human implications of our expansion into the solar system and beyond. While the engineering aspects of this grand adventure are critical to its accomplishment, the long-term impact will hinge on how human society evolves in response to a new age of exploration and development.

1 F. White, unpublished essay, circa 1977, 1978.

When the sailing ships of Columbus and other adventurers set out from Europe to explore the rest of the world, the technical accomplishments in building those ships were essential, but we don't focus very much attention on the ships today. Instead, we recall both the positive and negative results of human beings using them to explore the world.

When Columbus arrived in what was then called the New World, his discovery led to the creation of new nations in both North and South America, innovative forms of government, and a great migration of Europeans to these continents. In many ways, his discoveries were positive for Europeans, but catastrophic for indigenous people, who were conquered, enslaved, and subjected to diseases from which they had no natural immunity.

The same can be said regarding westward expansion on the American frontier. Again, the outcomes of this early "space settlement" were very mixed, depending on whether you were a settler or someone who was already settled on the land.

While all of these insights can be considered to be a series of events that took place in the past, no longer relevant to our future, the fact is that "frontier thinking" remains prominent among those looking to expand our reach into the solar system, and we still use the term "colonization" regarding other planets, even though this term has negative connotations for many people.

Please don't let me be misunderstood: I am still an advocate of space exploration, which I believe is the key to human evolution. However, I want us to think ahead and avoid some of the mistakes we have made in the past.

Our underlying philosophy of space exploration and development will shape our actions, for good or ill, as we leave

There glinting darkly, scoured by the years, rough edged and unknowable…

our home planet and move outward. Perhaps the time has come to explicitly consider what we are doing before we undertake this great adventure.

THE INFLUENCE OF GERARD K. O'NEILL

After writing that initial paper, I discovered the Space Studies Institute, led by Gerard K. O'Neill, who was talking about the creation of freestanding space settlements at the Lagrange points between the Earth and the Moon. Here was an organization interested not only in the science and technology of space settlements but also the human issues that would arise once they were established. As a social scientist and systems thinker, I eagerly joined their ranks and began writing about "space settlements as human systems."[2]

It was during this time that I had the insight that led to writing *The Overview Effect: Space Exploration and Human Evolution* and developing a comprehensive theory of space exploration and development based on it. The overview effect is the experience of astronauts in orbit or on lunar missions in which they see the Earth as a whole system and realize that there is a connection and interdependence of everything on the planet, including human beings. It is the first of many shifts in human consciousness that arise as we explore outer space.[3]

This was an important discovery for life on Earth, because it suggested that we could engender a profound revolution in terrestrial thinking as more people experienced the

2 White, F., "Understanding Space Settlements as Human Systems," *Space Manufacturing 1983, Advances in the Astronautical Sciences, Proceedings of the Sixth Princeton/SSI Conference on Space Manufacturing*, edited by J. D. Burke and A. S. Whitt, Vol. 53, Univelt, San Diego, 1983.

3 F. White, *The Overview Effect: Space Exploration and Human Evolution*, AIAA, Reston, VA., 1987, 1998, 2014.

cognitive shift in worldview that is now called the overview effect by people around the world.

I began interviewing astronauts about their experiences because I was trying to conduct research on the future worldview of space settlers, people who did not yet exist. The hypothesis was that those who lived in space continuously would always see the Earth as a whole system and they would have insights that we had been trying to understand for centuries regarding the unity and oneness of our planet.

It also seemed clear that as human beings expanded further into the solar system, additional changes would take place, such as the "Copernican Perspective." This is a realization that not only is the Earth a whole system of which we are a part but the solar system itself is also a whole system of which the Earth is a part.[4]

The decision to talk with astronauts about their experiences has reaped rewards far beyond my expectations at the time. It has led to the writing of my book, a film by Planetary Collective called "Overview," which has been seen by more than seven million people on Vimeo, three major events at Harvard University, and the founding of the Overview Institute with David Beaver—among other things.[5]

Ultimately, it led to creating the "Academy in Space Initiative" and its successor project, "Earth in Space."

4 Ibid.

5 For more information on the Overview Institute:
 www.overviewinstitute.org.

THE ACADEMY IN SPACE AND EARTH IN SPACE

After spending some 35 years looking at the overview effect's implications for our home planet, I have now returned to the original hypothesis and am working on "Earth in Space," which has grown out of the "Academy in Space Initiative." These projects focus on how the overview effect's basic principles might be expanded to guide us toward a new philosophy of space exploration and development.

The Academy in Space effort was launched at Framingham State University on April 6, 2016 with the support of Irene Porro, director of the Christa Corrigan McAuliffe Center for Integrated Science Learning.[6]

Now with the assistance of Ted Field, a classmate of mine at Harvard College, this project is being expanded beyond the academy to government agencies, private enterprise, and other sectors of society.

The goal is to "create a comprehensive, sustainable, and inclusive blueprint for exploring and developing the solar system." The approach is to examine some 15 critical questions through a series of task forces, each of which will develop a report that will be integrated into the overall plan.[7]

Of particular concern is another question raised by President Kennedy in his address to the UN: will human exploration of the solar system be a unified effort by a world united through the experience of the overview effect, or a mad scramble of nations seeking power and advantage over others, as we have on the Earth?

6 http://christa.org.

7 A document describing this project will be available in the near future.

TOWARD A NEW PHILOSOPHY OF SPACE EXPLORATION

President Kennedy understood that we have clear choices about how we explore the Universe. While the origins of space exploration seem to have been driven by national competition, he constantly searched for a better, more global, approach to this great enterprise.

In spite of its impact on every aspect of human life, there has been remarkably little effort by academia or the governments of the world to understand the meaning of space exploration and development in all its complexity.

Developing a philosophy of space exploration and development does not mean engaging in abstract questions of epistemology and ontology; it means developing an approach to the next step in human evolution. It can be done only through a vigorous debate among the best minds on the planet about central questions, like the following:

Government: How would human settlements on the Moon or Mars be governed? Would they be "colonies" of national governments or international zones of cooperation like Antarctica? Would a settlement on Mars eventually issue a "declaration of independence?" If so, why? If not, why not?

Economics and Business: How would the global economy grow if it expanded beyond the limits of the Earth? How many jobs might be created? What are the challenges to existing enterprises?

History: What can we learn from the history of exploration and expansion onto new frontiers during the great ages of exploration in the 15th and 16th centuries and the 19th century?

Environment: To what extent has the overview effect given an impetus to the environmental movement? How might our concerns about the environment shift if our definition expanded to include the solar system? Should we be using nuclear power to explore and settle the planets?

Ethics: At a time of increasing economic hardship, what is the justification for investing billions of dollars in space exploration and development? Should the wealthy be able to spend millions on trips to Low Earth Orbit and beyond, even if they travel on private spacecraft?

Sociology: What has been the social impact of space exploration to date? NASA is finding more and more planets outside the solar system that might sustain life. What would be the impact of contacting extraterrestrial civilizations? Would the result resemble what happened to indigenous peoples when they came into contact with European explorers?

Religion: The major religions of the world have survived the early years of the Space Age, but how will they fare in the future? Will new forms of religion evolve as human beings live and work in what was once considered "the heavens?"

Medicine and Public Health: Living in zero-gravity or low-gravity environments has already pointed to a number of medical problems, including loss of calcium in the bones, cardiac issues, and eye diseases. The space environment is hostile to human life as we know it. If human beings are going to live and work outside the Earth's biosphere for long periods of time, these issues must be addressed.

Education: How would education change if it took place away from the Earth? There is serious discussion of establishing a university on the Moon. How might terrestrial educators become involved in such a venture? Should they?

Law: Space law is well established from an Earth-centered perspective, i.e., to consider questions like what happens if a satellite de-orbits and causes damage on the ground. How might law evolve in a space settlement on the Moon or Mars? What new laws might be needed on the frontier?

SUMMARY

"Space" has been known as "the final frontier" and "the high frontier," and it is not only a physical boundary but also a frontier of the mind that needs greater exploration.

"Space" is more than a physical or even mental frontier, however. It is also our true environment. The Earth is in space, it always has been in space, and it always will be in space. The more we know about our real environment, the better chance we will have of creating a positive future for ourselves and our descendants.

Leaving the Blue Dot

Michael Najjar

Exploring the Implications of Colonizing Our Solar System from an Artist's Perspective

"We cannot even put our planetary home in order, are WE to venture out into space? By the time we are ready to settle even the nearest other planetary systems we will have changed. The simple passage of so many generations will have changed us; necessity will have changed us."

Carl Sagan

As an artist I feel the essential need to raise awareness about the existential questions implicit in future space exploration. What is the fundamental purpose of space exploration and why do we do it? The attempt to penetrate the far reaches of space bears witness to our innate sense of curiosity, our drive for exploration and our unquench-able desire to push back frontiers and go beyond them. The human species is facing growing threats on planet Earth including overpopulation, climate change, dimin-ishing resources, and shortages in the energy, food and water supply. Despite the fact that we need to protect our home planet, colonization of our solar system might be the ultimate solution to guarantee survival of our species. Yet a range of technical innovations are needed before we can

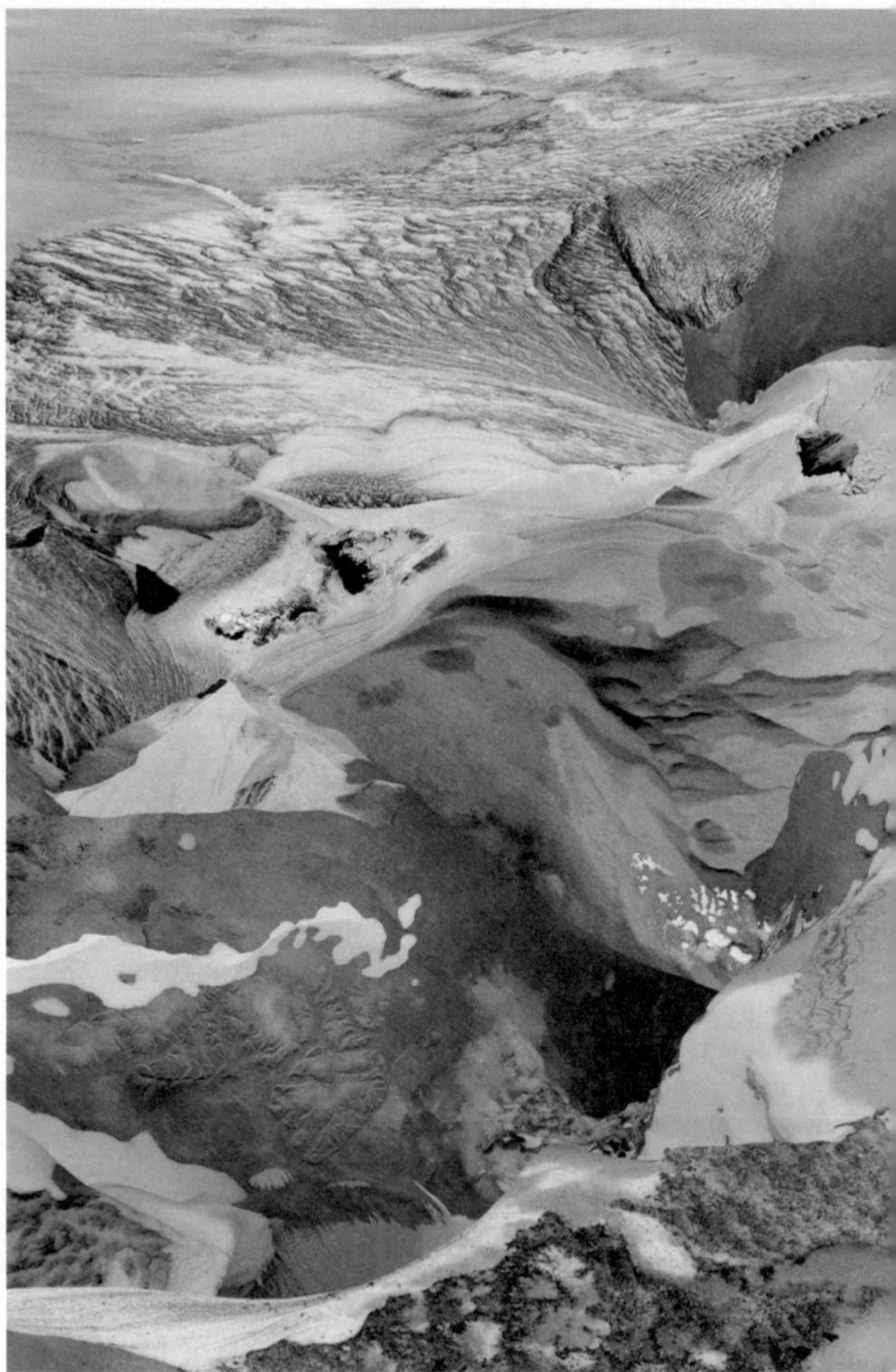

planetary overview, 2017, 202 × 132 cm, 79.5 × 52 in

planetary overview

implant and sustain life away from Earth. As all the previous colonial and frontier experiments of humankind have occurred within the biosphere of Earth, leaving the blue planet presents a host of major challenges of which supply chain management, logistics, communication and sustainability are only a few. Astronauts will not only have to grow their own food and filter their water, but generate power and build structures on distant planets and Moons using only indigenous materials. At the same time innovations in space travel will engineer sustainable technologies that will help us better maintain our own Spaceship Earth.

The paradigm shift to the Copernican Perspective in the 16th century exemplified that Earth is not only a complete system of which humans form only part, but also itself part of the solar system. If the next step in human evolution is to build a solar civilization, we must deal with problems and opportunities on a global level. We should observe the planet both as a whole and as part of a universal system. Yet in the few short decades since we first ventured into space, our ambitions have switched from just reaching the Moon to the profound idea that our species may eventually live away from Earth and inhabit other worlds. This shift in perspective will change the very nature of what it means to be human—for the first time in our species' existence, we shall call more than one planet "home." We need to extend our existential framework of reference from one that is purely Earth-bound to one which includes Earth orbits and outer space in general.

On our actual home planet we are now confronted with rising levels of carbon dioxide in the atmosphere that may well render life untenable across vast swathes of the Earth. NASA predicts that, based on current emission rates, temperatures could increase by up to 4.5 degrees Celsius by 2100. Consequently, the creation of a permanent home for humankind on the Moon, Mars or elsewhere in the solar system may be imperative. The human species now faces

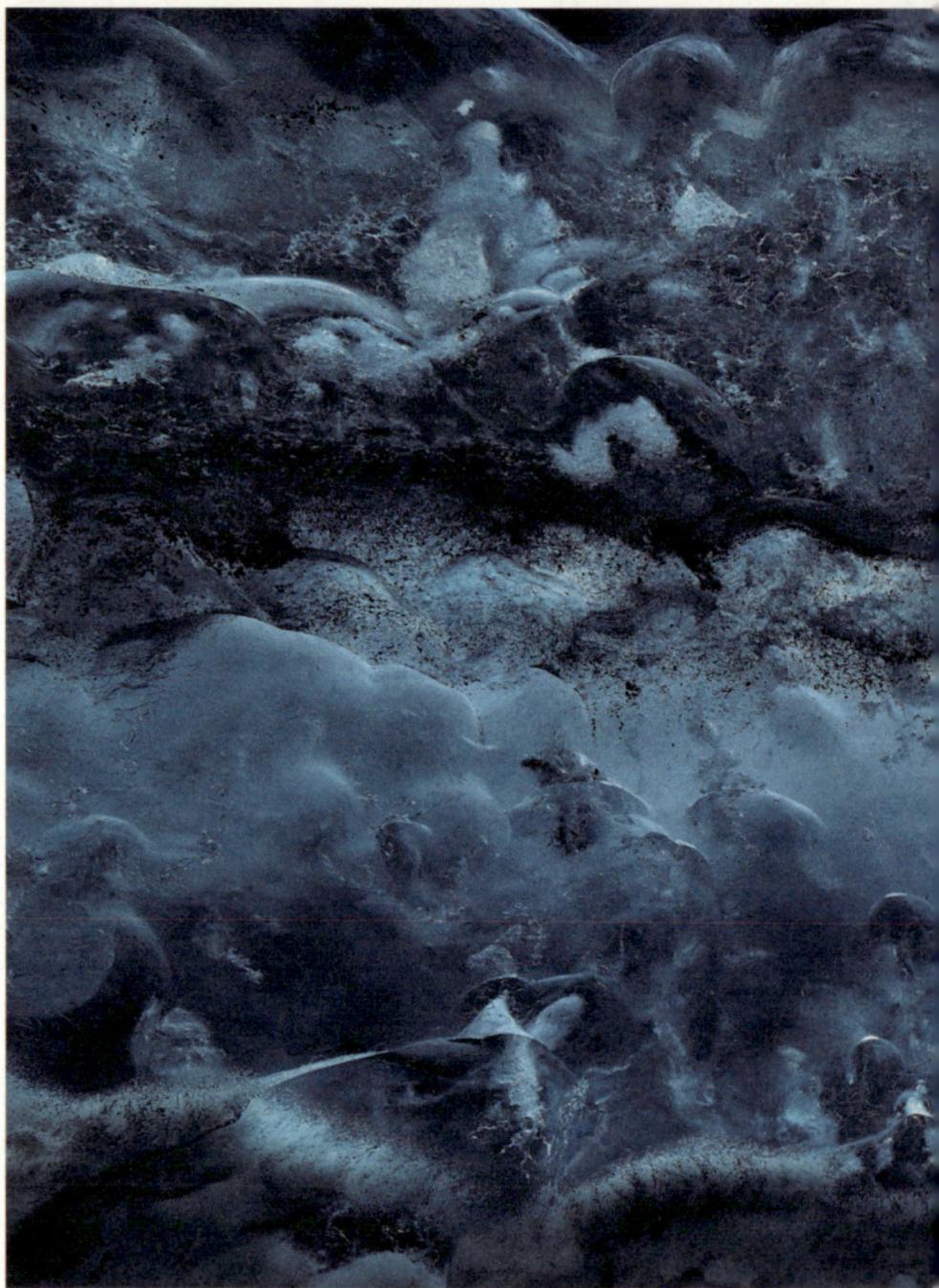

liquid time, 2017, 132 × 202 cm, 52 × 79.5 in

liquid time

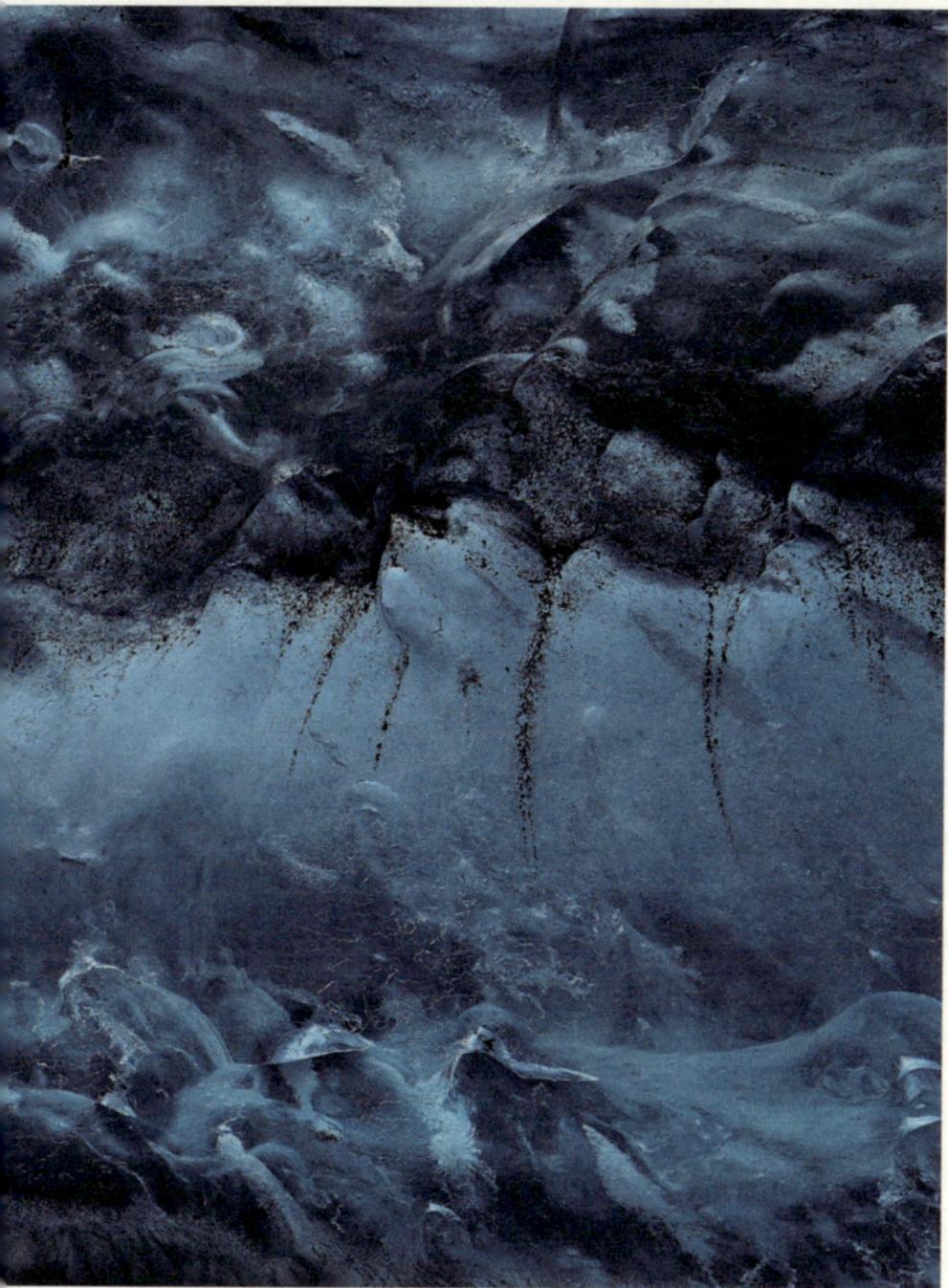

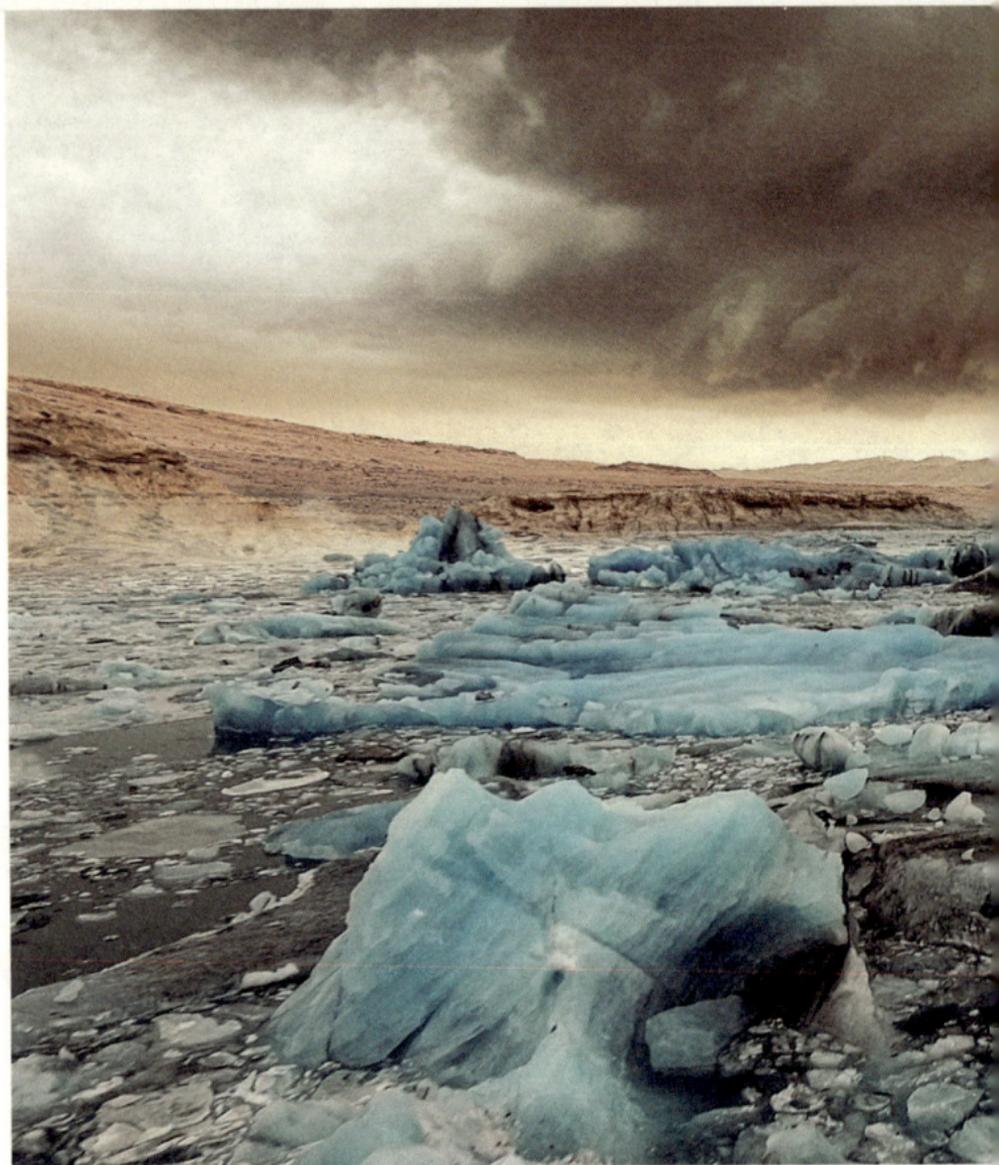

terraforming, (videostill), 2017, HD video, 9.10 min., single channel, stereo

terraforming

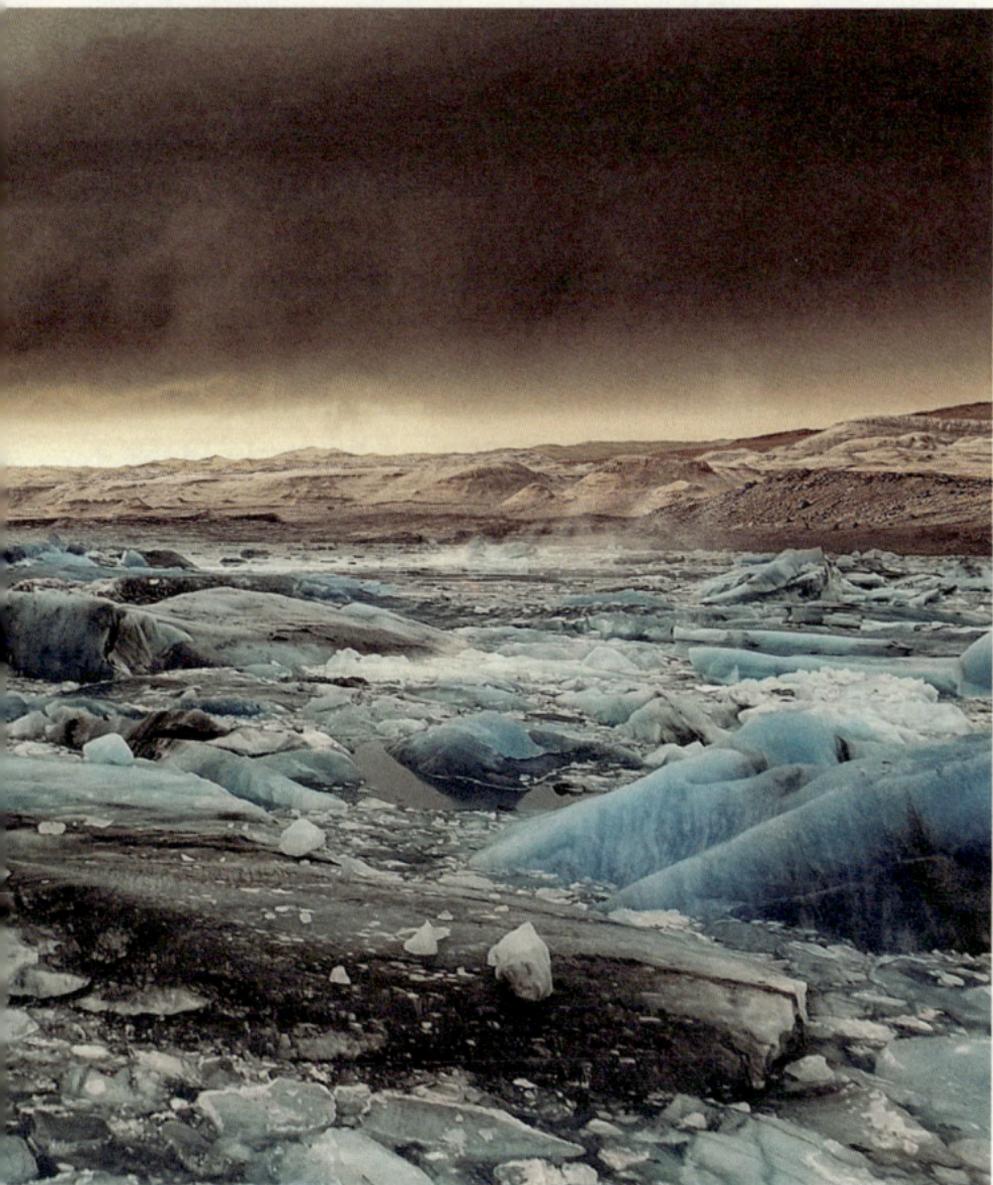

From Earth to the Universe

existential threats arising from environmental transformation caused directly by humans which is nothing less than the process known as "terraforming." On the other hand, the self-same process might be the key to transforming other planets in our solar system into a new home for humankind. Terraforming (literally: Earth-shaping) is the process whereby a hostile environment, i.e. a planet that is too cold, too hot, or that has an unbreathable atmosphere, is altered to make it suitable for human life. This could involve modifying the temperature, atmosphere, surface topography, ecology—or all of these—to make a planet or Moon more "Earth-like." At this stage the most popular candidate for terraforming is the planet Mars. Its proximity and similarities to Earth, and the fact that it once had an environment very similar to that of the Earth—which included a thicker atmosphere and the presence of warm, flowing water on the surface—makes the Red Planet an ideal object lesson for terraforming. Furthermore, we now believe that Mars may have additional sources of water beneath its surface. Even so, Mars would need to undergo vast transformations before human beings could live on its surface. Humankind is already well-versed in altering planetary environments. For centuries, humankind's reliance on industrial machinery, and coal and fossil fuels has had a measurable effect on the Earth's environment. Whereas the greenhouse effect we have triggered was not deliberate, the experience and insight gained in creating it here on Earth could be put to good use on planets whose surface temperatures need to be raised artificially.

The similarities between Mars and Earth might be one good reason to terraform it. Mars once resembled Earth until its atmosphere was stripped away, causing it to lose virtually all the liquid water on its surface. Terraforming it would therefore be tantamount to returning it to its once warm and watery state. Given the ethical implications and the sheer cost involved, the cost-to-benefit ratio of terraforming Mars seems like a crazy idea. But in time we might

find that we have no choice but to go there, simply because Earth is becoming too crowded, too stuffy and too uninhabitable for us. The artificial creation of a sustainable ecosystem on a lifeless planet like Mars is a fascinating vision that one day might guarantee our survival as a species.

Another result of space exploration is the appearance of a planetary overview system as described by Frank White in his book "The Overview Effect." The overview effect of seeing and feeling the unity of Earth is a meta-experience previously only accessible for astronauts. Today's dramatically growing Earth-observing technologies (satellites) intensify this effect and make it accessible to all of us. Even so, this new way of measuring and visualizing the globe brings with it a stern ecological warning as space exploration visions are not just focused outwards into space but include the Earth as well. The dawning of a planetary overview system might transform awareness of the human social system and lead to a revolution in thinking. The more we venture into space, the more our intellectual and scientific understanding of our place in the universe will be complemented by a direct experience which will lead to a shift in our own identity and our understanding of who we are and where we come from. By expanding human presence throughout the solar system we will achieve the next level of evolution, the "homo spaciens"—a new type of human being highly adapted to the space environment and more capable of exploring and settling it—capable of living away from Earth. We need to understand that there is no dichotomy between Earth and space because the Earth is already in space as Frank White underscores in his book.

In my artistic work I take a complex and critical look at the technological forces shaping and drastically transforming the early 21st century. Space exploration will significantly change our lives in this century. In 2011 I watched the launch of the Atlantis Space Shuttle at Kennedy Space

Center. It marked the end of the shuttle program and the beginning of a new era in space travel driven by new private space companies like Elon Musk's SpaceX. I was blown away by this experience, and ever since then I have been working on my new "outer space" series which deals with the latest developments in space exploration and the way they will shape our future life on Earth, in Earth's near orbit and on other planets. The cultural dimension represented by emergent cutting-edge space technologies is very much at the center of this work—in terms of the deeper knowledge these new technologies will impart about the Universe, their impact on space travel, and the way they will influence and shape our lives and work on Earth. I have travelled to the world's most important spaceports like the Kennedy Space Center, Baikonur Cosmodrome in Kazakhstan, and the Guiana Space Center near Kourou in French Guiana. I have met with numerous scientists, engineers and astronauts, and visited space laboratories around the globe constructing new spacecraft, satellites and telescopes. My collaboration with leading scientists and space agencies has given me privileged access to locations which are usually unknown to, and unseen by, the public. The photographic and video artworks from the "outer space" series blend documentary and fictive scenarios to create visionary enactments of current and future space exploration. As one of Virgin Galactic's Pioneer Astronauts I will travel into space onboard SpaceShipTwo in the near future. And I am truly convinced that this experience will have a significant influence on my artistic practice and will certainly raise yet more questions about the visions, the challenges and the sense of human space exploration.

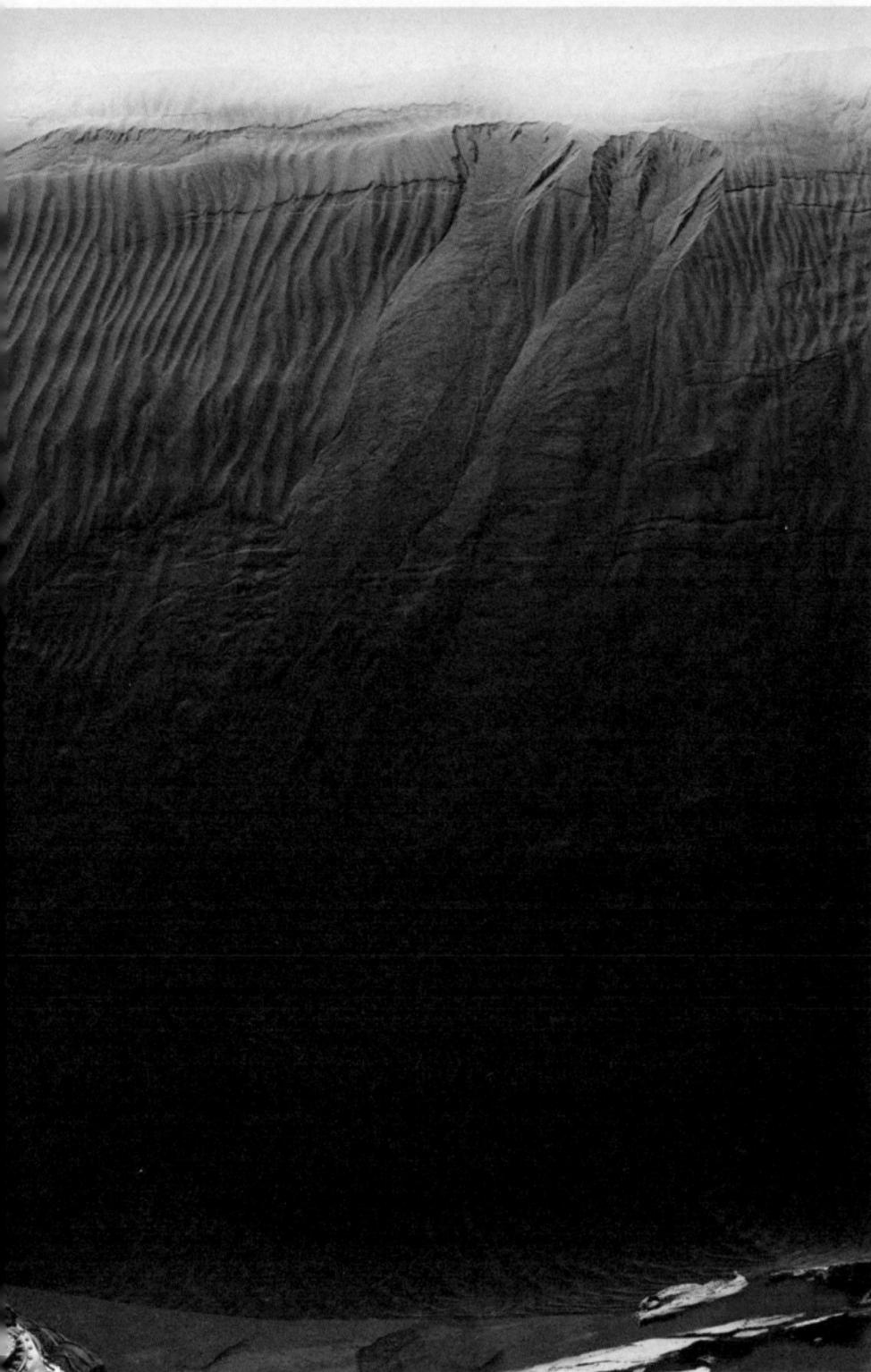

waves of mars, 2016, 202 × 132 cm, 79.5 × 52 in

waves of mars

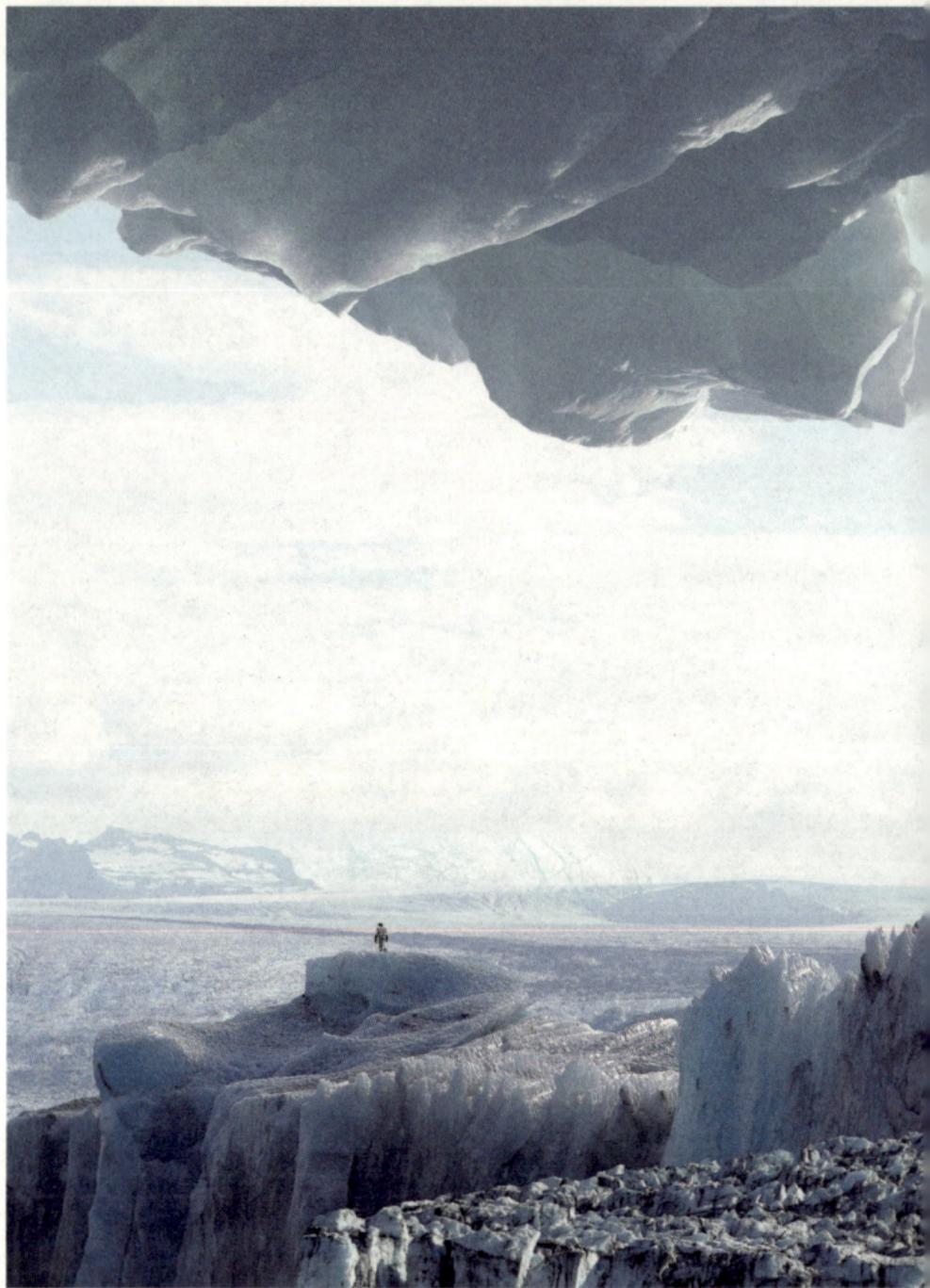

europa, 2016, 132 × 202 cm, 52 × 79.5 in

europa

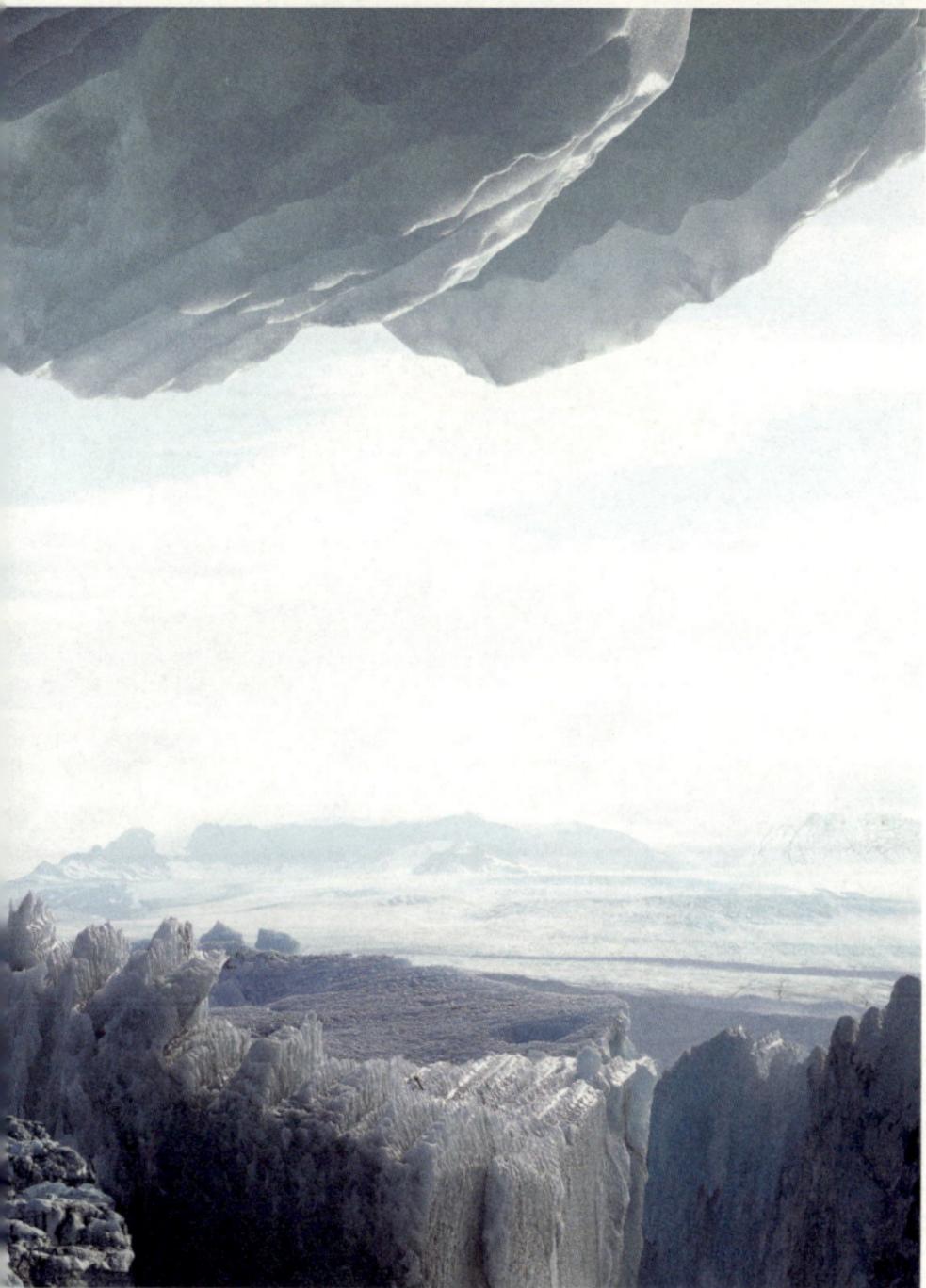

From Earth to the Universe

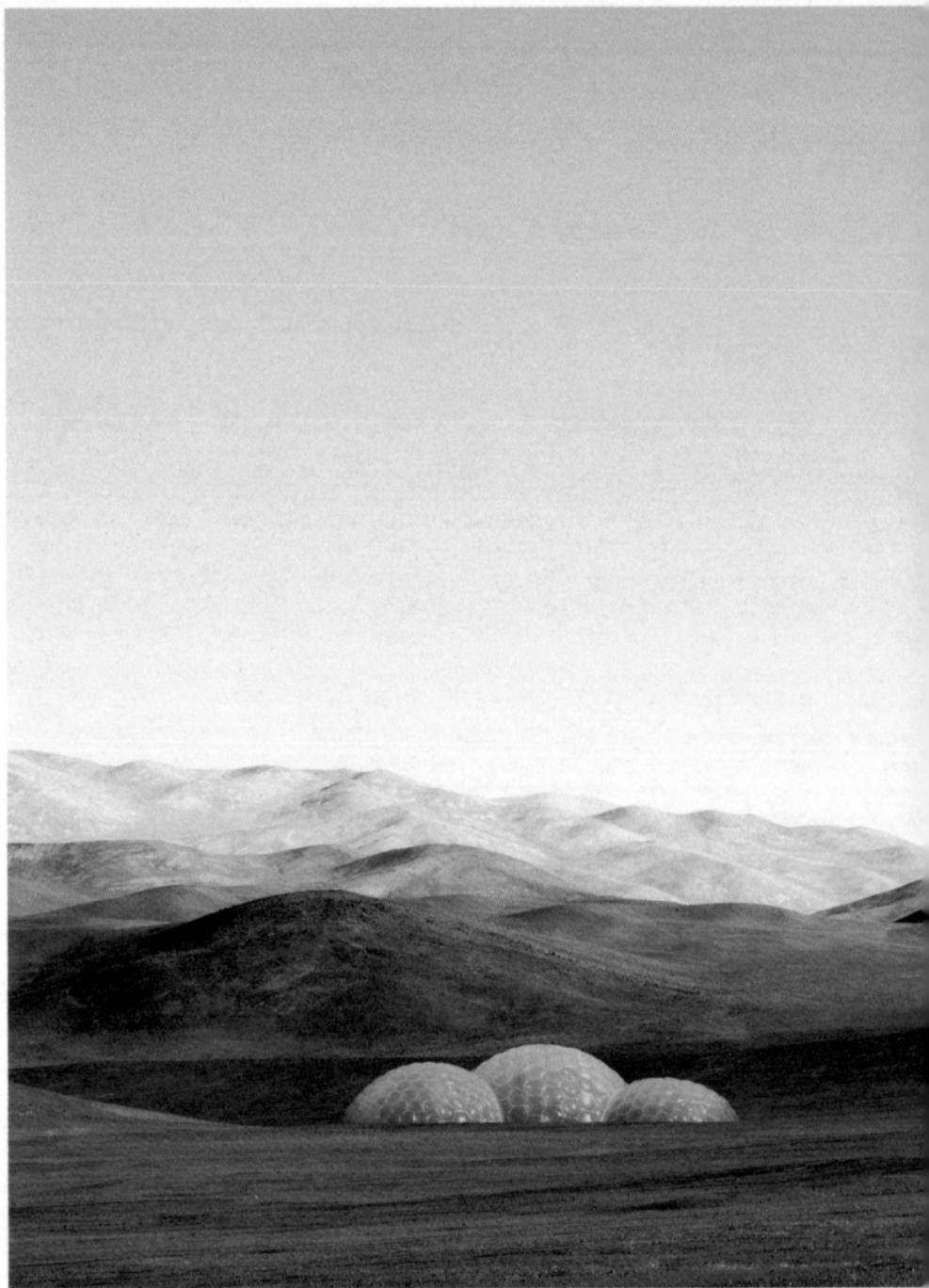

sands of mars, 2014, 132 × 202 cm, 52 × 79.5 in

sands of mars

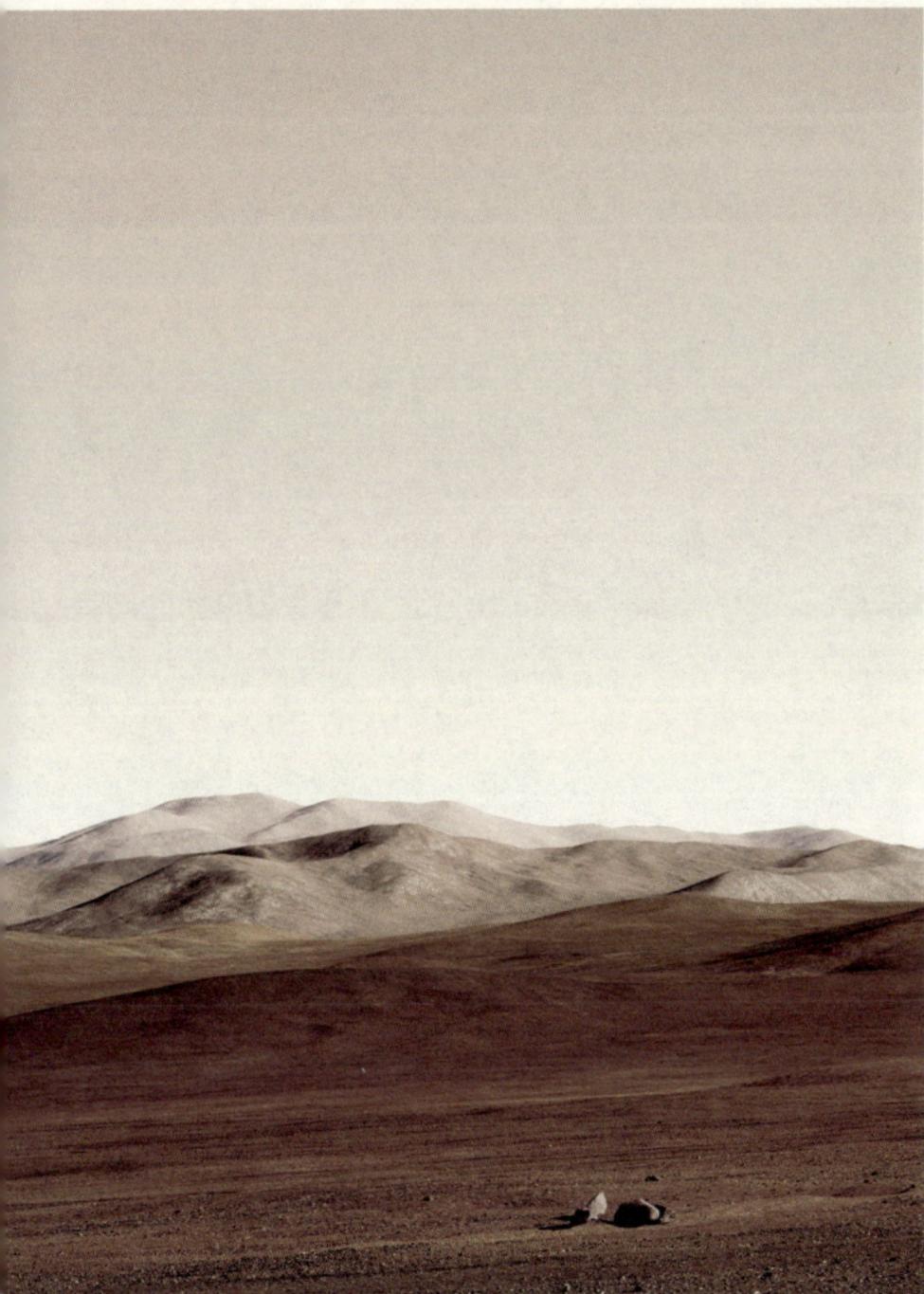

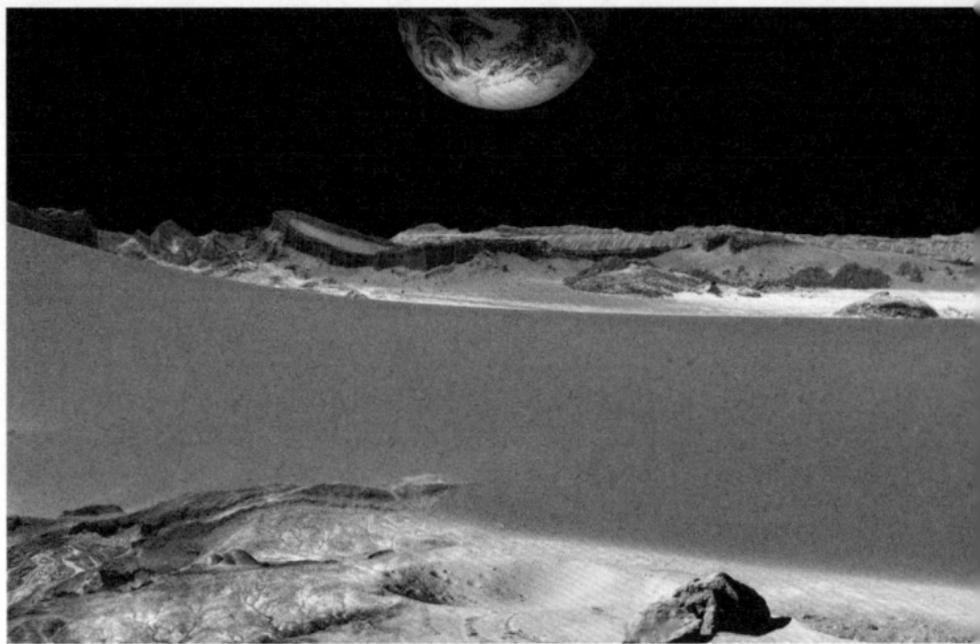

moon mining, 2016, 132 × 202 cm, 52 × 79.5 in

moon mining

Chapter 2

"There is no way back into the past; the choice, as Wells once said, is the Universe— or nothing. Though men and civilizations may yearn for rest, for the dream of the lotus-eaters, that is a desire that merges imperceptibly into death. The challenge of the great spaces between the worlds is a stupendous one; but if we fail to meet it, the story of our race will be drawing to its close."

Arthur C. Clarke, *Interplanetary Flight*, 1950

Future Trajectories of Space Travel

Humanity's Future in Space

Buzz Aldrin

Looking back on those early, frenzied years of the "Space Race" between the former Soviet Union and the United States, it became quite clear in my own mind that if space was destined to be a new frontier, then I wanted to be part of getting there.

After serving my country during the Korean conflict, flying over 65 combat missions, I decided to continue my education and earned my Doctorate of Science in Astronautics from the Massachusetts Institute of Technology—the same university my father had attended. My MIT thesis was titled "Guidance for Manned Orbital Rendezvous," dedicating that research work to the American astronauts. To write that lengthy treatment of the topic, I drew upon my experience as a fighter pilot and the skills needed to intercept enemy aircraft. From that expertise I developed a technique for two piloted spacecraft to rendezvous in space.

My hopes of becoming an astronaut, however, were short-circuited early on when my NASA application was first turned down. I was not a test pilot. But with dogged determination to seek a career as an astronaut, I applied again. This time, my jet fighter experience and NASA's growing interest in mastering space rendezvous influenced them to accept me in the third group of astronauts in October 1963. I was the first astronaut selected with a doctorate and became known to my fellow astronauts as "Dr. Rendezvous."

I am proud to say that my rendezvous and docking ideas were vital to the success of the Gemini and Apollo pro-

grams, and they are still used today. My early astronaut years allowed me also to pioneer underwater training techniques, as a substitute for zero gravity flights, to simulate spacewalking.

My first space journey was in 1966, as pilot of Gemini 12, with James Lovell as command pilot of the mission. That nearly four-day flight brought to a successful close the stepping stone Gemini program of ten piloted missions. During that flight I was able to establish a new record for spacewalking, spending five and a half hours outside the two-seater Gemini.

But when Gemini 12 splashed down, the unmistakable realization was that we had but a handful of years remaining to achieve Kennedy's challenge to land a man on the Moon by the end of the decade. There was much work ahead of us. It was inspirational watching a team of 400,000 people working together on a common dream. It was a unified enterprise, a synergy of innovation, effort, and teamwork that was unstoppable—all necessary ingredients to make real a long-held dream of humankind leaning forward to the Moon.

FUTURE TRAJECTORY

Those early pioneering years were instrumental in shaping my passion today: to help forge our future trajectory in space. That zeal is guided by two principles: a continuously expanding human presence in space; and promoting U.S. global leadership in space by being a "global team player." That means working with other countries so all can reap the countless benefits that stem from space exploration.

When Neil and I each stepped off our Eagle lander's ladder onto the stark terrain of the Moon's Sea of Tranquility, it was just eight years after U.S. President John F. Kennedy committed America to strive for the impossible. I'm often

asked: did I feel alone standing on the Moon? Not really. There were nearly a billion people all over the Earth who watched and listened as we moonwalked across that magnificent desolation. With Mike Collins circling the Moon in the Columbia command module, we became elite members of the Lonely Hearts Club—we were farther away than any three humans had ever been. Still, we felt connected to home.

During my hours on the lunar surface, I did gaze back at Earth. In that solitude, I saw our world as it sat suspended, surrounded by the darkness of space. That blackness is so deep that I could almost reach out and touch it. But then you see planet Earth. It is a soft, glowing presence, bulging from the abyss. It has vividness, aliveness that is not captured in photographs. All of humanity and those I knew and loved resided on that blue sphere.

My stay on the Moon in 1969 filled me with countless other recollections. By the way, while Neil was the first to step on the Moon, I'm the first alien from another world to enter a spacecraft that was going to Earth!

INFRASTRUCTURE AND LEADERSHIP

But fast forward into the Twenty-First Century and those reminiscences, as dear to me as they are, fall victim to the saying: "That was then, this is now."

Today, I see the Moon in a far different light.

Firstly, America should not re-engage in a second "Moon Race." That constitutes a dead end, a waste of precious resources. The United States won that contest more than four and a half decades ago. What is needed is to lay out what the U.S. involvement at the Moon should be—a plan that refrains from competing but assists every other nation that is planning to land on the lunar surface. That improved

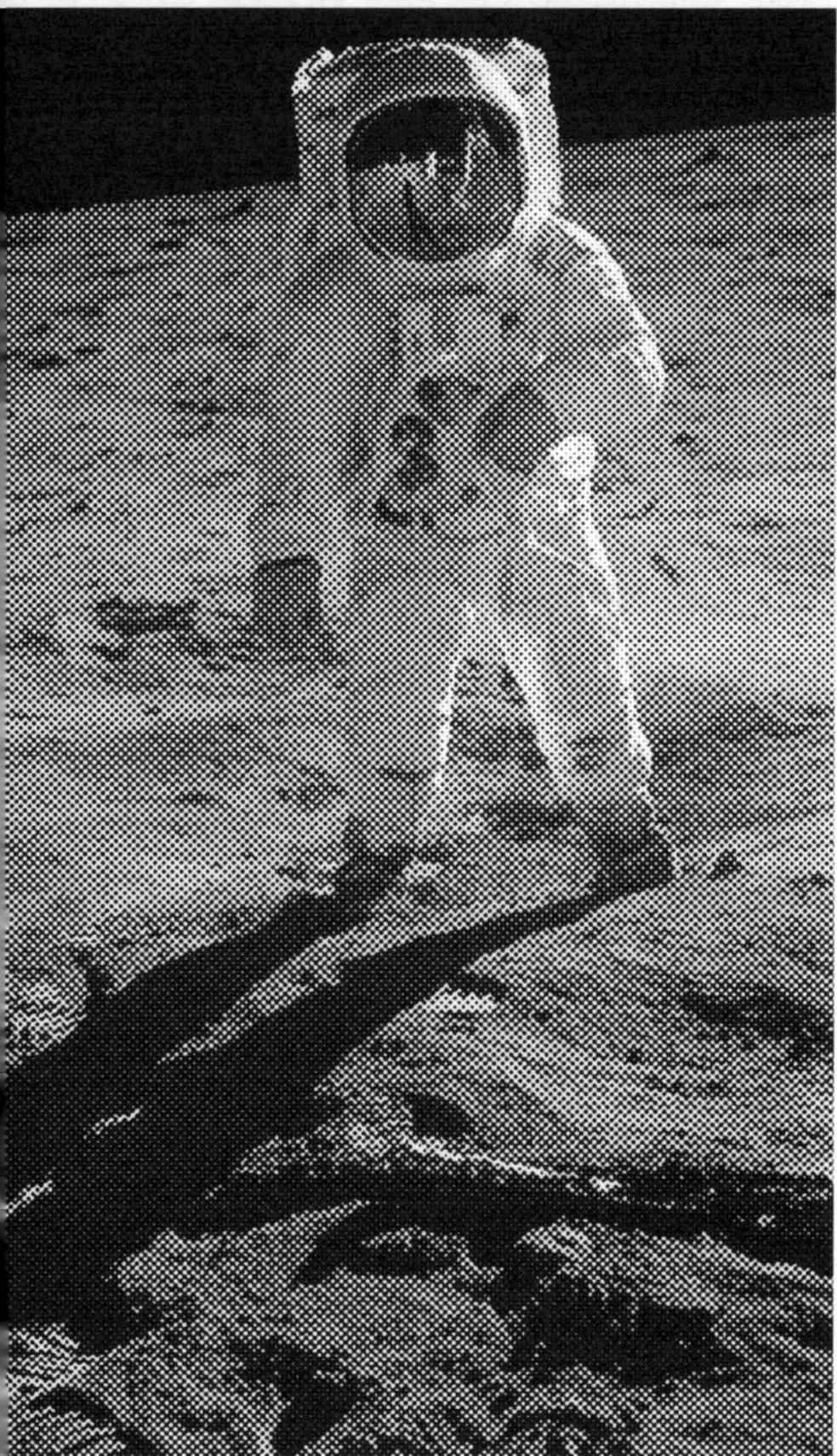

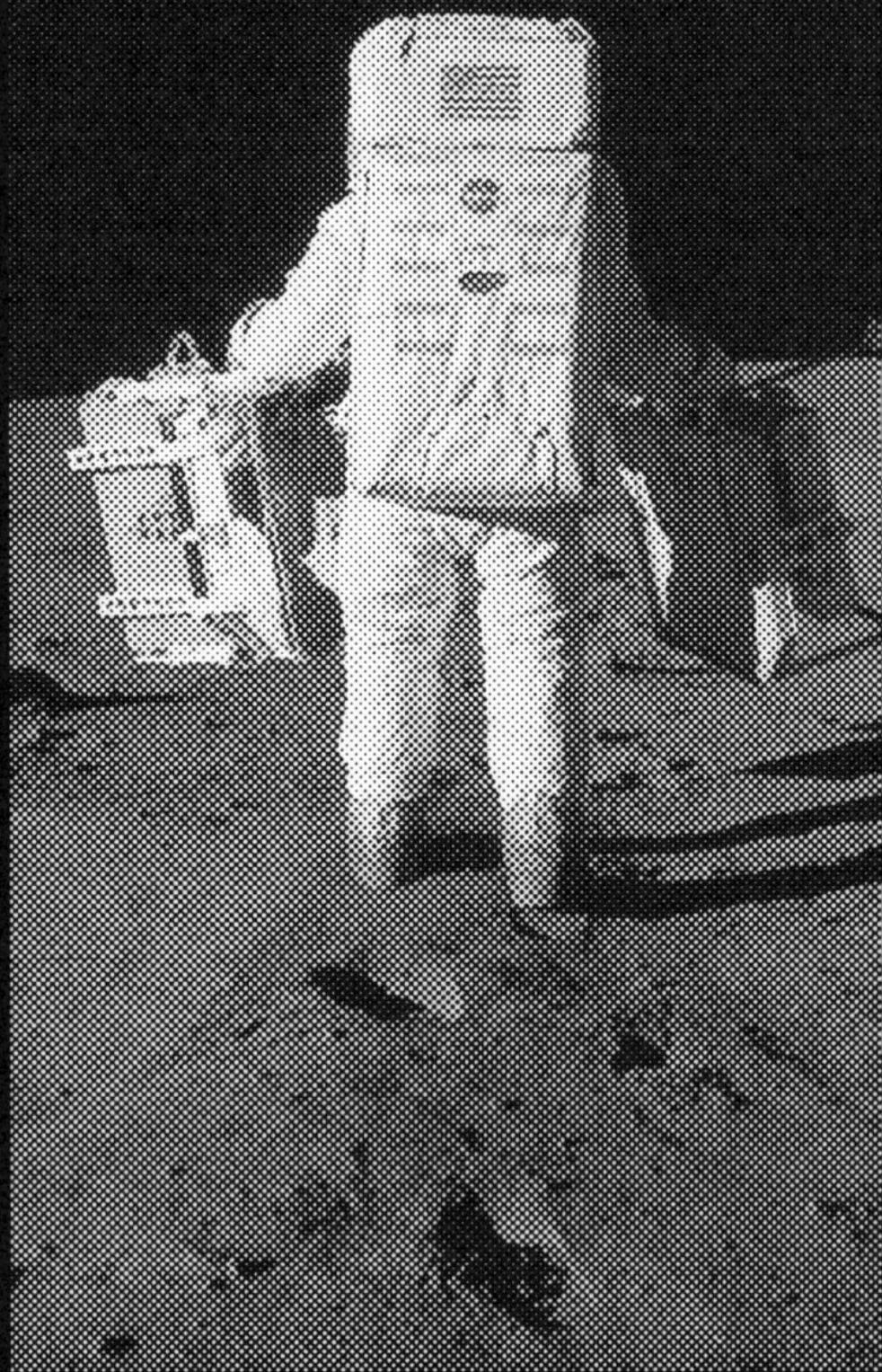

plan is to be cooperative with international partners who also want to reach the Moon. In sum, we can afford to be magnanimous. Yes, the United States got there first... but now is the time to make it a first step for others.

My vision for the Moon is for both a nearside and farside Lunar Operations Complex. The establishment of this infrastructure would not only tap the resource rich Moon by commercial, private sector groups, but also stimulate international partnerships between nations. America can lead the way in robotic hab/lab building on the Moon by fostering a presence at the Earth-Moon L1 and L2 points, libration gateports that permit robotic assembly—piece by piece—of hardware and habitation on the Moon. Furthermore, how best to accomplish this on the Moon can be hammered out earlier at a Hawaii-based International Lunar Research Park—essentially trial-running assembly tasks that would be done on the Moon. The high-technology job for the U.S. is developing a Universal Interconnecting Device, equipment that enables the coupling of modules and other gear from multiple nations.

In short, America's return to the Moon is one that is robotic, to offer infrastructure and leadership. It is one that embraces the talents of China, India, Russia, Japan, Europe, and others, to establish a solid—and this time permanent—foothold on the Moon. Furthermore, in doing so, the U.S. and other nations can sharpen their respective technological skill sets, the know-how that's mandatory for eventual homesteading of Mars.

SPEED, ALTITUDE... AND ATTITUDE

Future space travelers will include men and women from all walks of life, taking advantage of trips aboard commercial spaceships. Expectations are high to create a money-making, booming market for tourist-carrying spaceliners. Initially, vehicles will fly "suborbital" trajectories; then

commercial rocket ships will be dedicated to speed tourists into Earth's orbit. While such voyages are history-making affairs, there's no leap of faith required. The evolution of flight from the Wright Brothers to today underscores the taming of speed and altitude.

Indeed, it wasn't until the twentieth century that man took that first powered flight. In 1903, on a windy morning at Kitty Hawk in North Carolina, the Wright Brothers' Flyer took their maiden voyage, defying gravity. Incidentally, my mother, Marion Moon, was born that same year. And only sixty six years later, Neil and I stepped on the Moon, fulfilling the dreams of millions.

The word "tourism" may sound tame. But travel and tourism now form the world's largest industry, with a gross annual output of several trillion dollars a year. Space tourism is the logical destination for that market.

What's more, at this very instant, over 300,000 people are off the Earth. That is, they are in the air and safely seated within aircraft zooming from one destination to another. Anchored in the history of aviation and the advancements ahead, public space travel is in the offing, a progression of technology… and economics. Yes, that means going a little higher, and gaining a bit more speed.

Are there technical challenges ahead in creating the space transportation systems to support space tourism? Yes. In my view, the future resides in reaching orbit less expensively via the development of reusable, two-stage systems capable of airline-type operations. These systems will have high reliability, very quick turn-around, and a large passenger capacity.

Years ago I formed ShareSpace for several reasons: to support public interest in space travel and to educate people of all ages and incomes about the possibility—the

very real possibility—that they themselves might live this dream.

I call them "Global Space Travelers," those that will experience the wonder of space first-hand, while increasing our knowledge of how common people—without years of astronaut training—take to the environment of space. At the same time, it will ignite the market for commercial space vehicles. This enthusiasm, on the part of industry and the public, will inspire the government to set up sensible, forward-looking regulations. The space tourism industry will begin.

A growing number of citizen space explorers would put backbone into the expression: "If the people lead, the leaders will follow." It's not difficult for me to envision various types of vehicles dedicated to space tourism, built by aerospace firms, operated by private firms, and perhaps booked through companies like Wilderness Travel and Club Med!

Space tourism gives new meaning to "you are free to move about the cabin." By far the most exhilarating aspect of space travel is the ability to feel your body being liberated from a two-dimensional existence to a 3D existence. Secondly, having face time with Earth is a bonding experience, to get a unique view of our planet. That perspective has been dubbed the "Overview Effect." Getting an eyeful of Earth from space can affect a person's attitude about themselves, their planet of origin, and their own place in space and time.

By lessening the expense of attaining Earth orbit, many new industries are waiting to develop, one of which will be space tourism. Within time, cis-lunar and interplanetary cruise ships will evolve. The upshot is that tens of thousands of citizens will have the opportunity to travel into space, gaining a sense of "participation" in opening the

frontier of space to enterprise, exploration, and settlement.

My motto: everybody needs space!

Wanted: a unified space vision

There is a pressing need to get the world excited once again about space exploration and to harness the pioneering spirit to reach beyond our boundaries and current capabilities. After all, what's a future for?

To reach beyond low Earth orbit requires a progressive suite of missions that are the vital underpinnings—a foundation—for what I call a Unified Space Vision (USV). It's a blueprint that will maintain U.S. leadership in human spaceflight, but avoids a counterproductive space race with China to be second back to the Moon, and leads to a permanent American-led human presence on Mars by 2040.

But plotting out, putting in place, and staying on track with a unified approach to space program activities must begin now. There are no "giant leaps" this time. More like a hop, skip and a jump strategy. Step by step—just as Mercury and Gemini made Apollo possible—we move deeper into space to land on Phobos, the inner Moon of Mars, all in prelude to sojourns on the Red Planet itself. A Phobos base would be the ideal perch from which to monitor and control the robots that will build the infrastructure on the Martian surface, in preparation for the first human visitors. The techniques and technologies for doing so will be honed at the Moon.

Such bold missions of exploration will require determination, support and political will, as did our mission to the Moon over four-and-a-half decades ago. If we have the vision, we can reach a diversity of destinations, including asteroids, on the pathway to Mars.

THIS TEXT BY BUZZ ALDRIN HAS BEEN ORIGINALLY WRITTEN IN 2016 FOR THE PROJECT "VISIONARY STATEMENT 2046" AS PART OF MICHAEL NAJJAR'S *OUTER SPACE SERIES*

My USV (Unmanned Surface Vehicle) calls for essential basics, such as an Exploration Module imbued with radiation shielding, food-production, and recycling facilities needed for spaceflight of up to three years. The International Space Station is the ideal test bed for showcasing these capabilities, as well as for evaluating rigid and inflatable structures useful for the outward movement of crew into deep space. We must use our station savvy to prototype specialized safe-haven, interplanetary, and taxi modules, hardware that can be combined with NASA Orion-type crew vehicles.

By way of reusable spacecraft that I call "Cyclers" traffic routes between Earth and the Moon, Mars and Earth can be put in motion. Very much like ocean liners, the Cycler system would perpetually glide along predictable pathways, moving people, equipment, and other materials to and from the Earth over inner-Solar System mileage.

Looking towards 2046, the Earth, the Moon, and Mars will form a celestial triad of worlds—busy hubs for the ebb and flow of passengers, cargo and commerce traversing the inner-Solar System. The common, sustainable link that ties humanity's space future together is reusability—a progressive set of reusable boosters, reusable access to space, and reusable interplanetary cyclers.

Humankind is at an inflection moment in history, a chance to test the next generation of space adventurers to reach out into deep space and start moving along the pathway to homesteading the Red Planet and becoming a multi-planet species.

The challenge ahead is not only daunting, it is monumental and historic. And it's time to roll up our sleeves and get to work.

The Inflexion Point of Human Space Flight

Michael López-Alegría

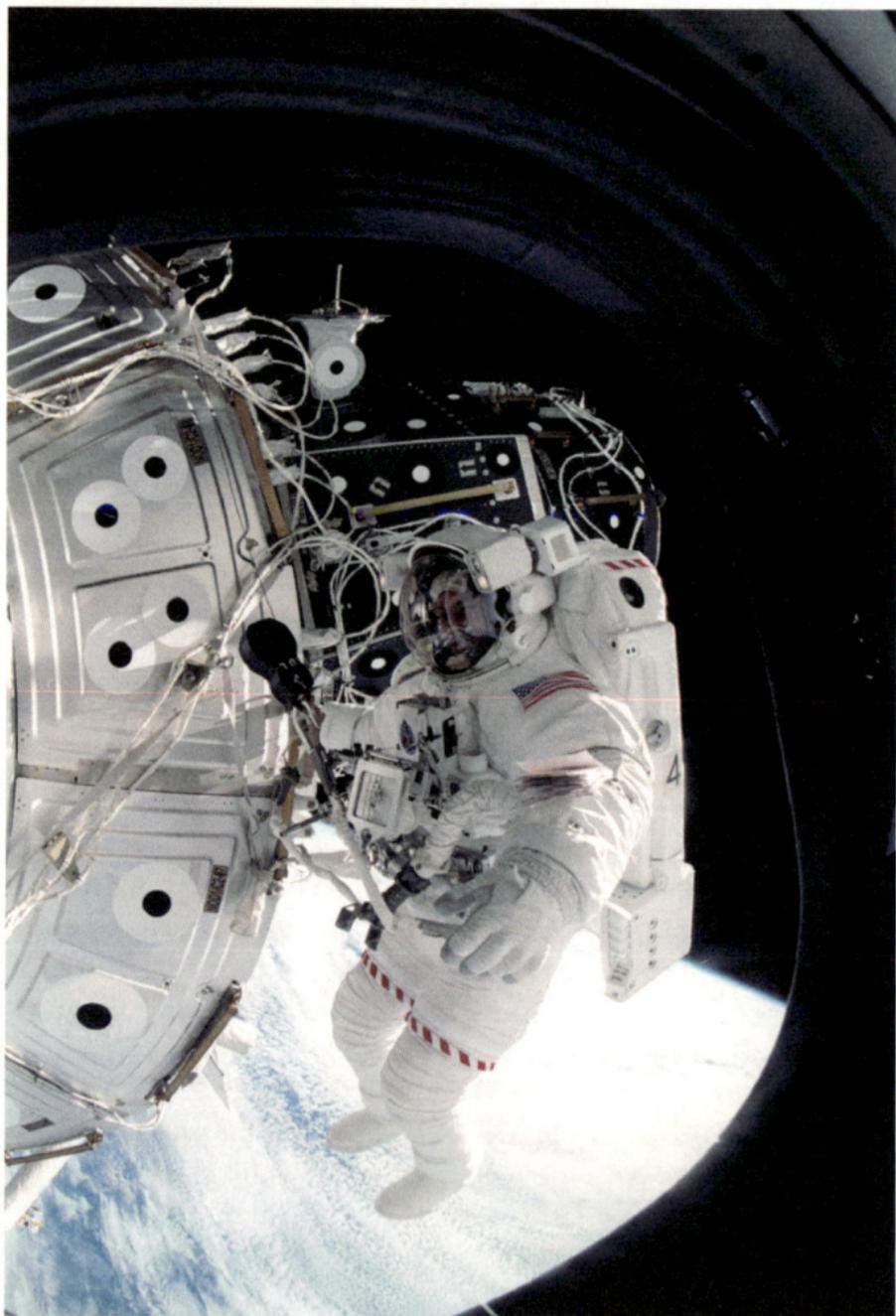

We are at an inflexion point in the curve of human space-flight. Men and women have been traveling to low Earth orbit for over 50 years. Some completed a handful of orbits; others—thousands. But to date, those that have had the privilege of seeing our planet from above its atmosphere number not much more than 500.

That is about to change. Companies offering ordinary citizens the possibility to fly to above the Kármán line 100km above the surface of the Earth—accepted to be the beginning of space—have emerged in America and will soon do so elsewhere. The number of space travelers will have doubled in the next few years, and will increase by an order of magnitude in the decade to come. As the number of flights increases and lessons in operations and reusability are learned and applied, launch costs—and ticket prices—will come down. That will in turn escalate demand, which will increase flight rates, further reducing costs, once again driving down prices and ultimately leading to a virtuous cycle. We are soon to witness the first steps of the evolution of commercial space transportation not unlike that which occurred in commercial aviation in the late 1920's. What was once the domain of only those with the "right stuff" will be accessible to millions. Access to space is being democratized.

While the technical and financial hurdles to get to orbit remain significantly more challenging than those facing suborbital spacecraft developers, they too are being overcome by private enterprises. Several companies are vying to achieve what has only been accomplished heretofore by a handful of governments—sending humans to low Earth orbit. At first, their destination will be the massive and magnificent International Space Station, and their customers will be government astronauts of the five partner space agencies involved in that project. But other firms are conceiving orbital destinations for research customers—be they companies or countries—and will later develop

habitats for other uses. With transportation and destinations in development today, the establishment of a marketplace in low Earth orbit is around the corner.

The sensations—both physiological and psychological—that many more will experience than ever before are not to be taken lightly. Massive amounts of energy will be transformed from solid, liquid or hybrid rocket propellant to thunderous accelerations that will hurtle the spaceflight participant into the heavens with ferocity and ceaselessness that are as difficult to imagine as they are unbelievably exhilarating. The thrill I experienced during my launches—one each on Space Shuttles Columbia, Discovery, and Endeavour, and Soyuz TMA-9—seemed only to increase with each episode. I seemed able to more acutely perceive nuances amid the unrelenting acceleration and the sheer violence of the staging events.

And after eight and half minutes of a white-knuckled roller coaster ride, there is the peace, serenity and silence of weightlessness. Pencils, gloves, and checklists join the occasional dust particle in floating tranquilly before our eyes. The contrast with the ascent is dizzying. Once we unstrap from our launch restraints our bodies too float carefree. Motion initiated in a given direction continues on that same course until something gets in the way. Movement from one end of a module to another is effortless. A force as light as the pressure of a fingertip on a laptop keyboard is enough to propel the typist in the opposite direction. The sensation is as pleasant as it is magical.

But it gets better. The view of our planet from space is nothing short of breathtaking. Colors—the deep blue of the oceans, the reddish brown of deserts, the pristine white of clouds and snow, and the lush green of rain forests—are vivid and stunning. Glaciers, thunderstorms, aurora are spectacular. Sunrises and sunsets—which occur sixteen times in a 24-hour period—are as magnificent as they are

accelerated. These natural phenomena are in stark contrast to the dull grey of the buildings and roads of urban centers. But although cities are less appealing to the eye, it is the cities that catch our attention. Our hometown. Where we attended university. Where our mother and father were raised. Significant places of human history. We marvel that we can see with the naked eye manmade objects—runways, bridges, stadiums—and we constantly search for them. The connection we feel with places of importance overrides the undeniable raw beauty of nature.

As spectacular as the view from inside a spacecraft is, it is magnified during a spacewalk. An invisible, thin polycarbonate faceplate is all that separates our eyes from the void. Lightly holding onto a handrail with one hand, we look down at the Earth, 400 kilometers below, passing beneath us at eight kilometers per second. I cannot imagine any other experience that could approach this one. Curiously, I found that when "outside" I was much more moved by nature and less drawn to particular places. The perspective is so much grander that zooming in on a city seems uninteresting. And while city lights provide a unique and fascinating panorama from within the spacecraft during night passes, nothing can match the overwhelming view of the night sky from outside. Away from the light sources inside the vehicle, the sheer number of celestial bodies is almost shocking. Rather than a black sky dotted with white, it appears nearly inverse. But best not forget to lower the sun visor before sunrise; the hue of sunlight is unforgivingly blazing white.

Unfortunately, there is precious little time to enjoy the views when performing a spacewalk. Each EVA (Extravehicular Activity) is choreographed to the minute, with the two spacewalkers working as part of a team of three astronauts—the other being either inside the spacecraft or on the ground in Mission Control. They are in turn only a small part of a vast team of specialists that are concentrated on

achieving the objectives planned for that event. In my ten spacewalks—all of them part of the on-orbit assembly of the ISS—I performed tasks from physically coupling entire modules to inserting a ping pong ball into a conical spring that acted as a tee so my partner could hit it with a golf club. In between were tightening and loosening bolts, disconnecting and connecting myriad electrical and fluid connectors, removing launch locks, discarding unnecessary thermal shrouds, pushing—and riding on—a wheeled cart on rails loaded with tools and equipment, installing experiments, removing and replacing failed components, and even test flying a self rescue backpack. All of this is done under the care and guidance of the Mission Control team, with whom we have constant communication and who are able to observe our work thanks to cameras mounted in our helmets. It is incredibly satisfying to be part of a complex operation that uses such sophisticated tools and technology that allows us to perform what amounts to basic construction in an environment as beautiful as it is deadly.

Back inside, the work on the ISS is divided between what is required to keep the orbiting laboratory healthy, and exploiting the unique environment to not only understand its effects on human physiology, but also to conduct both basic research and technology development in the absence of that preponderant and inescapable force on Earth—gravity. Although the advance of science and technology is the appropriate goal for any laboratory, the ISS has a separate, and no less noble, legacy—that of international cooperation. In collaboration that will no doubt serve as the model for future human exploration of the heavens beyond low Earth orbit, philosophies, designs, measurement systems and even alphabets from around the world were integrated and resulted in components that came from distant corners of the globe being assembled in space. Furthermore, astronauts from different cultures and with different native languages live and work in harmony aboard the ISS.

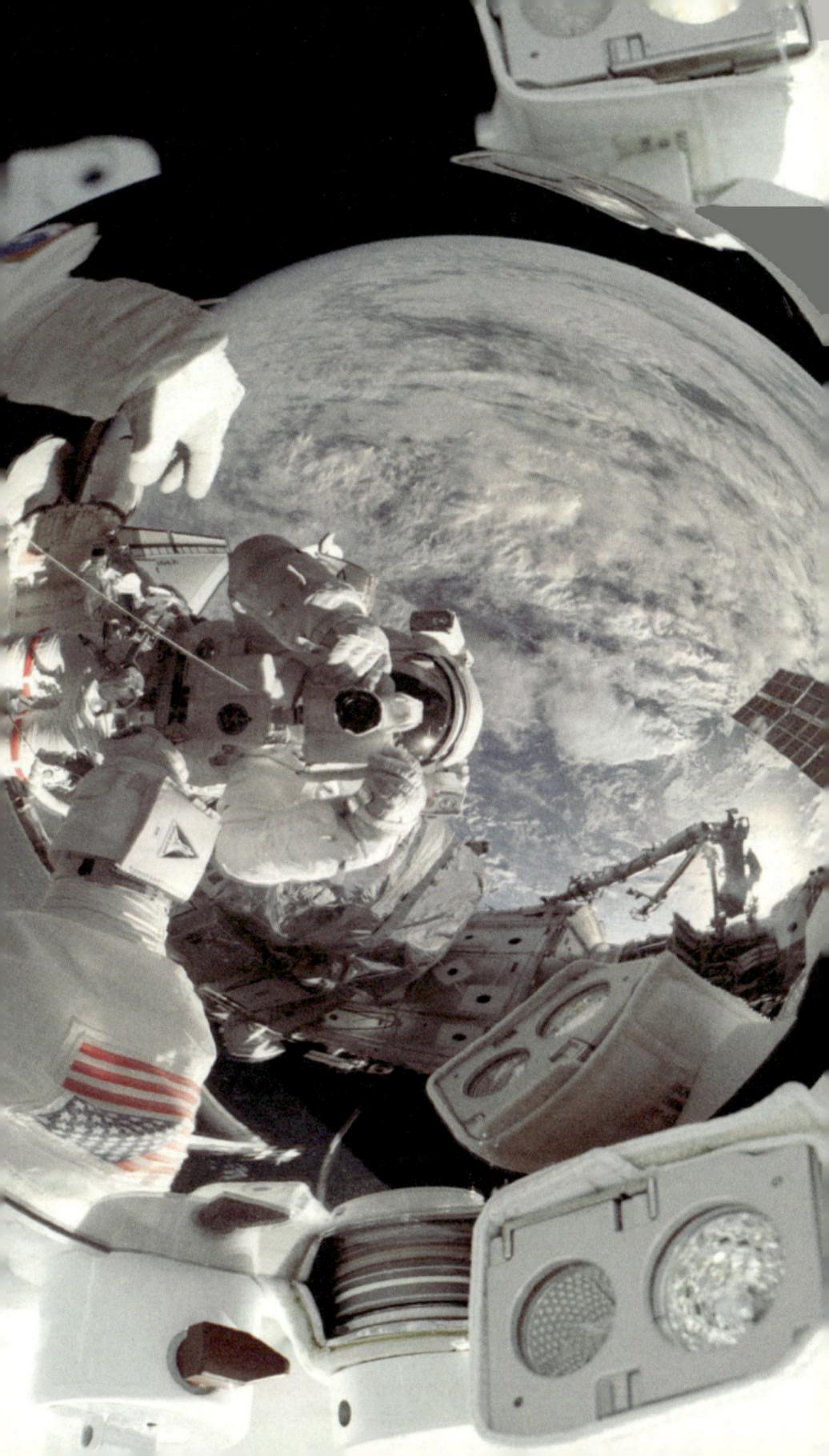

For all of the physiological sensations involved in the launch, subsequent weightlessness, incredible views of Earth, performing spacewalks, and day-to-day living and working aboard a spacecraft, the psychological impact is no less important. For me the experience has seemed surreal. I feel I've lived two lives—one on the planet, and one off. The two worlds are like parallel planes; they don't intersect. It's difficult to reach across the "boundary" and sample the "other" life at will; one has to go there.

There is more; the experience has changed me. The change is not dramatic, but rather subtle. But it's noticeable. The view of the Earth, of the places where the entirety of human history has occurred, from the vantage point of space has seemed to give me a different perspective—in both the literal and figurative meaning of the word. From space, political boundaries between countries are not visible. The gunshots of wars are not heard. Urban centers are small and rather insignificant when viewed from outside the spacecraft, regional problems and quarrels seem petty. Poverty, hunger and religious and ethnic intolerance are likewise invisible. The Earth seems tranquil, peaceful and beautiful. But it also seems fragile at the same time. Air pollution is visible, as are depletion of forests and shrinkage of bodies of water. Sustainability gains importance when one travels completely around the only Earth we have in 90 minutes.

It is my belief and sincere hope that, in addition to the economic benefits of opening access to space to so many more than just the privileged few that have gone there thus far, there will be an even more important increase in the goodwill of the brotherhood of man that is a result of the very experience.

THIS TEXT BY MICHAEL LÓPEZ-ALEGRIA WAS ORIGINALLY WRITTEN IN 2014 FOR THE PROJECT "VISIONARY STATEMENT 2046" AS PART OF MICHAEL NAJJAR'S OUTER SPACE SERIES

Michael López-Alegría

More Autonomy, not Automation—the Future of Interactive Robotics in our Society

Sethu Vijayakumar

Recent advances in robotics have seen the creation of ever more powerful and compact mechanical devices through breakthroughs in high fidelity and high torque actuation systems, low price and extremely rich sensor modalities (like stereo cameras, depth sensors (RGB-D), Lidars, IMUs), and significantly enhanced computational power in small packages.

However, great challenges still remain in the operation of these robots in domains outside well-controlled laboratory situations. So, for reasons of safety, the solution has been either to make robots move very slowly or to isolate them from humans. Yet both of these answers are impractical for real world applications of robotics except in car manufacturing scenarios.

So what is the future? Our robotic labs at the University of Edinburgh have been at the forefront of developing novel compliant technology (actuators and controllers capable of reacting safely when interacting with humans) and reactive planning that helps solve these problems by making robotic technology more accessible to much closer human-robot interaction scenarios in healthcare, robotic surgery, co-workers in agile manufacturing and exo-skeletons for human assist systems.

Many of the robotic applications that we see in remote handling (nuclear), space or surgery use the concept of teleoperation—which involves the robot precisely following a sequence of movements that are kinaesthetically demonstrated through some user interface. Recently I saw at first-hand the extremely skilful teleoperation of robots in a "fun" setting as I am the judge on the BBC series of *Robot Wars*[1] (an extremely popular technology show). There were some amazingly agile and destructive machines and some terrific young drivers on this show. I also realized that if I were to be given the winning machine and asked to drive it against an experienced competitor, I wouldn't stand a chance. Teleoperation in this setting, and in many other more practical settings, relies heavily on the skills of the operator which can be a significant barrier to the more widespread adoption of robotics due to the skills gap—in other words, not everybody can effectively operate robots, even if their engineering design is amazing.

At the other extreme, many robotics research agendas are striving to develop technologies for "fully autonomous" robot operations—"look ma, no hands." Many of the world's leading groups, including our own, have been working on this problem. Their work is highly relevant in many domains such as underwater AUV navigation, and remote operations in communication denied or corrupted environments. Testing and validating autonomous behaviour in real world environments is indeed a significant challenge. Recently Professor Rodney Brooks (of iRobot and Rethink Robotics) and Professor Marc Raibert (of Boston Dynamics) were quoted as saying that full autonomy is still very far away in spite of impressive videos like that of the Boston Dynamics humanoid robots making the rounds in the news.

Full autonomy has several components including being able to define an "optimality" or "goodness criterion"—

1 http://robotwars.wikia.com/wiki/Sethu_Vijayakumar.

which is intuitive and doable in many cases but the robot also has to define and generate intentions. Generating intent and testing whether it results in an expected behaviour can be extremely hard for complex robotic platforms. Google DeepMind recently showed that by simulating the environment and playing simulated games against its own various versions, it could solve complex AI problems like the game of Go. However, it had to rely on lots of examples from real games. Trying to play these on real robots is quite simply impossible—due to the complexities and variants that the myriad of action possibilities can generate. Most importantly, it is hard to simulate reality to the extent that we can guarantee success every time— something lawmakers are quite keen on ensuring.

So what does it look like from the perspective of creating a business model in robotics? Jerry Pratt, a professor at iHMC in Florida, was quoted as saying, "any business typically needs an MVP (Minimally Viable Product) and this is very hard in robotics since the simple, cheap robots are no good (as of now, at least!) and will most likely cost you money, and so there is no gradual scaling possible with market uptake"—the concept of graceful degradation with level of investment does not hold quite true in this field. This is illustrative of the significant research challenges that still exist in the control, sensing and autonomous planning and navigation of complex robotic platforms— which are still active areas of research in many universities including in my own group.

So how can we make the benefits of robotics accessible to the general public without worrying about the skill gap (teleop scenario) or waiting for a reliable solution to the "full autonomy" problem? We can think of a concept that is perhaps deployable now and also perhaps socially much more acceptable. This is a paradigm that marries the best of both worlds: the precision and accuracy of robots and the contextual decision-making capabilities of humans—

look ma,

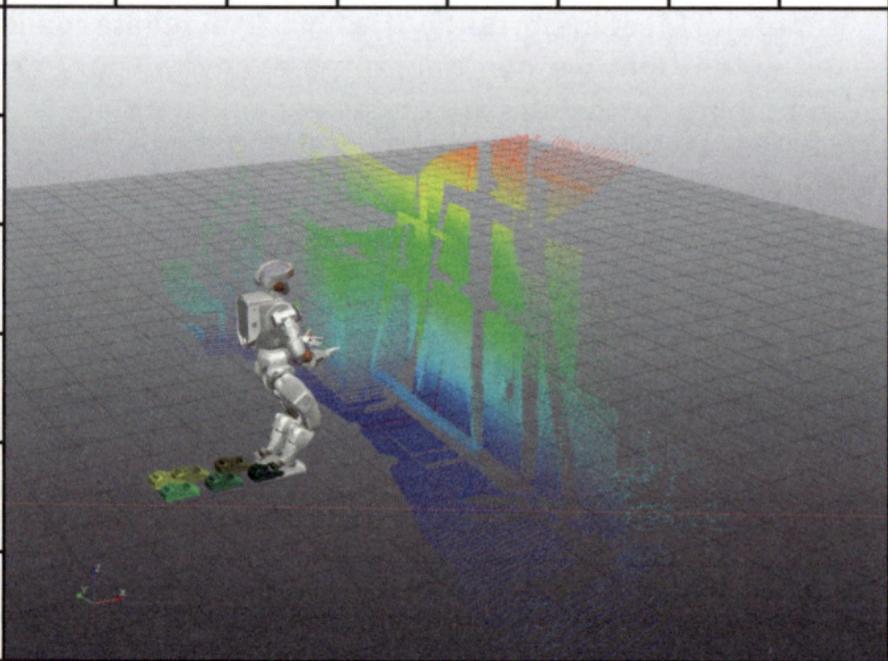

no hands'

Sethu Vijayakumar

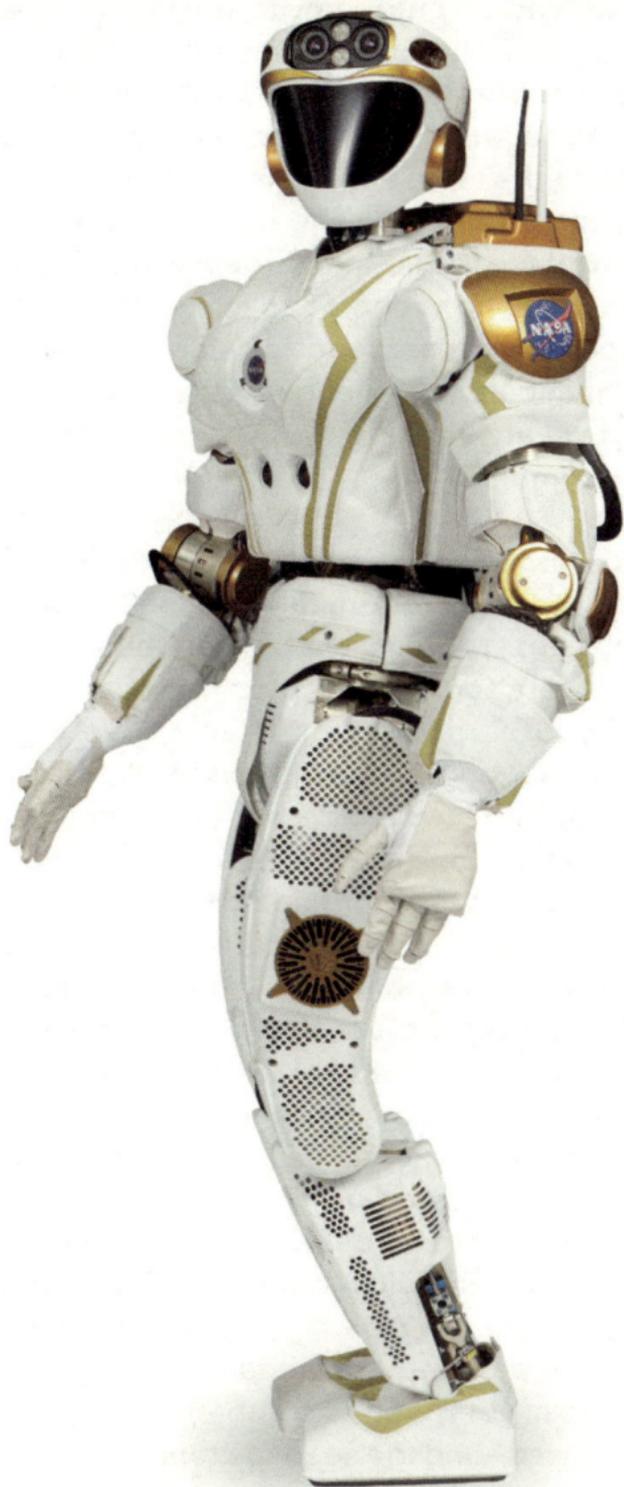

Future Trajectories of Space Travel

one I would call "Shared Autonomy." This is a paradigm that devolves significant autonomy to the machine while still having humans in the loop as key decision-makers. The key research challenge here is to create systems that have the ability to seamlessly change the levels of autonomy depending on the task, and even within a single task at different moments in time. The main emphasis thus shifts to how to reduce the cognitive load on the person in charge of a task and to how robots can make some of these tasks "idiot proof" in the presence of significant delays, noise and communication challenges. One example of an exciting project we are working on involves an ambitious "out of this world" mission.

These examples and this narrative also address the issue of the highly topical "Will robots take my job?" question. Personally, I think that robotics will be more economically viable and much more socially acceptable operating within the "Shared Control" paradigm. They are very much designed to be co-workers, taking over dull, dirty and mundane jobs that are typically easy to automate, and require far less "cognitive" prowess while freeing up time and resources. Perhaps the more pressing and important question is the distribution of the potential wealth (and benefits) that a robotics revolution will bring. This question is not very different from the issue of identifying essential skills for the next generation and planning ahead to equip people with these skills, ensuring a rounded education that matches demands and the skills gap. Furthermore, security of personal data and privacy legislation should be carefully looked at—personal data is the "new oil," since various of these advances will require you to divulge various levels of user-generated data in return for potentially huge benefits. And finally, there is the issue of responsibility and legislation that needs to be addressed when autonomy is devolved—and the need to create and develop systems that work closely with such legislation so that clear accountability can be established.

A wonderful, exciting and transformational future beckons… and undoubtedly, interactive robotics and artificial intelligence are at the very heart of it!

The University of Edinburgh's NASA Valkyrie Robot Project

TECHNICAL SPECS:

The NASA Valkyrie is a humanoid robot, about 170cm tall, weighing around 120kg. It has 44 movable joints or degrees of freedom (in robot speak) and is anthropomorphic—meaning that it has very similar levels of dexterity to a human being. It is equipped with a range of sensors including stereo cameras, touch sensors, torque sensors, and a LIDAR—a kind of scanning laser. All of these are used to sense the world in depth, color, and forces. It is bipedal—capable of walking on two legs—which makes it very agile as well as challenging to control. All of its joints are driven by very powerful electric motors and there is an on-board high density battery and four state-of-the-art computers—making it capable of fully autonomous behaviour. The computers on board receive all the sensor information, process it and make decisions about the next step the robot should take—sending commands to the individual joints. This robot is one of the few humanoids in the world that is fully torque controlled.

THE AIM:

The Valkyrie robot is a result of collaboration between NASA and the University of Edinburgh on a very ambitious futuristic project. NASA plans to use humanoid robots to send un-manned robotic missions to Mars. The idea is that it would make manned missions much cheaper, safer and efficient if we could use humanoid robots to pre-deploy essential capabilities on the surface of Mars—ahead of the manned mission (see the movie *The Martian* for inspiration about the capabilities needed). Other space-related goals include robots co-working in the space station and taking over repetitive as well as high risk tasks (e.g. space walks) from the astronauts. Why do we need this? Besides the goals of exploring the capability of being a multi-planet species, there are several existing functionalities in the space domain—such as repairing the ISS in the presence of ever growing amounts of space debris and the capabilities needed to put and manage satellites in orbit—that crucially affect our everyday lives (c.f. GPS navigation, weather forecasting).

Space Holds the Key to the Future of Humanity

Anousheh Ansari

Our Universe is a place of infinite wonders. As a young girl in Iran, I marveled at the stars in the beautiful night skies and dreamed of flying into space one day, and I know that many share this dream with me. In 2004, when Space ShipOne was awarded the Ansari Xprize sponsored by my family, we all felt that there was finally hope for all those who dream of going into space.

I have also been fortunate enough to see that this childhood dream can actually become a reality as I prepared to fly into space in 2006 on an eleven day mission to the ISS. Space travel gives you a new found freedom while at the same time it's a very humbling and empowering experience. When marveling at the beauty of space from my temporary home onboard the space station, it became more apparent than ever that the lines we draw on our maps to separate us don't really exist. By drawing lines on our maps we have created a complicated world plagued by conflict. So as long as we don't start drawing them on our space maps, space can belong to all of us and WE can all work together to use it to preserve and enhance our lives and our species. I think access to space should be open source—it is so important to the future of humanity that we gain access to space and are able to sustain our life as the human species in this Universe. As our population grows, all the resources on Earth will not be able to sustain us. We need to find peace and a safe and cost-effective way to access resources in space if we are to survive.

This is not an easy problem to solve. Innovative collaboration in this area could significantly shorten our timelines to a safe, low cost, reusable launch vehicle (RLV). Unfortunately, especially when it comes to space, as soon as you start to talk about collaboration, bureaucracy and security concerns quickly bring everything to a screeching halt. There are millions of dollars being spent by the U.S., Russia, and European countries on building some form of

I THINK ACCESS TO

SPACE

SHOULD BE

OPEN SOURCE

a next generation orbital crew vehicle. And now we have two new serious entrants, China and India, spending billions on space research.

Can you imagine if we put all these resources and funds into one common effort, how much more we could accomplish? The result does not have to be one type of vehicle; it could equally be a sound and tested collaborative design principle that manifests itself in multiple forms in different parts of the world.

I do not accept boundaries. I am always reaching out for that next frontier and I hope that I can encourage our youth around the world do the same. I believe that space also holds the key to the future of humanity. In the coming decades, space research is expected to improve our knowledge of the origins of the Universe and teach us more than we have ever known about ourselves and our planet. Our exploration will teach us about sustainability of life outside our planet and how to make efficient use of space resources such as our Sun's energy and asteroid assets to live a better and more peaceful life on Earth.

Here are some fun possibilities that could come along as our technology improves and the cost of access to space drops:

✓ One potential is a new mode of transportation, the Space Plane. Now that the Concorde is no longer operational, people who travel the world a lot would appreciate a faster means of transportation. Of course, there is a need for some technological advances if space planes are to be a reality, but some work has already been done with SCRAM jets at NASA. These planes can not only be used for passengers but also for cargo and package delivery. Just imagine same-day transatlantic package delivery!

✓ Another possibility that I'm particularly interested in is solar powered space satellites. Our energy consumption is rapidly increasing and our current production methods are damaging to our environment and unable to sustain our growing needs. Access to clean, abundant solar energy in space could be the answer.

✓ Another area that can flourish and grow in the future is Space Research and Manufacturing. By potentially placing research and manufacturing facilities in orbit or even on the Moon, we can start developing new medicines, new treatments, new material, and even extraterrestrial mining that could supply us with some of our most essential materials.

✓ The last area I would like to touch on is "personal space" travel. It has been a dream of millions of people, including me, to be able to fly into space one day as easily as flying across the Atlantic. This promise was born when Yuri Gagarin and John Glenn first orbited our planet, and when Neil Armstrong and Buzz Aldrin first stepped on the Moon. However, so far it has remained unfulfilled, despite significant technological advancement in all aspects of our lives.

Of course not everyone can prepare for a full orbital flight, but a suborbital flight like the ones being offered by Virgin Galactic can be accessible to large swathes of people. These flights would give people a glimpse of what being in space is like, and will inspire a new vision of our world in many people. They can also be used for experiments in

orbit as well as being an inspiration for both teachers and students around the globe. Orbital flight is not that far away. Of course, it's still prohibitively expensive, but within three to five years the cost should fall to around 7–12 million dollars a flight from its present level of 40 million.

Now, imagine in 2046 we have an orbiting space station available for visiting as an exotic destination. It is still expensive, but the cost is rapidly dropping as the space elevator technology finally becomes available. A small station has been established on the Moon in a public private collaboration effort, and now private companies are conducting valuable research on how to sustain human life in space for stays of a longer duration. The lunar base is 80% self-sustaining and has been a breakthough in terms of collaboration between the U.S., Russia, China, and India. Our first trip to Mars was successful and future missions are now on their way to establish a Martian base built on all the lessons learned from the lunar base. Planetary Resources have made a very succcesful IPO based on their first successful asteroid mining mission and that has spun off hundreds of robotic missions to astroids orbiting our planet.

Anousheh Ansari

THIS TEXT BY ANOUSHEH ANSARI WAS ORIGINALLY WRITTEN IN 2014 FOR THE PROJECT "VISIONARY STATEMENT 2046" AS PART OF MICHAEL NAJJAR'S OUTER SPACE SERIES

The Role of Plants in Sustainable Space Travel

Tim Smit

When I first came to Cornwall—that wild jagged shard of granite jutting out into the western approaches of the Atlantic and the home of the most independent people on the British Isles, who even today regard themselves as separate and untamed—I was struck by the Clay. The Clay is the spine of Mid Cornwall, a devil's landscape of massive mounds of kaolin waste and deep ponds of poisonous looking green. The Clay was the past, and it had no hope save for the last economic eking of what still lay buried there, but it was done for long-term. The Brazilians had found clay on the surface—much cheaper.

I fell in love with the desolation and the symbolism of nurturing this broken landscape to create an icon of regeneration. My dream was to imagine these holes as the craters of long dead volcanoes harboring lost civilizations. Arthur Conan Doyle was my hero. Bruce Dern in *Silent Running* is often cited as an obvious inspiration, but in truth I never saw the film until after Eden was finished. Buckminster Fuller, on the other hand, had captured my imagination years before with his space age *Climatron* in St. Louis. However, I cannot claim the inspiration for his domes at Eden; this was caused by the constantly changing profile of the pit as the company mined the last dregs of clay out as we were busy with the design. One of the architects washing up at home noticed how soap bubbles settled on any surface, he then had a moment of eureka!, and now... Bucky rules!

Tim Smit

Future Trajectories of Space Travel

Eden is about education in the widest sense. We were always going to build something inspired by the shapes of nature in bio-mimicry, and wanted to tell of the dependence of humans on the natural world of which they are a part, or not apart of. Our ambition is that it shapes people's views on how we can live with the grain of nature, of how the shapes and resources can be used to provide models of closed systems thinking and a way to paint a roadmap to a future without waste. Everyone likes to claim an impact for their work, but all the science centers in the world combined have so far failed to shape this new culture. We believe that the tide is changing and the challenges we collectively face will provide a moment that will lead to a new renaissance, one in which we find out whether we are worthy of the name *Homo sapiens sapiens* (so good we had to name ourselves twice). If not we'll fail, and deservedly so. This is indeed a challenge worth meeting.

Biosphere 2 in Phoenix, Arizona, famously tried to create an airtight place in which ecosystems could be tested to prove their viability for interplanetary exploration. The results were interesting and proved many things, but not that such a space station could be viable. Eden is not concerned with this as our systems are open and our view is that the complexity of engineered ecosystems is only going to be worthy of study once we have access to the understanding of the micro-worlds that actually create the building blocks of life. For hundreds of years we have observed symptoms and not causes. The future will show the micro-biomes on and in our bodies being mirrored in the soil itself, and I am certain that very soon there will be a moment when we realize a whole new world of science is laid open to us and we'll wonder how we never guessed— but that is always the way with science.

Wherever you see plants you know they grow towards the Sun with greater or lesser speed. The absence of gravity is not the issue which is the strength of the fiber they put

on to support the weight of growth. It is my view that the future of sustainable space travel and colonization will require the involvement of plants, and that it is already imaginable that in 2046 the intelligence and capacity of 3D printers and their next generation offshoots will build entire communities out of the ingredients they find wherever they are. I can imagine micro-propagated plants, spores and microbes being mixed in a heady brew that will start life all over again, and as we enter the age of the invisible world of microbes, once we understand them we will truly be able to create miracles.

The danger is in our hubris of imagining that it is "we" who create these things. Our history in the management of conservation is terrible because we think we know more than we do. In the future I hope we will watch and learn how nature does it for itself when left to its own devices. After all, for living things the greatest driver is to live and to reproduce themselves. All living things will therefore have an innate interest in creating the conditions in which they can thrive.

I believe we are about to enter an era where much of what we thought we knew is going to be rewritten, and I hope we enjoy the ride because to learn and grow from the experience will lead us to a sustainable future while not to learn will give us a very uncomfortable endgame indeed. I'm voting for Homo sapiens, but it's a weird bet putting your house on something because you have no other choice.

THIS TEXT BY SIR TIM SMIT WAS ORIGINALLY WRITTEN IN 2013 FOR THE PROJECT "VISIONARY STATEMENT 2046" AS PART OF MICHAEL NAJJAR'S OUTER SPACE SERIES

The Future of Commercial Space Travel

Richard Branson

My natural instinct is to look at the world with optimism and a sense of infinite possibility. Watching the first pictures transmitted from space of our home planet and witnessing the Moon landing and walk were transformational. The early years of advancements in space travel filled me with curiosity about Earth and a deep sense of unlimited opportunity. And to this day, it has kept me utterly consumed with the pursuit of democratizing access to space and rallying others to join the cause.

The entrepreneurial spirit is reflected in how you see problems. The world today can be viewed as a planet ravaged by war, conflict, and environmental degradation. But despite man's efforts to run the planet into the ground, there are also Herculean efforts to preserve and protect it and advance space exploration to improve the prospects for our species' future. This sense of possibility has resulted in exciting entrepreneurial efforts to mine asteroids, send a spacecraft to the closest star system to our own and make humans a multi-planetary species.

The belief that we are creating something important—a force for good—can keep us united and going against the odds. Just as cooperation beyond borders must occur in space, the future will see greater cooperation among countries and across government and private sectors. There will be even more opportunities for investment, diverse modes of transportation and greater access to communication and information-sharing. Through the building blocks of investment, cooperation among governments

and the next generation of bright minds in pursuit of the STEM structure—science, technology, engineering and maths—the future will see many sustainable space businesses that improve livelihoods, bolster communities, and grow economies.

At Virgin Galactic, our early building blocks are our human commercial spaceflight program and our small-satellite launch service. Even as we focus now on the ground tests of our ambitious projects, we are constantly mindful of the greater purpose of it all, and of what might come next.

We created Virgin Galactic to open access to space to change the world for good. Even after five decades of exploration, space remains almost completely closed. More humans have won the Nobel Prize (900) than have flown in space (553). Satellites are more numerous, but if you were to ask a random stranger, it is extremely unlikely that their family, city, university or company would have built, operated or even seen one. We are striving to do our part to open space for more people and from all 196 nations through the companies that we have started—Virgin Galactic's commercial spaceline, our LauncherOne small-satellite launch service, and our aerospace manufacturing arm, The Spaceship Company.

With SpaceShipTwo, we will supercharge the overview effect—a fascinating phenomenon whereby space explorers come back to Earth as changed people, with a much greater perspective on world peace, our changing climate and global development—with more ambassadors capable of inspiring others just as those of us who laboured long and hard on the project were inspired by the Apollo program. Our future astronauts come from nearly 60 different nations, two dozen of which have never sent an astronaut to space and more than a dozen that have never sent a female astronaut before. After their flights, our customers will be able to return to their homes with a powerful

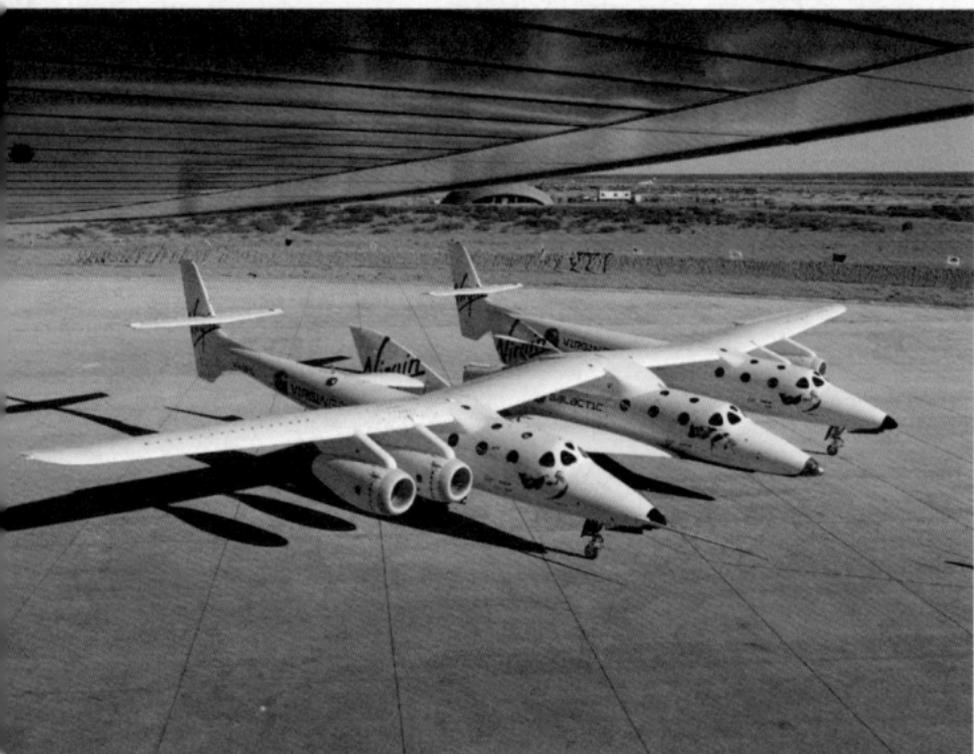

message to share with schoolchildren and local leaders alike.

SpaceShipTwo flights will also contribute unique data to help answer key questions across scientific disciplines—such as anonymous health data about how a very physically diverse group of astronauts respond to their flights, or by flying autonomous research experiments built by NASA labs, universities and research companies.

LauncherOne will help collect even larger data sets for still other fields. By lowering the cost of flexible, reliable and dedicated flights to orbit for small satellites, we are creating an opening for satellites from emerging designers that feature their fresh take on engineering possibilities. We will enable many more missions such as connecting the 3 billion unconnected residents of Earth, using next-generation weather instruments to improve forecasts as well as to feed into models of our climate, and cleaning up deactivated satellites in Earth orbit.

The impact of these services will grow with time as we build additional spaceships and refine and improve the missions. Like other technologies, with practice we will be able to make our forays to space cheaper and more frequent while increasing performance.

At the same time, we have to think beyond frequency and cost considerations: We are investigating how to make the way we access space cleaner. Even in the test and development phase, biofuels and renewables and other sustainability-focused operational practices will be integrated to address dwindling natural resources. This is one reason we are working on integrating renewables into LauncherOne's 747 air-launch vehicle ops. Being good stewards of our planet is partly what is fuelling our expansion; our aim is to consciously work toward responsible solutions and to and to keep improving.

As important and ambitious as SpaceShipTwo and
LauncherOne are, they are not an endpoint but rather one
step. To be honest, we don't yet know exactly what Space-
ShipThree or LauncherTwo will look like, but we do know
what we want our future vehicles to do—and how we think
our contribution to the exploration of space can help make
our planet a better place to live.

As we think about our future, we can't help but be excited.
As true believers in the value of space exploration, we
cheer for the success of all space programs. Touring Virgin
Galactic's manufacturing plants with our talented team and
generating ideas for next-generation airplanes, rockets,
and space habitats are truly dreams come true. However,
the technology is unimportant without ingraining every-
thing we do with our purpose—ensuring the future of
Earth—the only home we know today and my favourite
planet.

In the year 2046, when my children, grandchildren, and
perhaps even great-grandchildren look at the Earth from
space—while onboard a Virgin Galactic spaceship, natu-
rally—I think they will see a much more connected planet
than we have today. They will see a world where every
single nation has sent men and women into space to
explore, discover, and inspire. They'll see physical signs
that poverty and income inequality have been greatly
reduced by projects that use small satellites to connect
the world to the internet at high speeds and low prices.
They'll see that both the green parts and the blue parts of
our planet—our rainforests, our oceans, and more—have
been protected both by the lessons we've learned from
satellites and by the passion of space travelers who return
home with a renewed desire to protect our home world.
And I hope that they'll feel great pride that through Space-
ShipTwo, LauncherOne, and the vehicles that come
afterwards, Virgin Galactic has had a major and enabling
impact on all of those things.

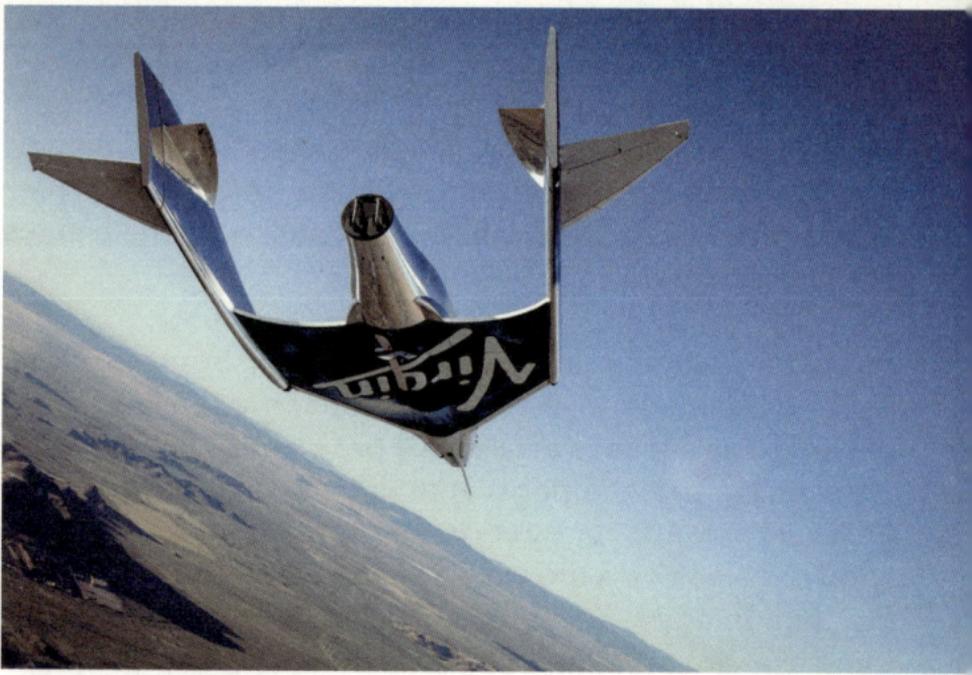
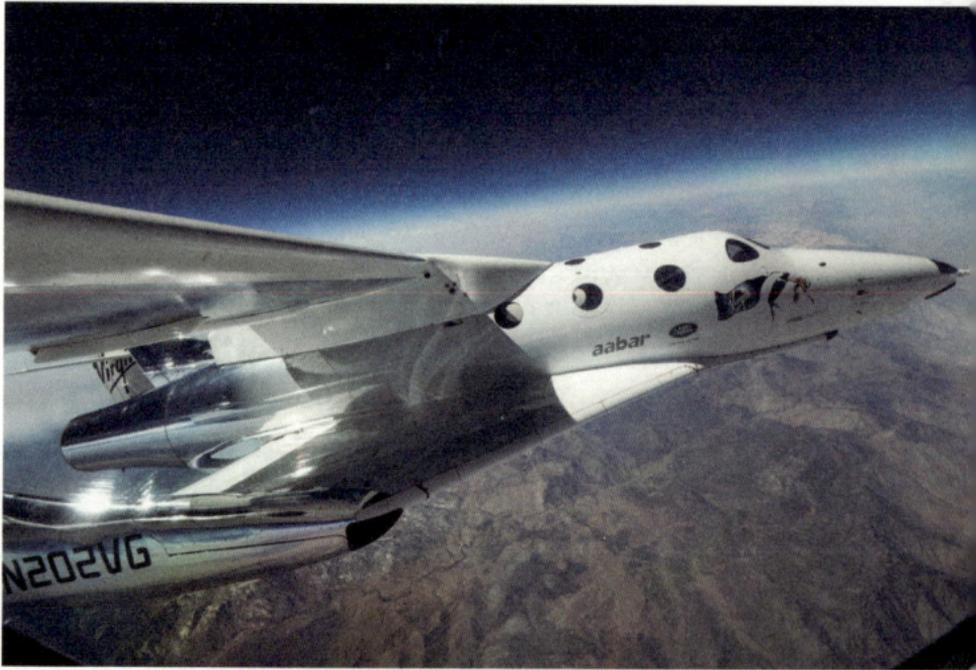

Richard Branson

Chapter 3

"Although the chance of a disaster to planet Earth in a given year may be quite low, it adds up over time, and becomes a near certainty in the next thousand or ten thousand years. By that time we should have spread out into space, and to other stars, so a disaster on Earth would not mean the end of the human race. However, we will not establish self-sustaining colonies in space for at least the next hundred years, so we have to be very careful in this period."

Stephen Hawking
The quote is taken from Stephen Hawking's BBC Reith lecture in 2016.

Imagining Habitats in Outer Space

Imaginary Infrastructures and the Making of Outer Space

Alexander C.T. Geppert

Outer space has shaped the twentieth century. Rather than having always been "out there," space was made, imagined and configured by humans on Earth, especially since the interwar period. In the wake of the Second World War and the subsequent Cold War, space was also politicized and militarized. Precisely because of—or despite—its human inaccessibility, outer space has taken on historical significance far beyond its immediate physicality. In an unbroken, yet rarely acknowledged continuity with the great imperial projects of the nineteenth century, it was widely assumed that the void surrounding planet Earth would be 'conquered' in the near future. Soon after, colonization of the entire solar system would follow. Experts agreed that such a collective movement into the spatial unknown was merely a matter of time. The expansion into worlds other than ours, they assumed, would eventually result not only in the annexation of far-flung planets but also the transformation of societies on Earth. The required technical means were supposedly long at hand, and the experts' trust in the unceasing progress of science and technology was as infinite as outer space itself.

Although seemingly evidenced by a rapid succession of so-called "space firsts"—the first artificial satellite (1957), the first human being in space (1961), the first Moon orbit (1968), the first man walking on an astronomical object other than Earth (1969)—the master narrative of an advancing "conquest of space" tends to obscure the limitations and contingencies of such an enlargement process. What in hindsight appears like a straight trajectory directly leading to the landing on Mare Tranquillitatis proves on closer inspection anything but inevitable. For approximately four decades, from the publication of Hermann Oberth's classic *Rakete zu den Planetenräumen* in 1923 through to the early 1960s, landing on the Moon was not the primary objective of spaceflight. A different imaginary infrastructural project proved the extra-terrestrial dream destination par excellence: an inhabited station in Earth orbit, sometimes referred

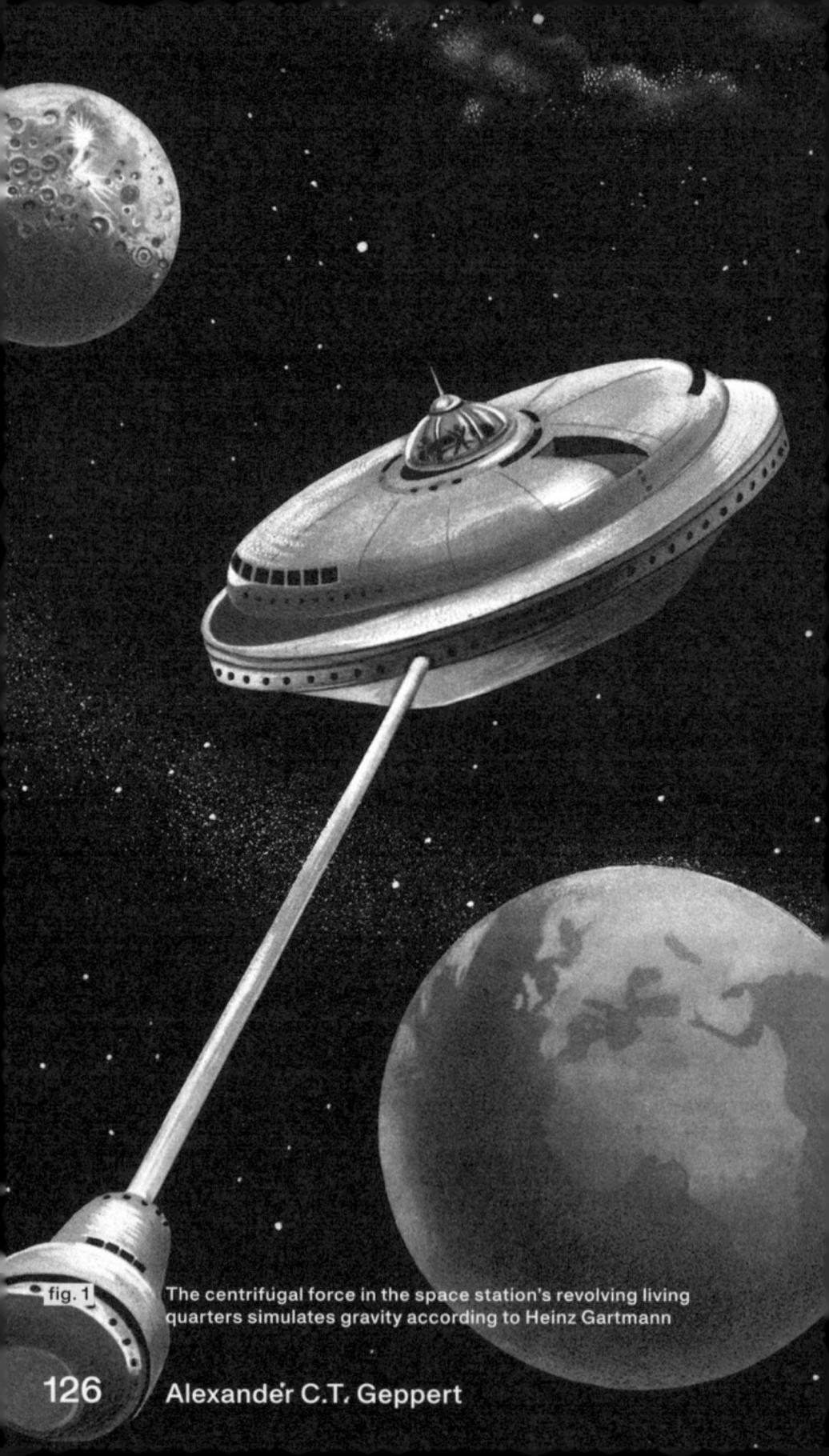

fig. 1 The centrifugal force in the space station's revolving living quarters simulates gravity according to Heinz Gartmann

Alexander C.T. Geppert

to as an outpost, *Weltraumwarte* or *plate-form pour le cosmos*. Heinz Gartmann (1917 – 1960), the most prolific of the West-German post-war space popularizers, characterized the outstation as the "principle reason of all spaceflight," while newspapers hailed a new epoch of human history dawning with the positioning of such a "guardhouse in the heavens." [fig. 1] [1]

This "principle reason" was the consensually given answer to the so-called "cosmonautic paradox," first discussed by a heterogeneous group of European engineers and space enthusiasts in the late 1920s. Because of the difficulty of overcoming Earth's gravity the first step on the way to the Universe was believed to be the hardest. "The voyage from the outstation to the planets is easier to manage than the journey to the outstation and its construction, respectively! [...] Once this is secured, everything else is relatively easy! For the realization of spaceflight the realization of the outdoor station is sufficient!," Austrian engineer Guido Freiherr von Pirquet (1880 – 1966) declared emphatically. [2] Oberth proposed to position a gigantic mirror with a diameter of 100 kilometers in space [fig. 2]; von Pirquet delivered detailed calculations on the best path for a spacecraft to leave Earth; and the Slovenian army officer Herman Potočnik (1892 – 1929), writing under the pseudonym Hermann Noordung, further embellished the space station concept by suggesting a complex three-unit structure, consisting of a "habitat wheel," an "observatory" and an "engine room" with a large space mirror attached. Together, Oberth, von

1 Albert Ducrocq, *Plate-forme pour le cosmos*, Paris: Julliard, 1962. Heinz Gartmann, *Träumer, Forscher, Konstrukteure: Das Abenteuer der Weltraumfahrt*, Düsseldorf: Econ, 1955, 39; Joachim Baumeister, "'Wachposten am Himmel': Die Eroberung des Weltalls durch Errichtung einer Außenstation," *Rheinischer Merkur* 26 (26 Juni 1953), 20.

2 Guido von Pirquet, "Fahrtrouten," *Die Rakete* 2 (May/June/July/August/September/October 1928), 67–74, 93f., 107–09, 117–21, 134–40, 155–58, here 88; see also Willy Ley, "The Birth of the Space Station (I/II)," *Galaxy: Science Fiction* 6 (April/May 1953), 52–8, 84–91, here 88.

Pirquet, and Potočnik put the establishment of an inhabited outpost in Earth orbit at the center of all expansion logic, as the infrastructural *conditio sine qua* non of future space-flight and indeed of any human outreach into the Universe. Employed to make far-fetched expansion scenarios seem viable, the space-station concept effectively acted as a visual icon and concrete reference point for wide-ranging debates about the future in space. Designed as a man-made hub placed into space, it helped to deplete the physical and imaginary void surrounding planet Earth and furthered the ongoing spatialization of outer space.[3]

It was Wernher von Braun (1912–1977), noted rocket engineer, recent German émigré and at this time director of the US Army's "Rocket Team," who re-addressed this paradox after the war, in close collaboration with some of his former West-European colleagues, in particular Heinz Gartmann, Willy Ley, and Heinz Haber. Launching a series of widely read articles in the popular *Collier's Weekly*, von Braun unremittingly began to propagate and popularize the space station scenario. "Inhabited by humans, and visible from the ground as a fast-moving star, it will sweep around the Earth at an incredible rate of speed in that dark void beyond the atmosphere which is known as space," von Braun fantasized. It was at the heart of von Braun's campaign to leave Earth behind,

3 Hermann Oberth, *Die Rakete zu den Planetenräumen*, Munich: Oldenbourg 1923, here 86–9 [eng.: idem, *The Rocket into Planetary Space*, Munich: Oldenbourg, 2013, 81–5]; idem, "Stationen im Weltraum," in: Willy Ley (ed.), *Die Möglichkeit der Weltraumfahrt: Allgemeinverständliche Beiträge zum Raumschiffahrtsproblem*, Leipzig: Hachmeister & Thal, 1928, 216–39. Guido von Pirquet, "Kann der Mensch die Erde verlassen?," Reichspost (1 January 1928), 18f.; idem, "Die Außenstation, das Sprungbrett ins Weltall," in Gesellschaft für Natur und Technik (ed.), *Weltraumfahrt – Utopie? Zehn Beiträge*, Vienna: Natur und Technik, 1948, 22–8. Hermann Noordung, *Das Problem der Befahrung des Weltraums: Der Raketen-Motor*, Berlin: Richard Carl Schmidt, 1929; for an early English translation see Captain Hermann Noordung, "The Problems of Space Flying," *Science Wonder Stories* 1.2/3/4 (July/August/September 1929), 170–80, 264–72, 361–8.

fig. 2 Hermann Oberth's concept of a gigantic space mirror positioned
600 kilometers above Earth

Imagining Habitats in Outer Space

eventually aiming for "man's oldest and last frontier: the heavens themselves." fig. 3 4

The station was the centerpiece of a three-step approach to space which American analyst Dwayne A. Day has retrospectively termed the "von Braun paradigm."[5] First, a permanently inhabited station would be positioned in space, not only to serve as an observation platform and a missile base to secure earthly "space superiority," but also as the last outpost of a civilization en route to infinity and a stepping stone for all subsequent expeditions further into the solar system. From the station, the exploration of the Moon would follow as a second stage, first unmanned, then manned, with a view to setting up a colony. In a third and, for the time being, final stage expeditions to Mars would follow from there, likewise with the goal of establishing a permanent presence. "For such a space expedition, of which scientists speak more and more seriously, a space station would be an indispensable prerequisite," *Der Spiegel* commented in the fall of 1951, thus confirming the paradigm's international primacy. Soon, von Braun's gigantic wheel developed into an oft-evoked visual icon of global twentieth-century astroculture, far outpacing competing alternative British, French, and West-German models and culminating in the wheel-shaped space station featured in arguably the Space Age's most influential science fiction film, Stanley Kubrick's *2001: A Space Odyssey* (1968). fig. 4 6

4 Wernher von Braun, "Crossing the Last Frontier," *Collier's* (22 March 1952), 24–8, 72–4, here 25, 74.

5 Dwayne A. Day, "The Von Braun Paradigm," *Space Times* 33 (1994), 12–15.

6 "Raumstation: Modernes Damoklesschwert," *Der Spiegel* 5 (26 September 1951), 26–28, here 28. See Wernher von Braun, Joseph Kaplan, Heinz Haber et al., *Across the Space Frontier*, New York: Viking Press, 1952 in addition to Wernher von Braun Papers, Library of Congress, Manuscript Division, 52/3. On "space superiority," see Michael J. Neufeld, "'Space Superiority: Wernher von Braun's Campaign for a Nuclear-Armed Space Station, 1946–1956," *Space Policy* 22.1 (February 2006), 52–62.

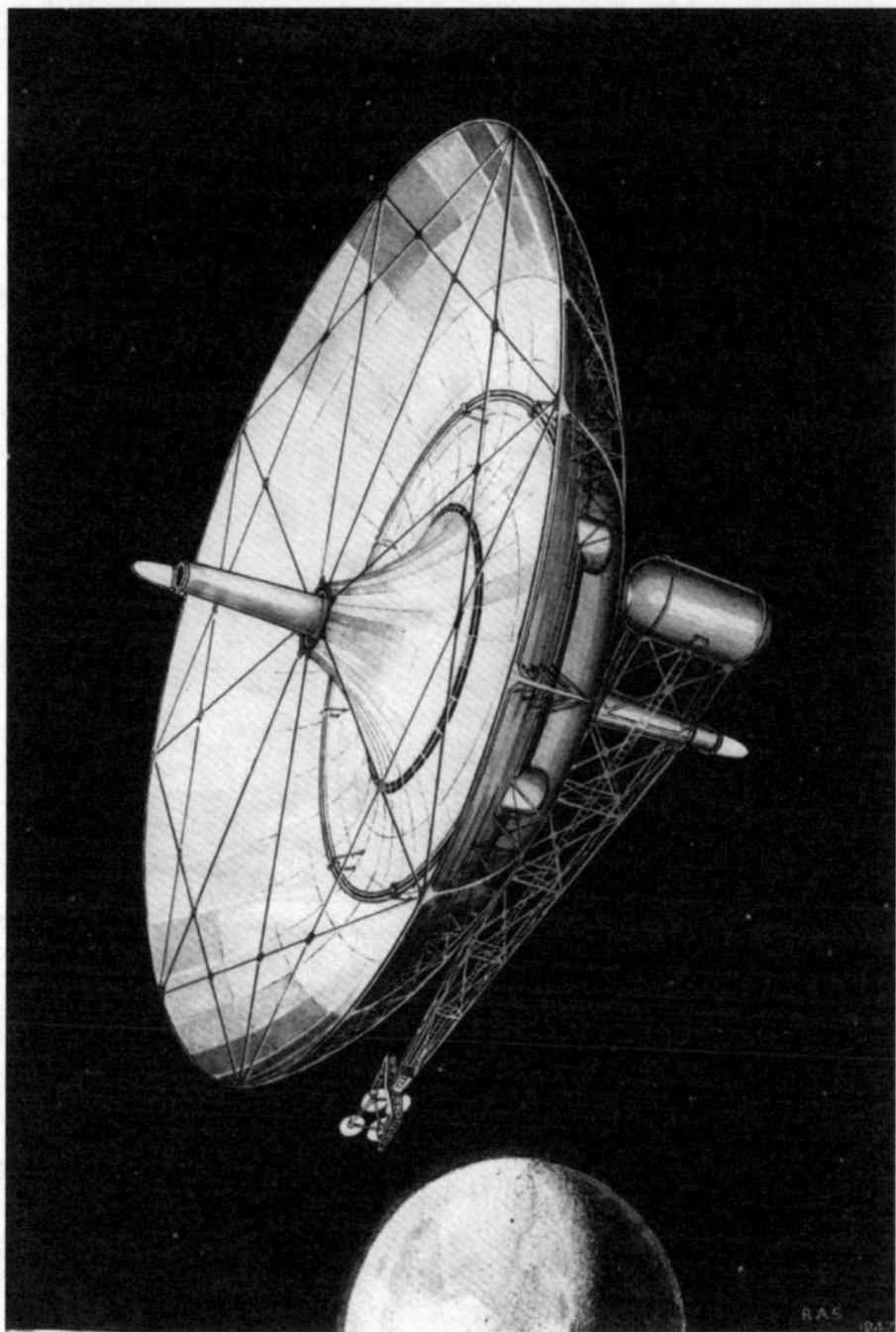

fig. 3 Featuring a 60-meter solar mirror, this alternative space station model was developed by Harry E. Ross and Ralph Andrew Smith on behalf of the influential British Interplanetary Society. Living quarters, laboratories, and workshops were integrated with the mirror; both would rotate in order to create a gravitational effect; Harry E. Ross, "Orbital Bases," *Journal of the British Interplanetary Society* 8 (January 1949), 1–19, here 9.

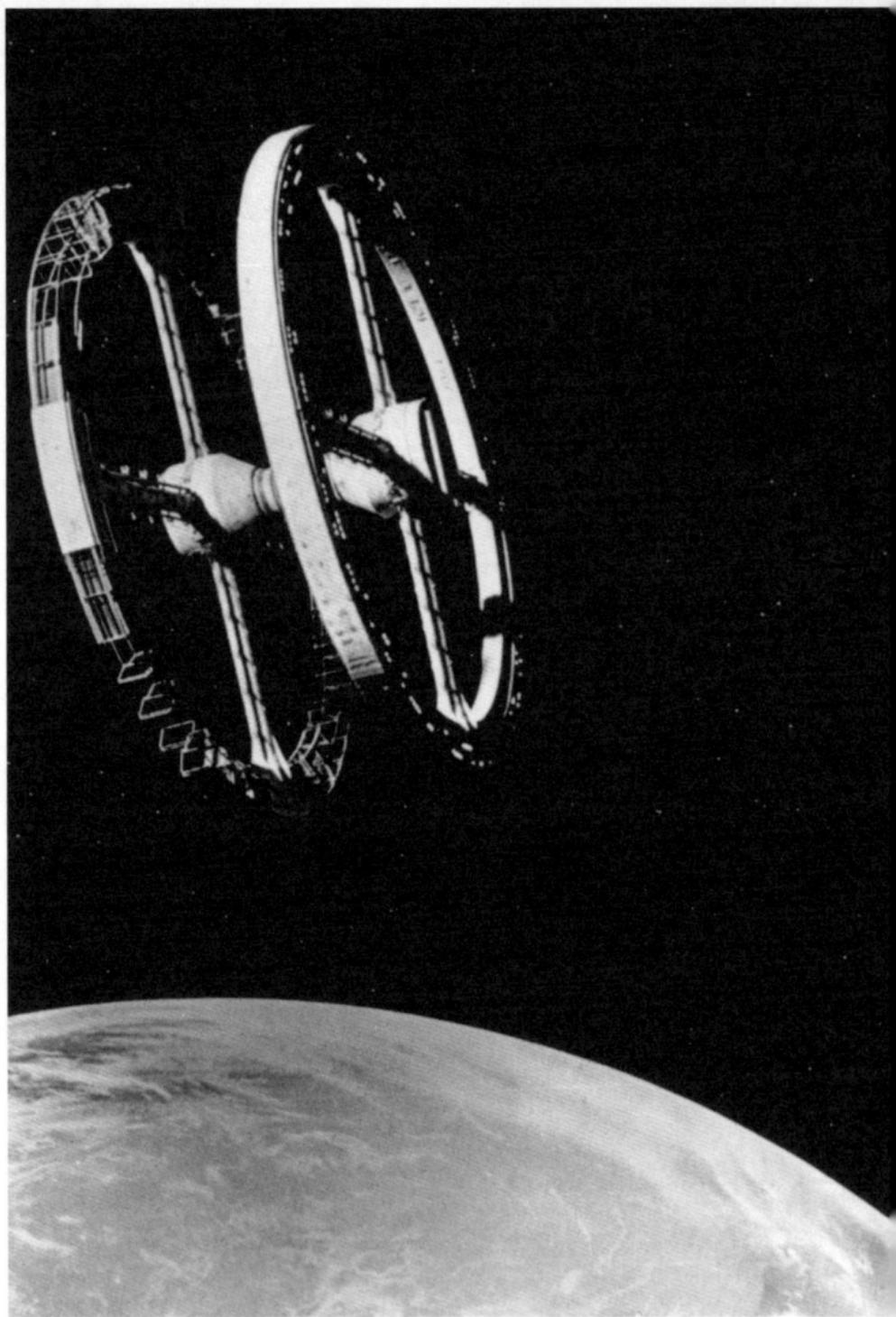

fig. 4 The wheel-shaped space station in Stanley Kubrick's
2001: A Space Odyssey (1968)

Space stations have been real since the early 1970s, after the Apollo Moon landings and ironically at a time when space imaginaries lost much of their former appeal. The abrupt ending of a decades-long Moon hype during the Post-Apollo period led to an unexpected renaissance of the earlier space-station-based itinerary, so predominant through 1962.[7] Marking the beginning of a 15-year-long program, Salyut 1, the first Russian space station, was stationed in Earth orbit for six months in April 1971. Skylab, its American counterpart, followed two years later. Partially assembled from recycled Apollo leftovers and less specialized than later stations, Skylab remained in a low orbit of 480 kilometers for much of the 1970s, even if its so-called "Orbital Workshop" was only inhabited for a total of 171 days during the first two years of operation. In early 1984, US President Ronald Reagan announced the building of "Space Station Freedom;" ten years later and with the Cold War having ended, a consortium of 14 national partners joined together to build an International Space Station (ISS). Construction began in 1998 and was completed in 2011. At an estimated cost of 9.544 billion Euro, the ISS is the most expensive civilian enterprise in human history.

Twentieth-century astroculture and space thought have continually oscillated between "science" and "fiction." Similarly, the meanings ascribed to such massive, and for the most part, exclusively imaginary, infrastructures have shifted in scale, but not in function. Oberth's and Potočnik's early concepts were already characterized by a complementary double purpose, simultaneously outward- and inward looking. On the one hand, the scientific-practical character of a space station as Earth's "suburbia in space" was emphasized. The station could be an observation platform to control climate and weather

7 On the reconfiguration of space imaginaries during the decade after the Moon landings, see Alexander C.T Geppert, ed., *Limiting Outer Space: Astroculture After Apollo*, London: Palgrave Macmillan, 2017 (= European Astroculture, vol. 2).

as much as to police the political enemy. On the other, its presence was believed to constitute only a first, intermediate and preliminary step into outer space: It was to be a "basis for the entire traffic into space" and a techno-scientific stairway to heaven.[8]

When present-day critics blame the ISS for neither advancing scientific knowledge nor serving as a basis for further interplanetary expeditions, they call the ISS's very *raison d'être* into question. Given that these two purposes were central to all prior space station designs, they also challenge the supposed precondition of future spaceflight since the 1920s. Despite the existence of a permanent outpost in space, circling planet Earth every 91 minutes and continuously inhabited since November 2000, space stations have lost much of their popular appeal. No longer do they embody a futuristic ideal of cosmic expansion, nor do they continue to serve as discursive reference points in the abiding spatialization of outer space and the ongoing planetization of planet Earth. As ideas of human presence in space have shifted, so too has the scope of astrofuturist yearning projected onto the space station. Yet, it is far too easy to dismiss the historical significance of this technological feat. For the first time, human beings have re-created the environment on which they depend for survival and successfully brought it with them to a non-human world. As the philosopher Peter Sloterdijk has recently noted, the creation of space stations represents a dramatic *caesura* in the history of humanity's relationship to itself.[9]

THIS TEXT BY ALEXANDER C.T. GEPPERT IS BASED ON THE GERMAN TEXT "INFRASTRUKTUREN DER WELTRAUMIMAGINATION: AUSSENSTATIONEN IM 20. JAHRHUNDERT," BUNDESKUNSTHALLE, EXHIBITION CATALOGUE, BONN, 2014

8 Noordung, *Problem der Befahrung des Weltraums*, 172.

9 Peter Sloterdijk, "Starke Beobachtung: Für eine Philosophie der Raumstation," in: *Was geschah im 20. Jahrhundert?*, Berlin: Suhrkamp, 2016, 177–84, here 178–9.

Architecture in Zero and Artificial Gravity

Norman Foster

Virgin Galactic is visionary in that it brings space travel within the reach of thousands of people, instead of just a select few. Until recently, the Russian Space Agency was the only organization to offer tourist flights into space; and then only a handful of people were able to do so—and at vast expense.

The Spaceport is designed to make the experience of space travel uplifting in every sense. At the same time, it has to meet quite complex operational demands. Just like our airport terminals, in order to maximise efficiency, the hanger, control and passenger functions have all been brought together under one roof. We have also designed to maximize energy efficiency and reduce environmental impact. The building is dug into the New Mexico landscape, which reduces its visual presence and allows us to harness its thermal mass to reduce energy use.

Interestingly, our work in this area goes back a little further. In 1990 I went to Space City, Baikonur with my colleague David Nelson as a guest of Russia's space agency, Energiya. This was in the early days in terms of opening up the space industry. We saw the first space tourist, Toyohiro Akiyama, blast off for a week on the Mir space station. And I visited the Museum of the Cosmonauts. I think space travel may now be at the point where computing was in the 1960s, when the creative impulse began to shift from government projects to private industry. Perhaps competition will open up space travel in ways we cannot yet imagine.

But working in a zero-gravity environment would certainly be a challenge! Interestingly, a specialist team in our studio has already been working as part of a consortium, appointed by the European Space Agency, to research the use of three-dimensional printing technology for building on the Moon. Their study has been exploring how to use lunar soil as a base material for printed building blocks to create shelters for astronauts and enable scientific experiments. For us as architects, it represents an extraordinary learning curve. It's a window into the future.

However, there are points of convergence, whether one is designing for Earth or the Moon. Firstly, one designs spaces for people, so they have to satisfy basic human needs, such as privacy and a sense of connection with the outside environment; and they have to be comfortable, enjoyable—inspirational. Secondly, wherever one builds, one always has to address a specific climate. Aside from offering protection from meteors, a structure on the Moon has to be able to deal with great swings of temperature and high levels of solar radiation. The work of the behavioural scientist, Jack Stuster, offers some insights. He studied people's reactions to a range of isolated environments and likened the experience of the space station to living in a motor home for three years with five people. Based on this he made a number of recommendations, from separating the sleeping areas to simply putting a window in the capsule.

The natural world is also very important in space—perhaps even more so than on Earth. Stuster draws an analogy between a seventeenth-century French explorer who placed great value on having plants and greenery on the ship at sea, and space crews, who take pleasure in spending time with growing experiments on board. Furthermore, the impact of seeing Earth from space remains just as meaningful today as it did fifty years ago. The first photographs of Earth as a serene blue-green globe triggered

the Whole Earth movement—you could say that the early astronauts astronauts made great contributions to environmentalism.

As a space tourist, to experience weightlessness is part of the thrill. The flight trajectory of the Virgin spacecraft will overlap the Earth's atmosphere at 70,000 feet, which means it will be a sub-orbital journey with a short period of weightlessness. The total flight time from the ignition of the booster aircraft which carries the spacecraft, until touchdown is approximately three-and-a-half hours, but the suborbital flight itself will only be a fraction of that time and one will be weightless for something like six minutes.

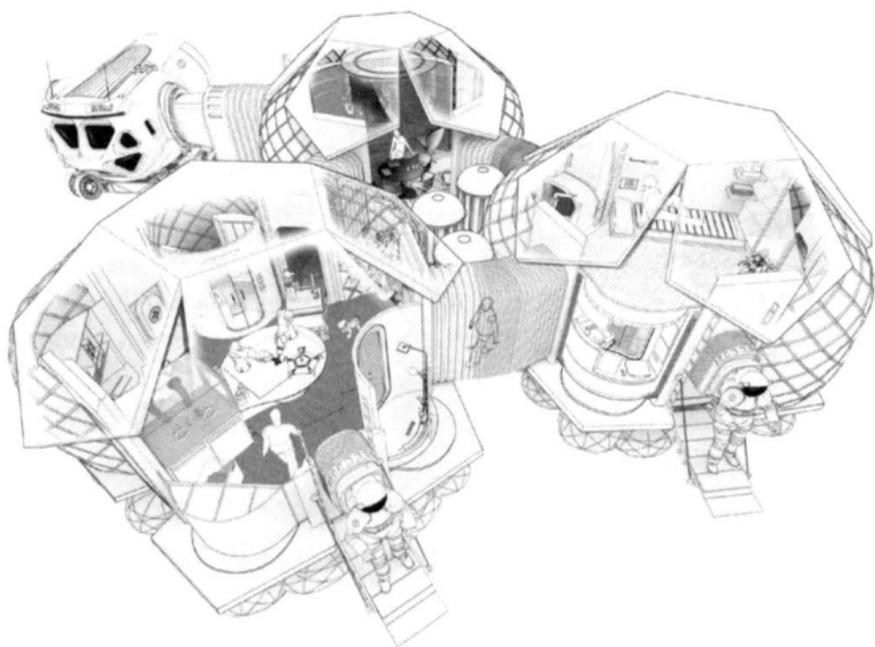

When one studies the effects of spending longer periods in a weightless environment, one finds that there are specific design considerations, over and above the technical questions. Orientation is particularly vital. When one is weightless, it makes less difference where objects are placed—everything is potentially within reach—but the impact on one's senses is huge. How astronauts mark time without the routine cycle of day and night—their mental orientation if you like—is also a factor. The challenge of

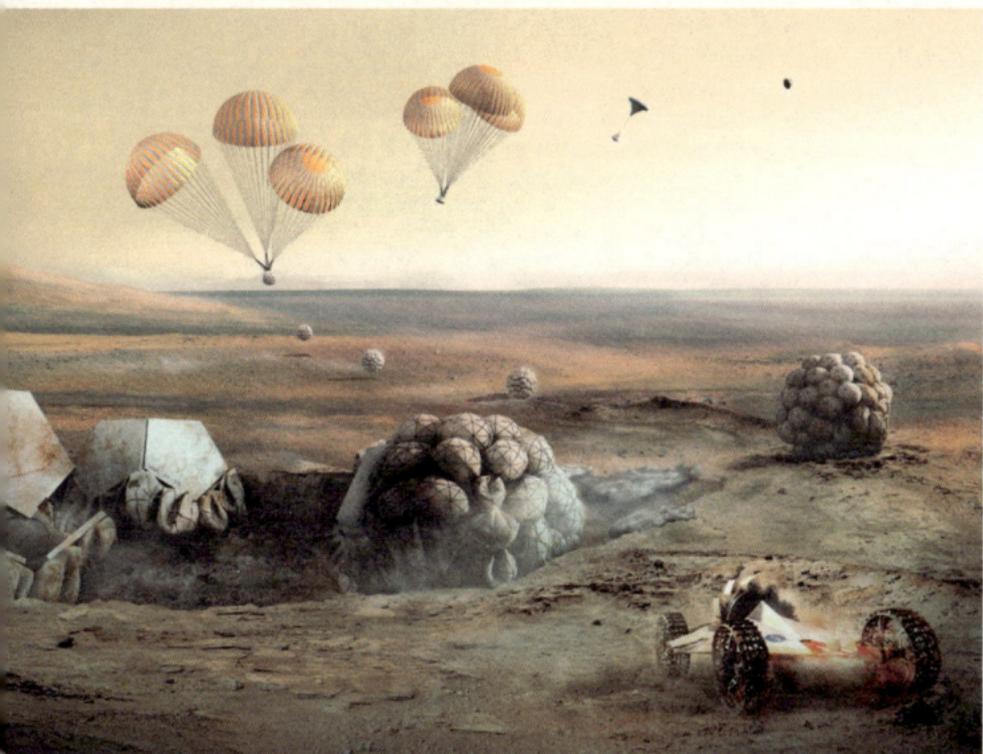

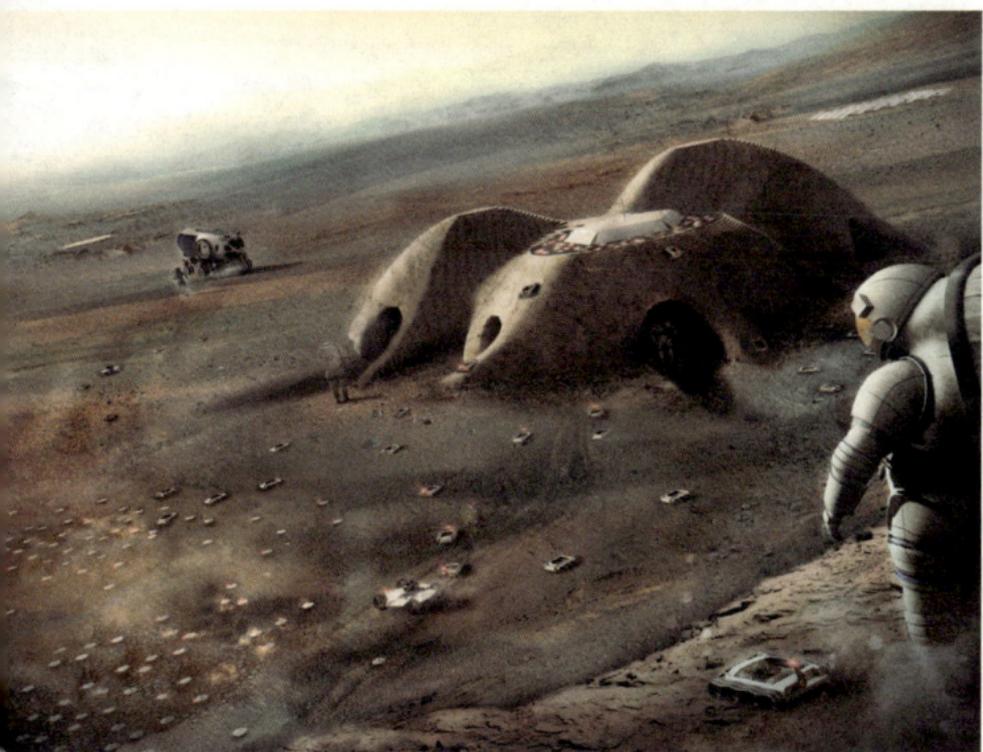

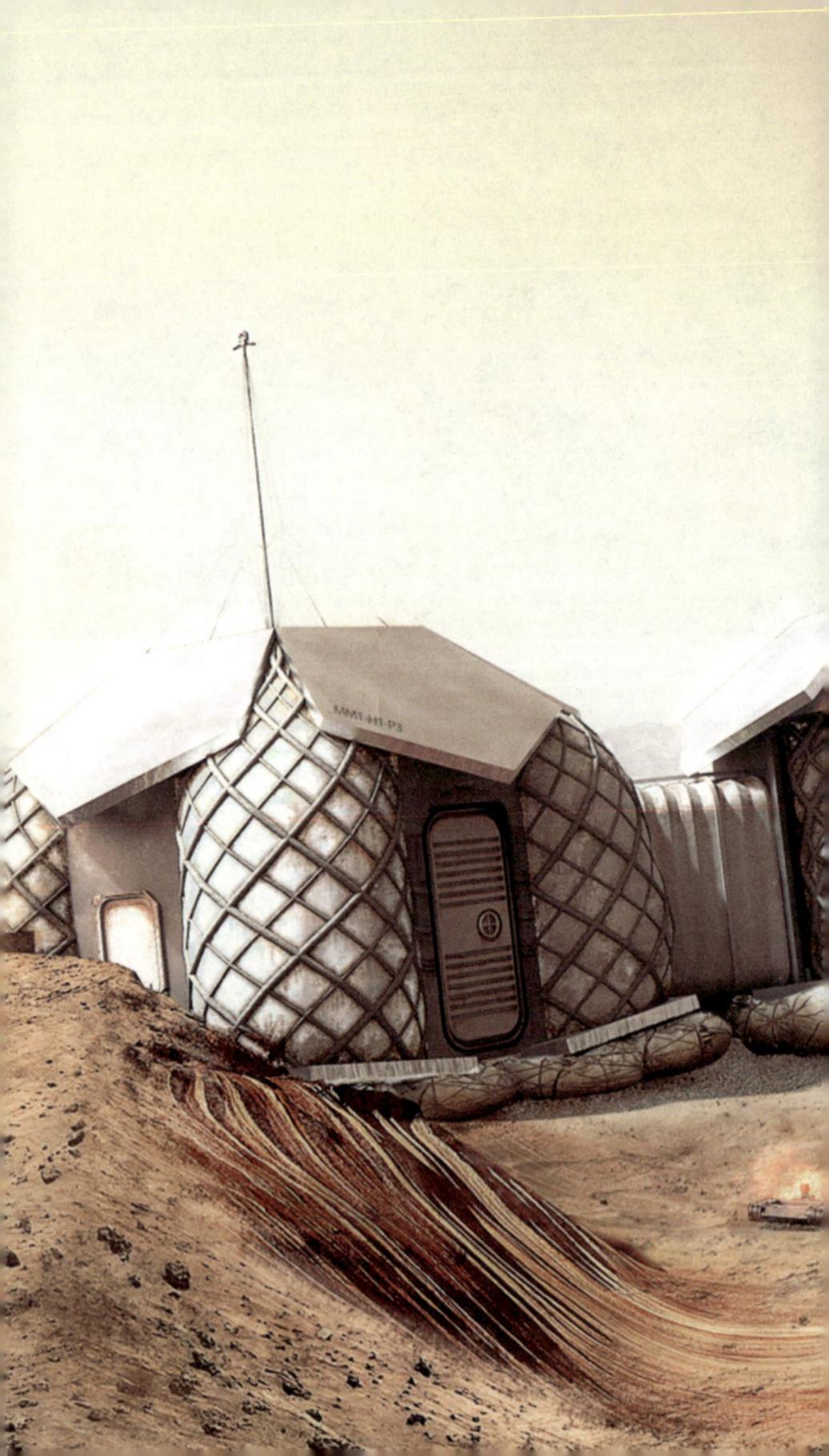

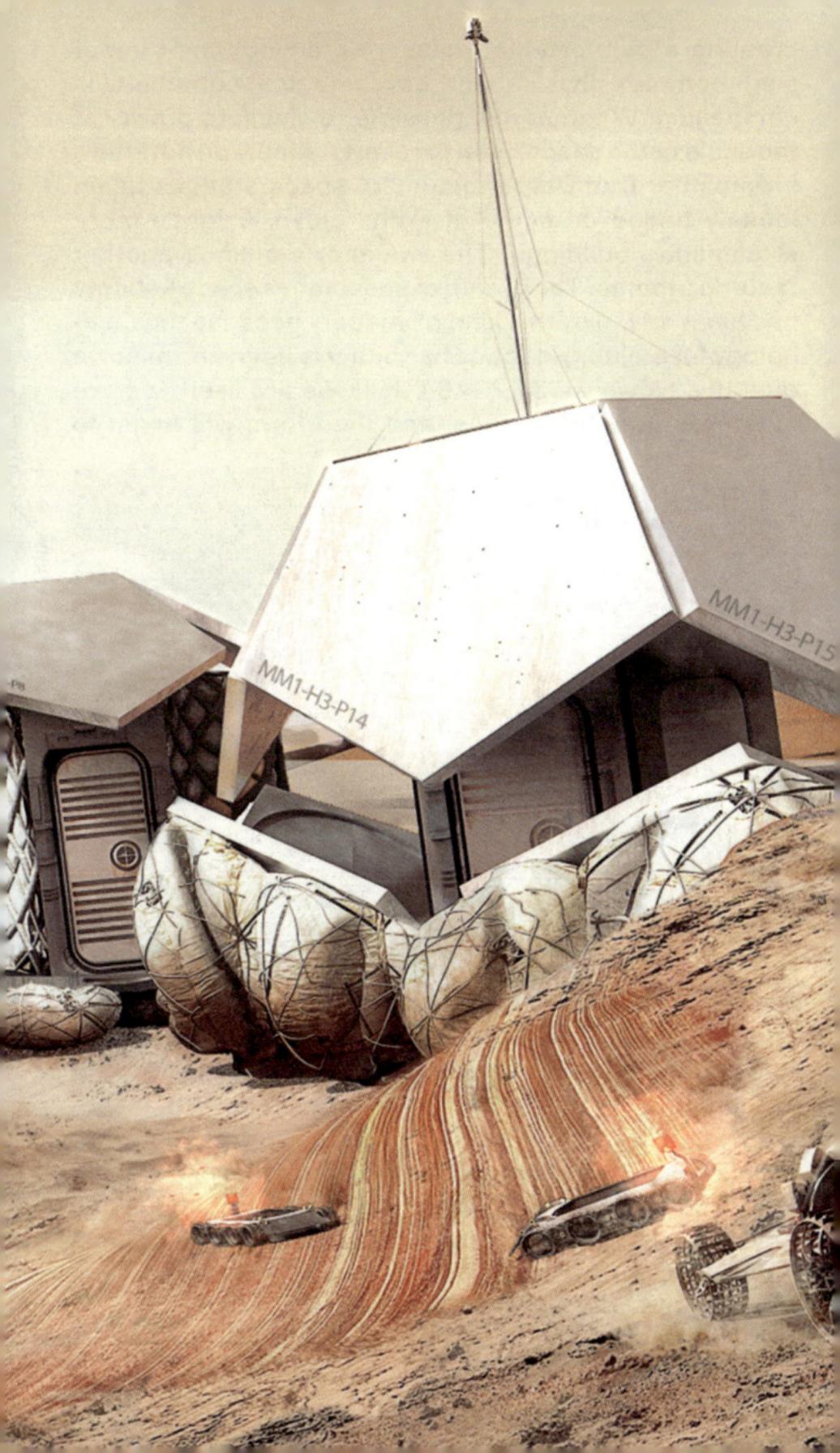

creating a comfortable, reassuring environment under such complex physical and psychological conditions is compelling. Whether it is possible to simulate gravity at the scale of the space hotel or resort, I simply do not know. I remember Dan Dare's imaginary space stations being loosely based on some of Frank Lloyd Wright's more streamlined buildings. The wheel or discus is another recurring theme. The design of speculative space habitats has been driven by this kind of imagery because the technology for building in space has hitherto been an unknown quantity. However, by 2046 I think we are likely to have mastered new techniques, and then form will begin to

THIS TEXT BY SIR NORMAN FOSTER WAS ORIGINALLY WRITTEN IN 2012 FOR THE PROJECT "VISIONARY STATEMENT 2046" AS PART OF MICHAEL NAJJAR'S OUTER SPACE SERIES

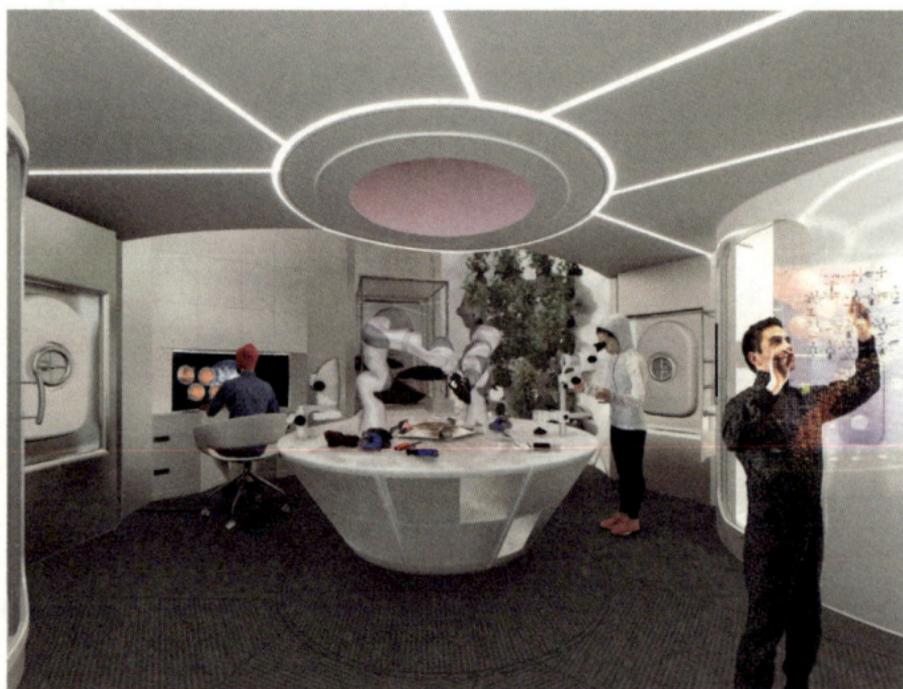

follow function far more closely. We might see compact settlements on the Moon—low-rise and densely planned. Or we might decide the best way of approaching the problem is to build the equivalent of an airship or an ocean liner, and to tether it to a mooring that has quite a small physical footprint. I recall a colleague who, when asked a similar question, replied that whatever you can imagine today would be a reality in the future.

Humanity in Space

Xavier De Kestelier

Elon Musk's vision for space travel to Mars: Interior of the Mars colonist living spaces

There is a 1/500,000 chance that a natural disaster will wipe out human civilization within the next 1000 years. While not perhaps the most terrifying odds, would you risk the future of humanity on it?[1]

As with most things in life, Earth needs a backup plan. We need a place where, should the worst happen, we can do a worldwide Ctl+Alt+Del and restart the human race.

Fortunately, there are plenty of people who are already thinking about this. And there are also plenty of people who are keen to understand the options available to us.

In September 2016, hundreds of people stormed the main auditorium of the International Astronautical Conference in Mexico to hear SpaceX founder, Elon Musk, outline his plan to colonize Mars.

1 T. Urban, The Elon Musk Blog Series: *Wait But Why*, Lioncrest Publishing, 2015

Raymond Fernand Loewy (1893–1986)

Skylab Astronauts in the wardroom

Xavier De Kestelier

In his eagerly anticipated keynote speech, Musk shared his vision to populate Mars with one million people within the next 100 years. He explained in great detail how this could happen and his presentation covered everything from the technological advances and engines required to get there, through to the critical timings for development, the launch schedule and economic plans. He included detailed plans, 3D models, mock-ups, and technical tests of the rocket engines and the fuselage.[2]

He even included a detailed animation of the technical requirements that would make interplanetary travel feasible. The animation brought the launch system to life; how it would be constructed, operated and maintained.

But there was one critical part he did not elaborate on—the human experience of getting there. He only showed some very preliminary ideas of what the living and working spaces on the spacecraft for the Mars colonists would look like. They are merely some abstract white floor plates, bridges and walls. There appeared to be no thought for what the future Mars colonist would experience and do on the months long journey to Mars. The interior is more reminiscent of a set for a sci-fi movie.

We can of course argue that Musk simply hadn't yet quite reached that stage of the design process. But I think that he's following a very typical pattern of design that has been apparent throughout the history of space exploration—he has forgotten about people.

Although it is the brilliance of human thinking that has got us to the point of potentially putting a person on Mars, the process has reduced people to being simply another sub-system of the spacecraft. They are seen merely as

2 E. Musk, Presentation at the International Astronautical Conference, Guadalajara (Mexico), 2016: https://www.youtube.com/watch?v=8unI6KHAocU

another part of the complex engineering system of a space mission. If left to the engineers, space exploration would not only be extra-terrestrial, it would be inhumane.

In the early days of space exploration with missions such as Apollo, Gemini, and Mercury, the main focus was on the engineering challenge and there was very little concern over habitability. This was largely because these missions often only lasted days or weeks.

This changed with Skylab in 1973. Skylab was NASA's first space station where astronauts would spend months living in lower Earth orbit.

Initially, Skylab was developed as a "wet workshop" space station. The wet workshop is a concept developed by rocket scientist, Wernher Von Braun, which saw part of the rocket stages being re-fitted in orbit and becoming an additional habitable part of the space station.

However, this concept of reuse put a lot of restrictions on the design. It essentially required transforming a tank that held liquid hydrogen during the launch into a living and working environment for astronauts.

As the design of Skylab advanced, the concept evolved from a wet workshop to a dry workshop, meaning that the astronauts were launched with their living and working modules already fitted out. However, the early design did little to progress the space beyond the status of a glorified gas cylinder.

Providing the astronauts with a comfortable living and working environment was simply not considered a priority. Habitability was only considered as one of the Skylab science experiments. It was called experiment M487 and in very practical terms it measured temperature, humidity, O_2, light, and noise levels. It became more an analysis of

Astronaut preparing for extra-vehicular activity

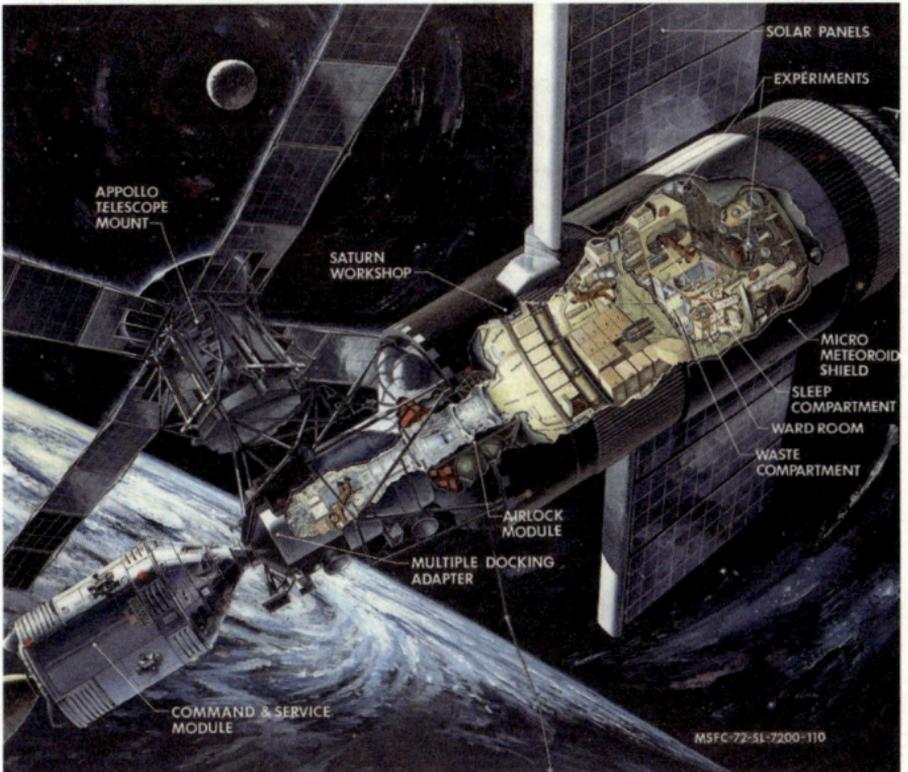

Cutaway illustration of the Skylab

Imagining Habitats in Outer Space

what conditions humans needed to survive, rather than being taken as an opportunity to improve the comfort and wellbeing of the astronauts.

Appalled by the Spartan living conditions of the Skylab astronauts, George Mueller, the Associate Administrator of Manned Space Flight at NASA, became the main proponent for the introduction of a habitability program for Skylab.

He enlisted the help of one of the most prominent industrial designers of that era, Raymond Loewy, to analyze the living conditions of Skylab and "provide comments and recommendations based on the latest industrial design concepts, relative to floor plan arrangements, color schemes, lighting, noise levels, and all other factors relating to human comfort in confined quarters.[3]

However, Loewy's approach went far beyond NASA's original brief. He discarded the constrained parameters set by the aerospace engineers and put people back at the center of the design process. He proposed a series of changes to Skylab that—while perhaps obvious today—were ground-breaking, and in some cases hard for NASA to embrace at the time.

The first change Loewy proposed was to create small personal pods for the astronauts where they could sleep, relax and take time out from the rigours of space travel. It would be the only private space they would have.

He also created a wardroom, or mess-cabin, with a small table where the astronauts were able to face each other, so they can socialize while eating . Perhaps having a table where people can see each other while they eat may seem an obvious decision, but from a purely engineering perspec-

3 R. Loewy, *Industrial Design*, Overlook Books, 1995

tive it was not a practical or functional requirement. The original design had the astronauts facing out towards the space station walls to eat. The psychological and social advantages of basic human interaction were not a given factor in the original, engineering-led design.

The biggest and most controversial proposal by Loewy was to include a window in Skylab. Although everybody liked the idea of a window, it wasn't seen as essential to the success of the mission. It was too expensive and it would be a weak point in the space station's structure. Loewy's response to this was unequivocal: not having a window was unthinkable. Purely on a recreational level, for the psychological wellbeing of the astronauts, it would be worth all the cost and effort. As a result, a small window was included in Skylab.

It has since been proven that access to long-distance views is essential for human wellbeing. Perhaps unsurprisingly, looking through the small window became one of the most important and popular pastimes for the Skylab astronauts.

The controversy over windows in space isn't unique to Skylab. Although the International Space Station had windows from the outset, it wasn't until 2010 that a large viewing platform called the Cupola was installed.

The Cupola was first developed in 1987 but it took 23 years before it was installed on the ISS. Like the window in Skylab, it was considered a non-essential part of the station and was often the first item to be cost engineered out. It has since become the most famous part of the ISS and the place most of the astronauts hang out to have a view to Earth. It is also the location where astronaut Chris Hadfield performed David Bowie's *Space Oddity* in 2015, and which is now probably the most famous footage of the ISS ever broadcast.

In aerospace design there is very little margin for error. Precision engineering can mean the difference between life and death; between decades of work and vast financial investment paying off or simply being doomed as an extravagant failed experiment.

But this margin of error must be expanded to include the people that are fundamental to the mission.

If anything, it is in the most extreme mechanistic environments—such as a space station—where the need for good human-centered design becomes fundamental.

In these environments design is often seen as an added extra, a nice to have. But, as Loewy demonstrated, it is the role of the architect to expand the parameters of what is considered a truly successful design.

Yes, a spacecraft must get its passengers into orbit safely and efficiently, and the astronauts must complete their mission with precision. However, their comfort while doing so, should not be an afterthought. In fact, there is a clear argument that their mental and social wellbeing are key factors influencing their ability to perform at their peak.

It is with this thought, that I look forward to seeing Elon Musk's vision to colonize Mars become a reality. But this time with architects and designers working hand-in-hand with the engineers to ensure that the spacecraft that transports humans there, and their accommodation when they reach the red planet, are habitable, comfortable, and, most importantly, humane.

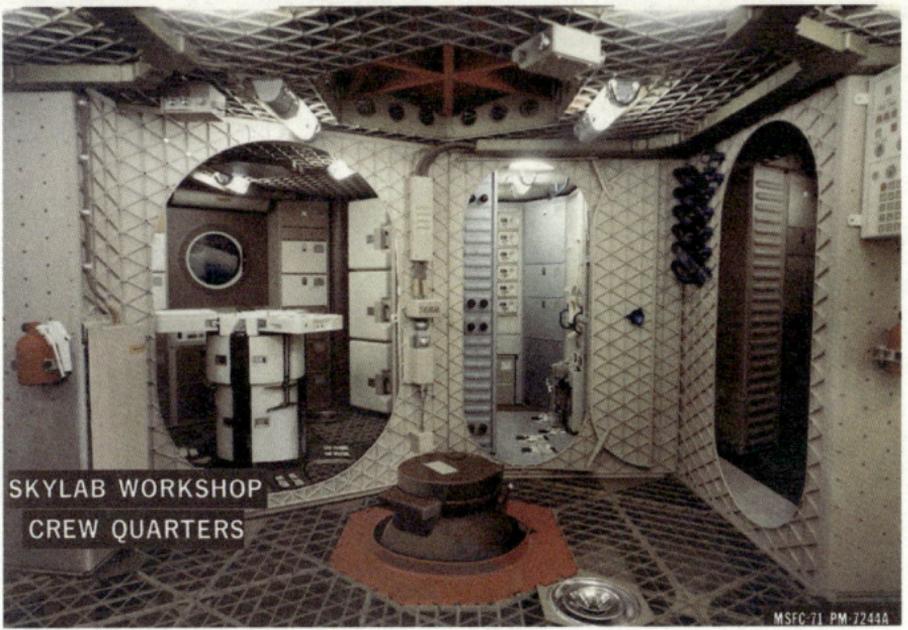

Skylab Workshop Crew Quarters

Interior view of the Orbital Workshop (OWS)

Imagining Habitats in Outer Space

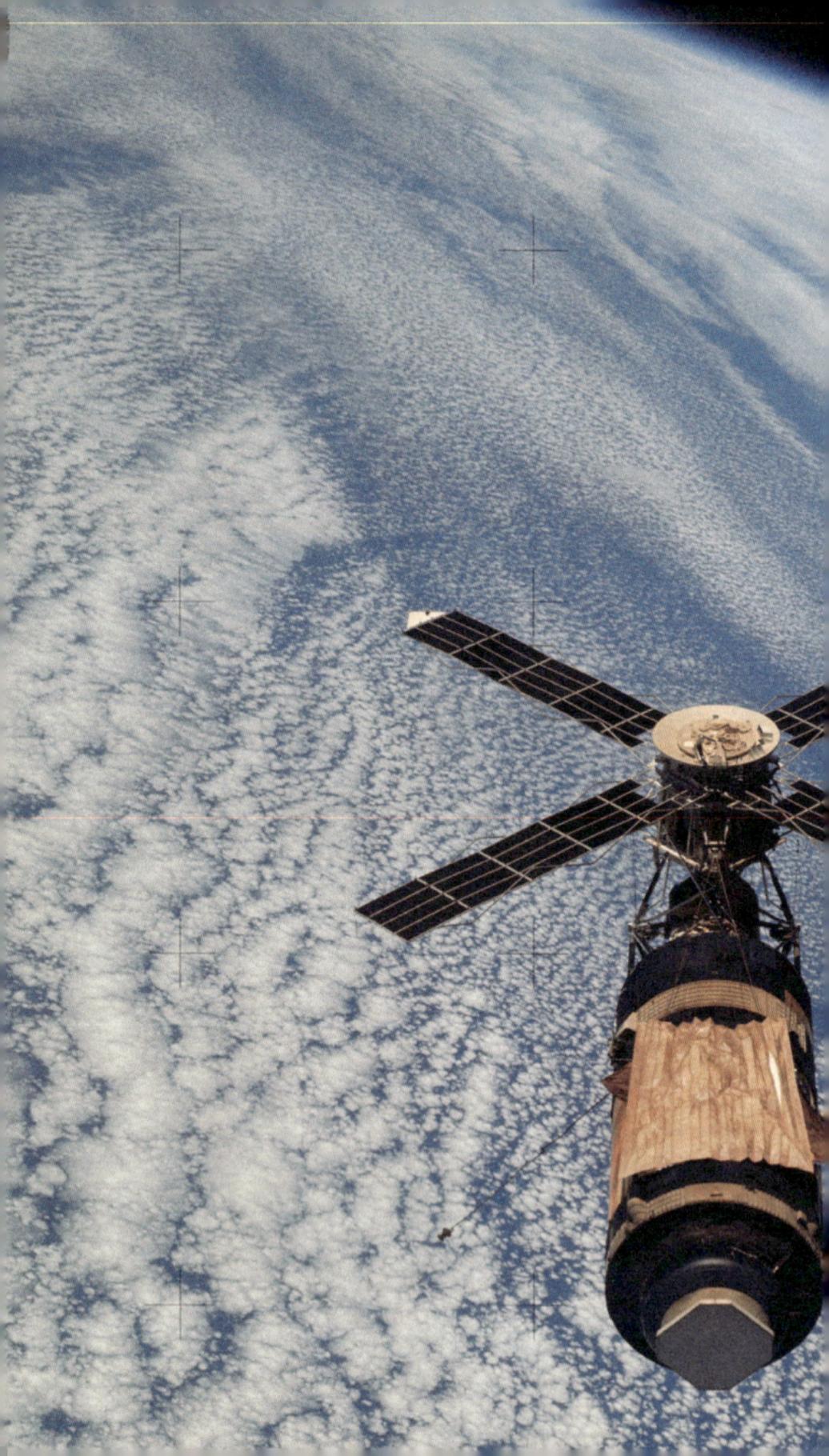

"Divide" — N.O.A.H. (New Outer Atmospheric Home)

Greg Lynn

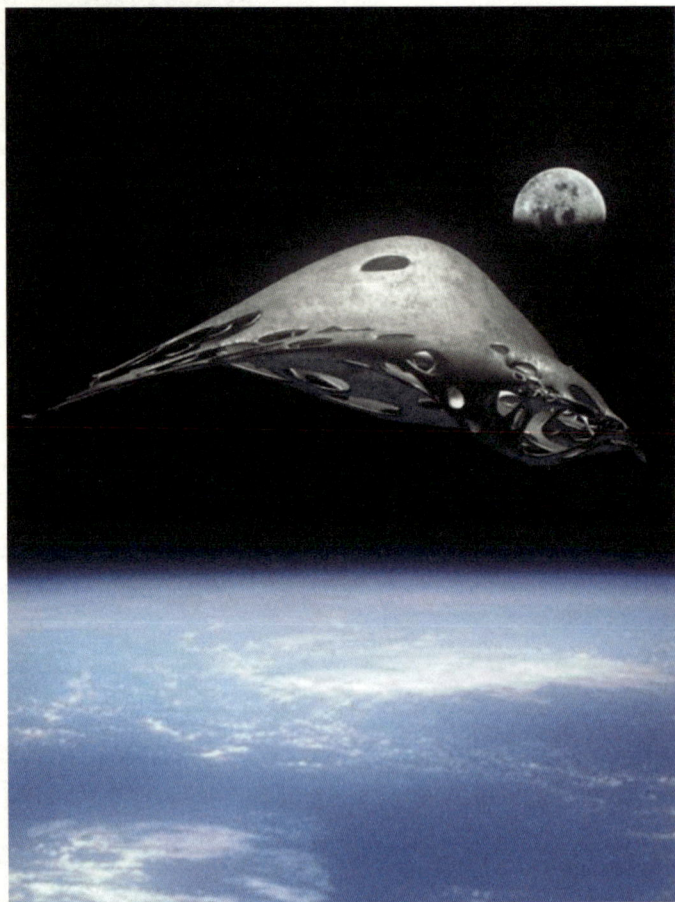

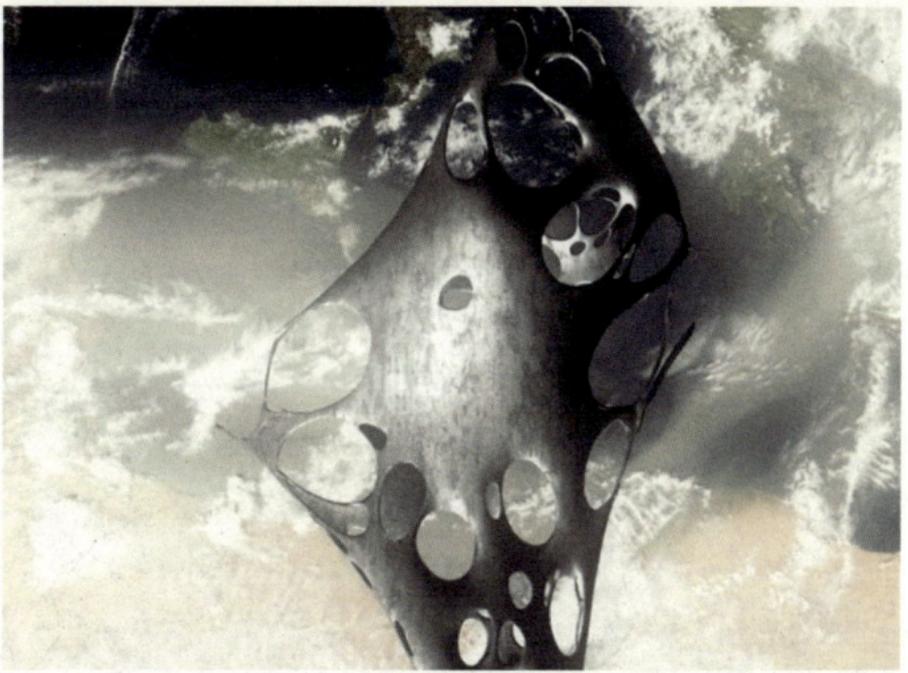

Fusing literature, architecture and social commentary within a cinematic work geared towards the general public, "Divide" is a high-concept science fiction allegory—currently in production—addressing the socio-political mores that shape our world and future. In this film, N.O.A.H. or the New Outer Atmospheric Home is a multi-oriented, porous, city-scaled, man-made space station housing millions. It is designed to take advantage of gravity-free orientation and, much like a cellular or bacterial space that is so small that gravity plays little role in interior orientation, N.O.A.H. is riddled with open spaces and micro-climates directly transplanted from Earth. It is a design concept that combines architecture, technology, and terrestrial nature to create a new ideal of living space—one not bound by gravity and planar surface. From a distance, N.O.A.H. resembles a single vast discrete shape, but from closer observation, it becomes an amalgamation of mutable and modular cellular pockets. These cells create a variety of structural layers—similar to a coral reef—and read as chambers and volumes within, and when intersected with the outer skin, as crater-like openings that bring light and air

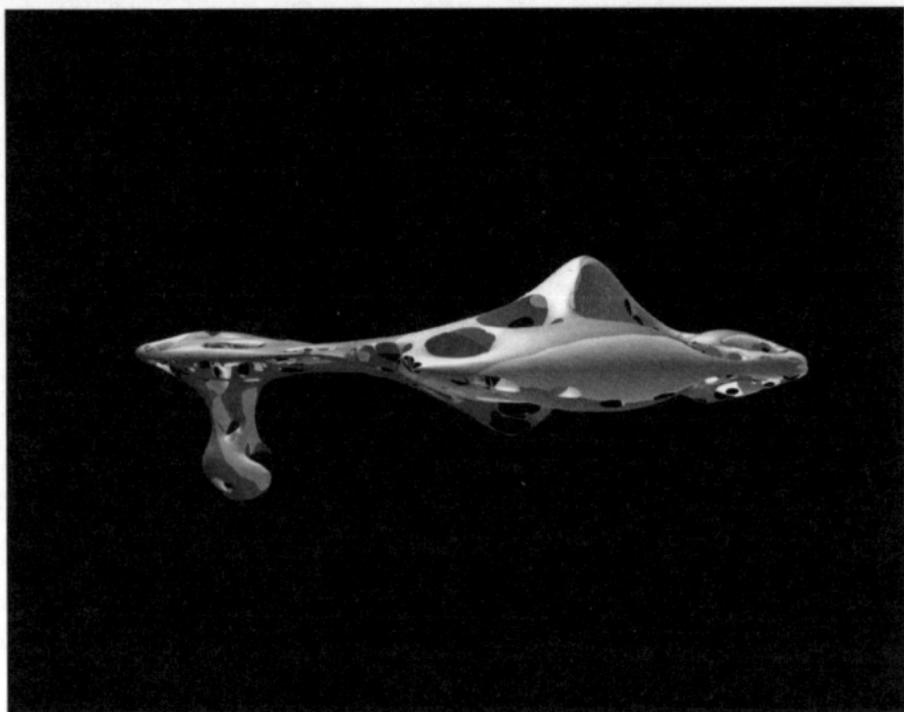

to the interior. The design of four N.O.A.H.s feature prominently in the film and their design and technology is the basis for the sci-fi social and political thriller that emerges between the inhabitants of the N.O.A.H.s and Earth.

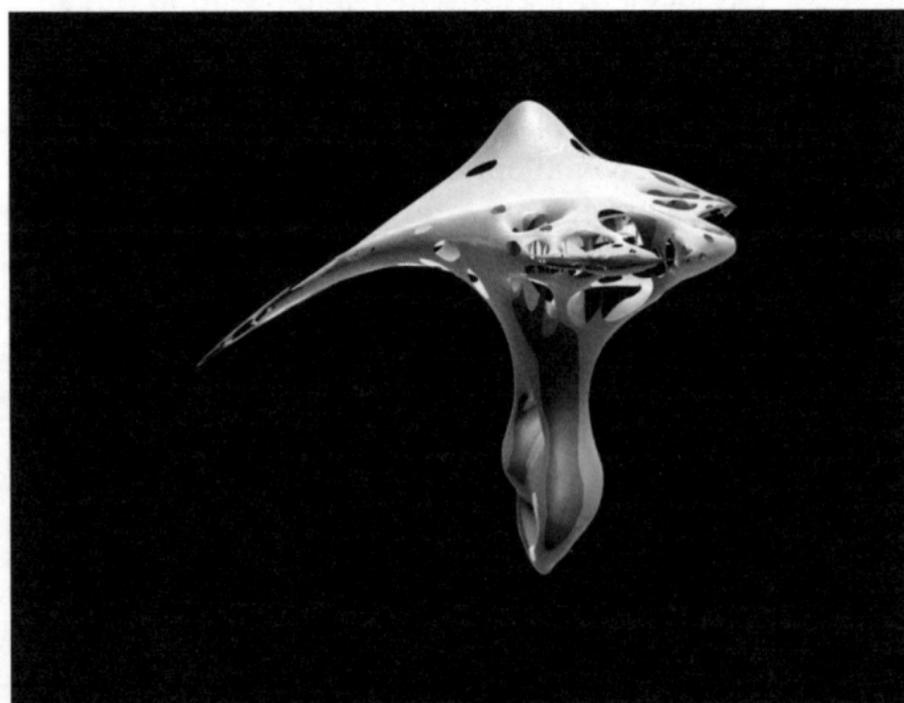

New City

Greg Lynn

New City is a concept for a living virtual world that is parallel and simultaneous to ours. A collaboration between Hollywood producer Peter Frankfurt, Greg Lynn, Hollywood production designer Alex McDowell, Imaginary Forces, and Greg Lynn, the design of this new virtual space marks the development of the first architecturally considered virtual world. Online social networking has had a huge impact on the way we now communicate, and this is really just the beginning; it only scratches the surface of the way we're going to interact with each other, communicate, and experience the world.

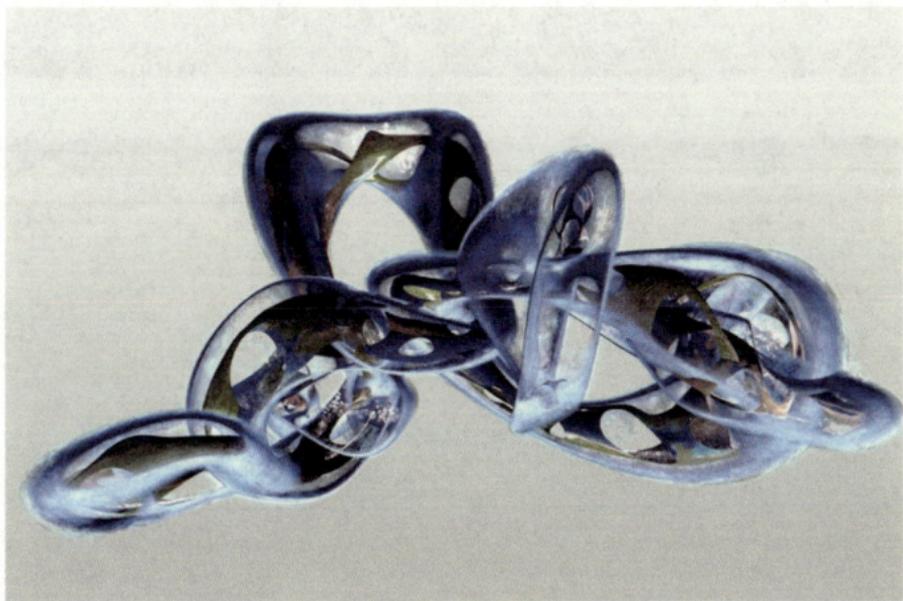

Our understanding of space is always changing. We once thought the world was flat because we drew the world as flat. All kinds of discoveries gave the world shape and depth. The way we conceptualize the world as a sphere changed the way we thought about space and distance.

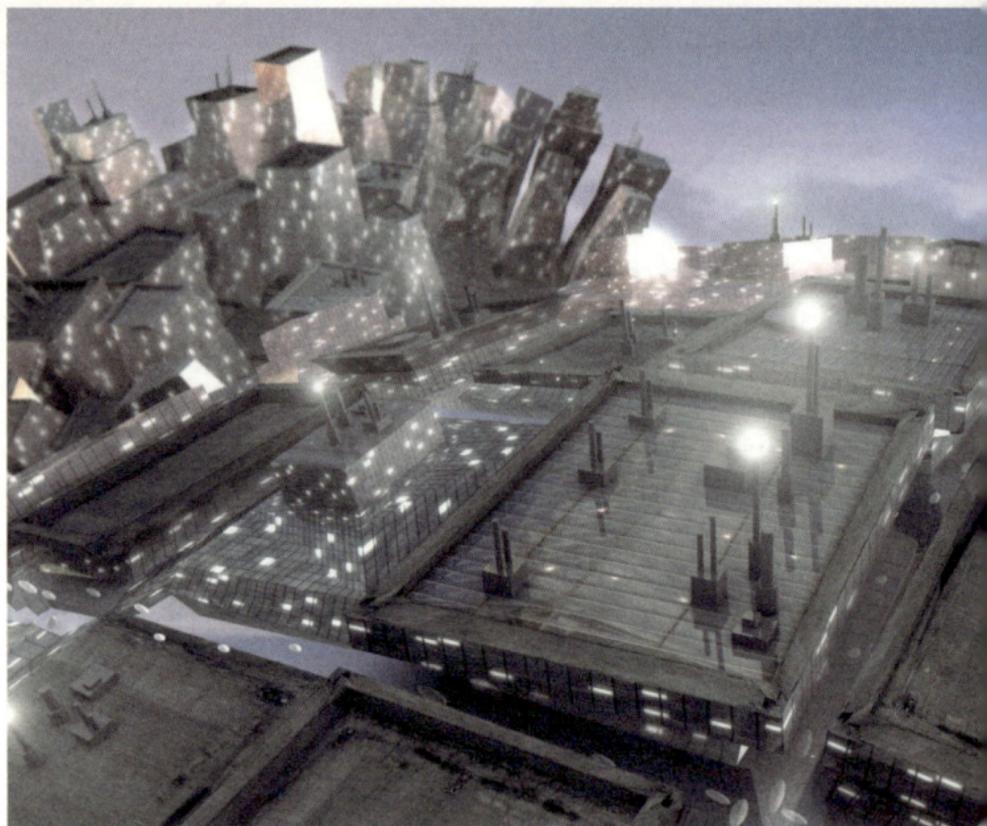

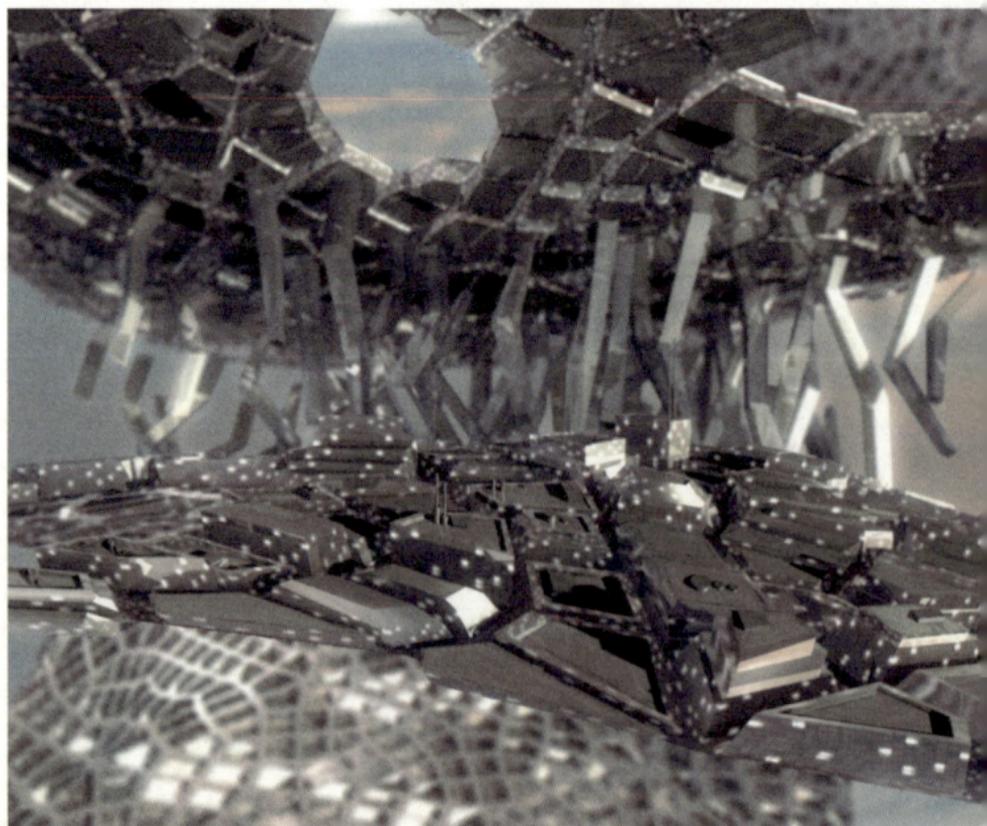

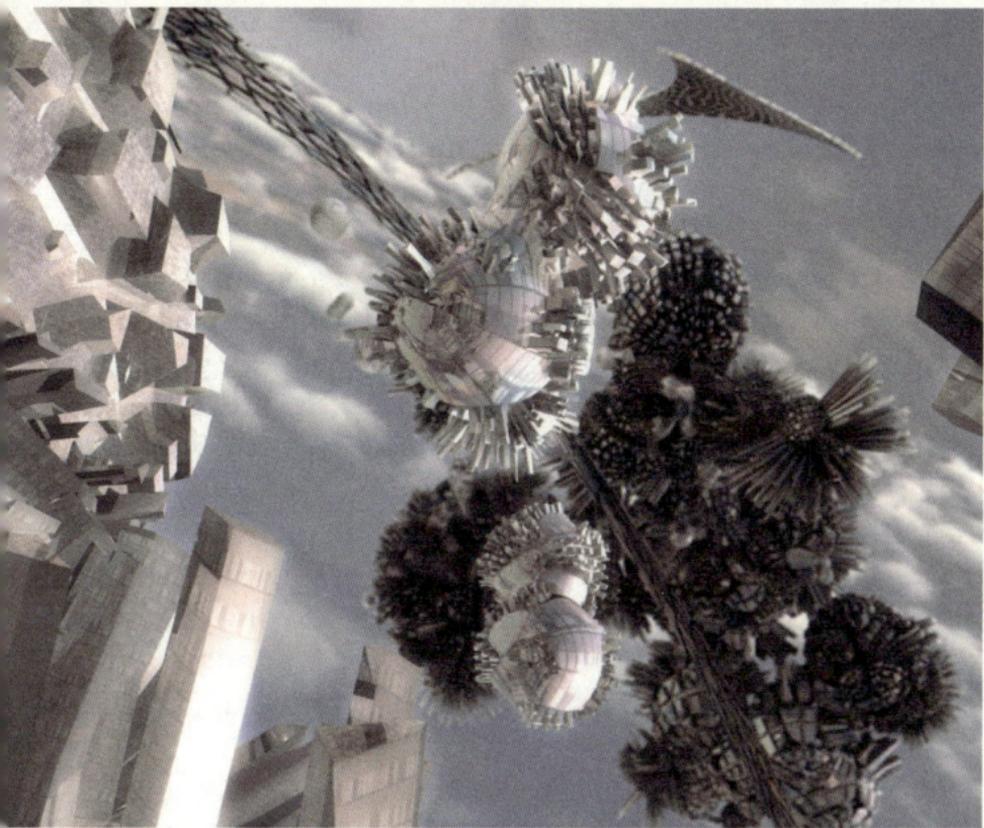
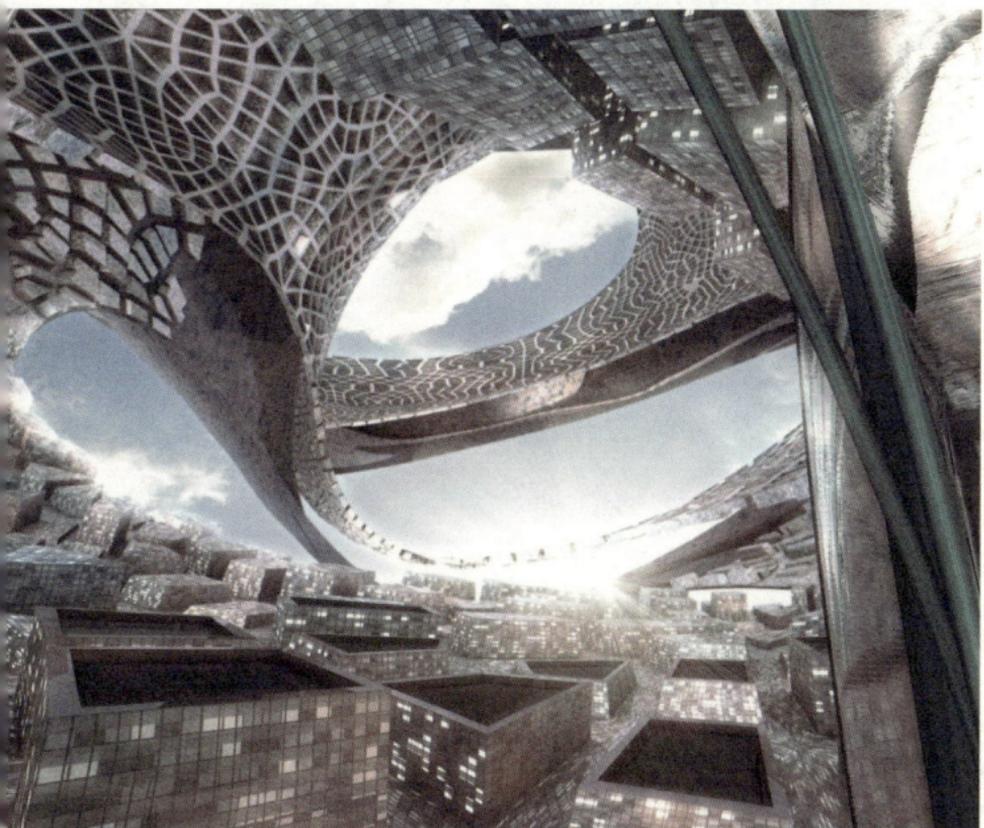

We decided to think of New City as the entire world, so the world is for the first time one connected city with 8 billion addresses, all located in a single virtual destination. It wasn't just about information design and geography; it was about how you'd experience this world.

New City is the first virtual place where architectural investigation can happen. Thinking about what the space of this city would be, we obviously didn't want to work with a flat map. We also didn't want to work with an Earth or a globe. So we thought of New City as a series of manifolds, which are reconfigurable pieces of geometry that can distort, fold through themselves, and connect in ways that they couldn't using a plane or a sphere. We decided to make each of the continents on the earth into one of these manifolds, and then let them move and ebb and flow with different kinds of communication and information.

What you would see if you went to New City is based on what you want to see. It's a series of lenses of information that you can overlay on the space to experience the city in very different ways. From abstract charts and data you can move seamlessly into the three-dimensional space of a virtual city.

Venus Station

Clouds Architecture Office

We were relieved to see it come into view shortly after transferring orbits, the big lump of rock hanging over the soft disc of Venus. As our craft approached the C-Type asteroid we could make out a web of intact cables fanning out to anchor points around the equator of the large rock. At least the support portion of the colony was intact. Our craft completed a series of burns to slow down and match the orbit of the asteroid, where we could park it for the duration of our descent into the thick cloudy atmosphere below. From this closer vantage point we could also see that the autonomous water harvesting system had done its job and extracted a sizable volume of water ice from the surface of the asteroid—most likely they had water down there, another positive sign.

Our mission was an unusual one, a verification mission to document what actually happened to the Aeneas voyage from four decades ago. The original Aeneas mission was comprised of twelve launches altogether: seven of these contained spiral city units, two contained horizontal field units, another pair contained life-support equipment, while the final craft transported a human crew. Ground control had lost contact with this last stage of the mission, the final ship containing several hundred human pioneers who were to move into the previously deployed habitat. About two months into their three month journey, communications went dark, though ground control could still see that the ship was moving along its intended course, seemingly intact.

Four of us looked out from the descent vehicle as we drifted down along the support cable into the thick clouds in hopes of finding the colony intact. After some time travelling

Plans and elevations of Aeneas City spiral tower

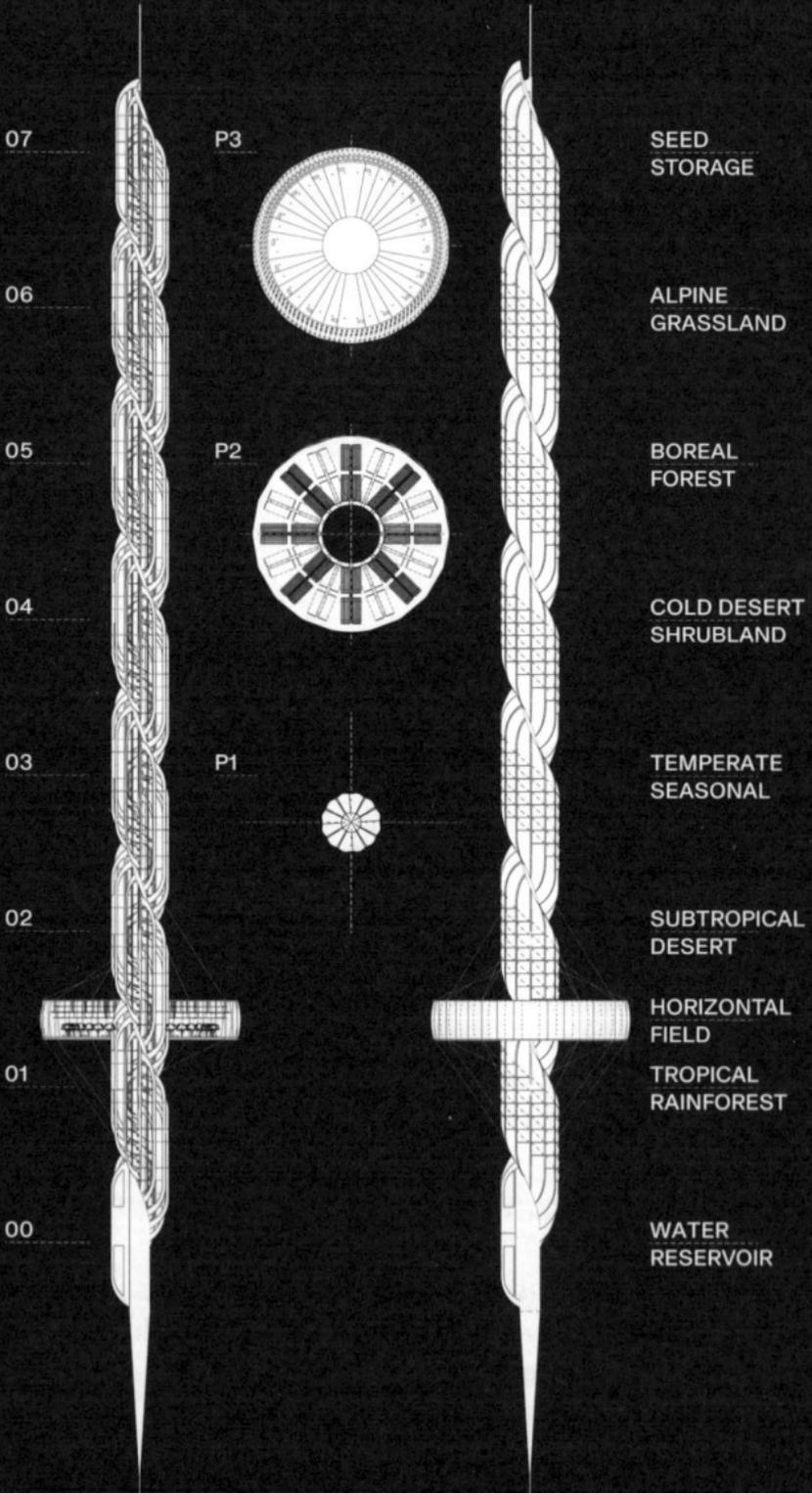

07	P3		SEED STORAGE
06			ALPINE GRASSLAND
05	P2		BOREAL FOREST
04			COLD DESERT SHRUBLAND
03	P1		TEMPERATE SEASONAL
02			SUBTROPICAL DESERT
			HORIZONTAL FIELD
01			TROPICAL RAINFOREST
00			WATER RESERVOIR

through an acid orange haze we passed through thick cloud decks, and in one of the breaks we caught site of the top of the city, a pointy thin mass attached to the cable.

Slowing down we came upon the top of the vertical spiral city, what appeared to be an overgrown ruin with plants of all varieties pushing up against the external mylar boundary layer, foggy with condensation. Conditions on Venus are particularly well suited to growing plants. Positioned closer to the Sun, Venus gets 1.9 times more sunlight than Earth. Its atmosphere is primarily carbon dioxide which plants need for photosynthesis. The atmosphere contains sufficient quantities of nitrogen which can be converted to ammonia-based fertilizer. Its trace amounts of sulfur dioxide can be harvested for use as a preservative. In the thinner higher reaches of the Venusian atmosphere temperatures are colder, which together with sulfur dioxide create ideal seed storage conditions. A suite of machines were deployed to support the city: a pair of machines for catalyzing oxygen out of the atmospheric carbon dioxide, a machine that spins carbon nanotubes from atmospheric carbon dioxide, and a machine for running the Haber/Bosch process to fix atmospheric nitrogen into ammonia fertilizer. The hydrogen required for the Haber/Bosch process was obtained through electrolysis of water from the supporting asteroid, splitting it into hydrogen and oxygen. A fixed amount of water was also transported down the cable to stock a closed loop cycle of water for the city.

The city maintains aspects of its originally intended design, specifically the vertical striation of plant biomes corresponding to the surrounding atmospheric conditions: warmer, higher pressure towards the bottom (suitable for tropical rain forests, etc.) and colder, lower pressure towards the top (suitable for dry Alpine mountain biomes). Seed storage containers are positioned at the very top of the city, while the very bottom of the city is a collection

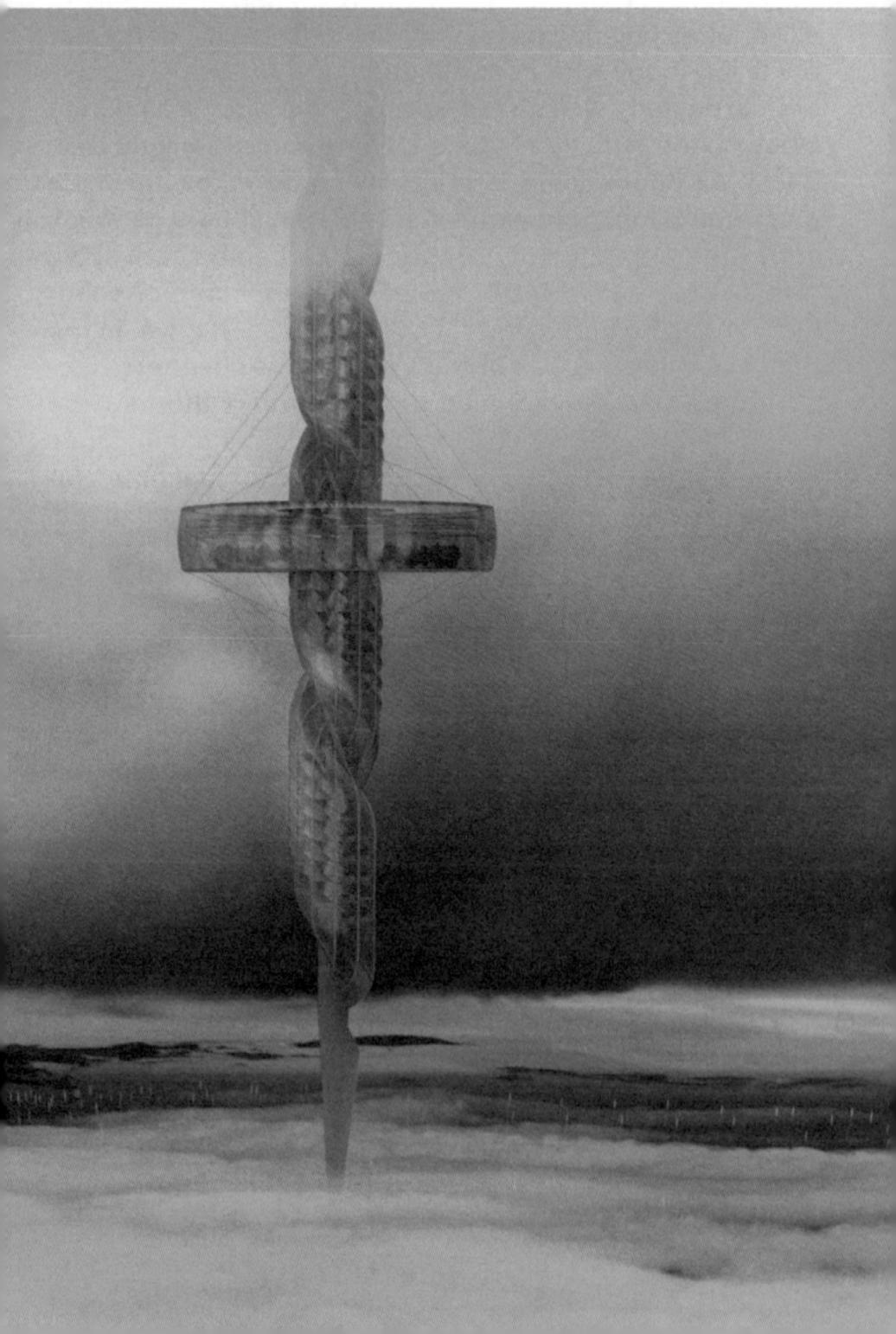

Spiral tower of Aeneas City passes by a peak in the offset pointillist Venusian topography, the horizontal field unit is attached to the second spiral section

reservoir where water drains for filtration and reuse in the closed loop system.

The sole task of the city's remaining inhabitants seems to be a constant struggle to hold back the lush vegetation from choking the city entirely. This consists of pruning plants back from the central cable to which the sun-lines were attached as well as patching the boundary layer where plants had pushed through and ruptured the film. Inhabitants seem to have forgotten the original purpose of their mission, since most of the first wave settlers had passed away without revealing to their descendants that during the three month journey to Venus they had decided to abandon the mission assigned to them. In a fit of isolation-induced frenzy, a small band of astronauts destroyed communication equipment severing links back to Earth as a way to consolidate their control over the city. Instead of carrying out the forgotten mission directive the city inhabitants applied themselves to addressing the oppressive qualities of their new home. Though they had no way of reaching the asteroid supporting them from above, and thus no way to change their orbital path, they were still able to affect their surroundings in other ways. Soon after settling into the vertical spiral tower they came to realize that the featureless cloudscape enwrapping their city was causing them to become depressed. After several incidents of jumpers who plunged to the hot surface 50 km below it was decided to take action and somehow mark their environment, to create features in contrast to the hazy gradient of the persistent cloudscape. Several proposals were considered until they settled on an idea which sought to offset the surface of the planet up to their height. The carbon nanotube machine was retooled to weave cables in a fixed length of 50 km. A weight was fixed to one end and an inflatable buoy to the other. At first they made 396 of these cables, one for each intersection of latitude and longitude reachable from their orbital path. Upon reaching each grid point (example: 10° east / 30° north) they would

People float in chemical-resistant hover suits next to the spiral city, the offset pointillist topography is visible in areas between sulfuric acid clouds

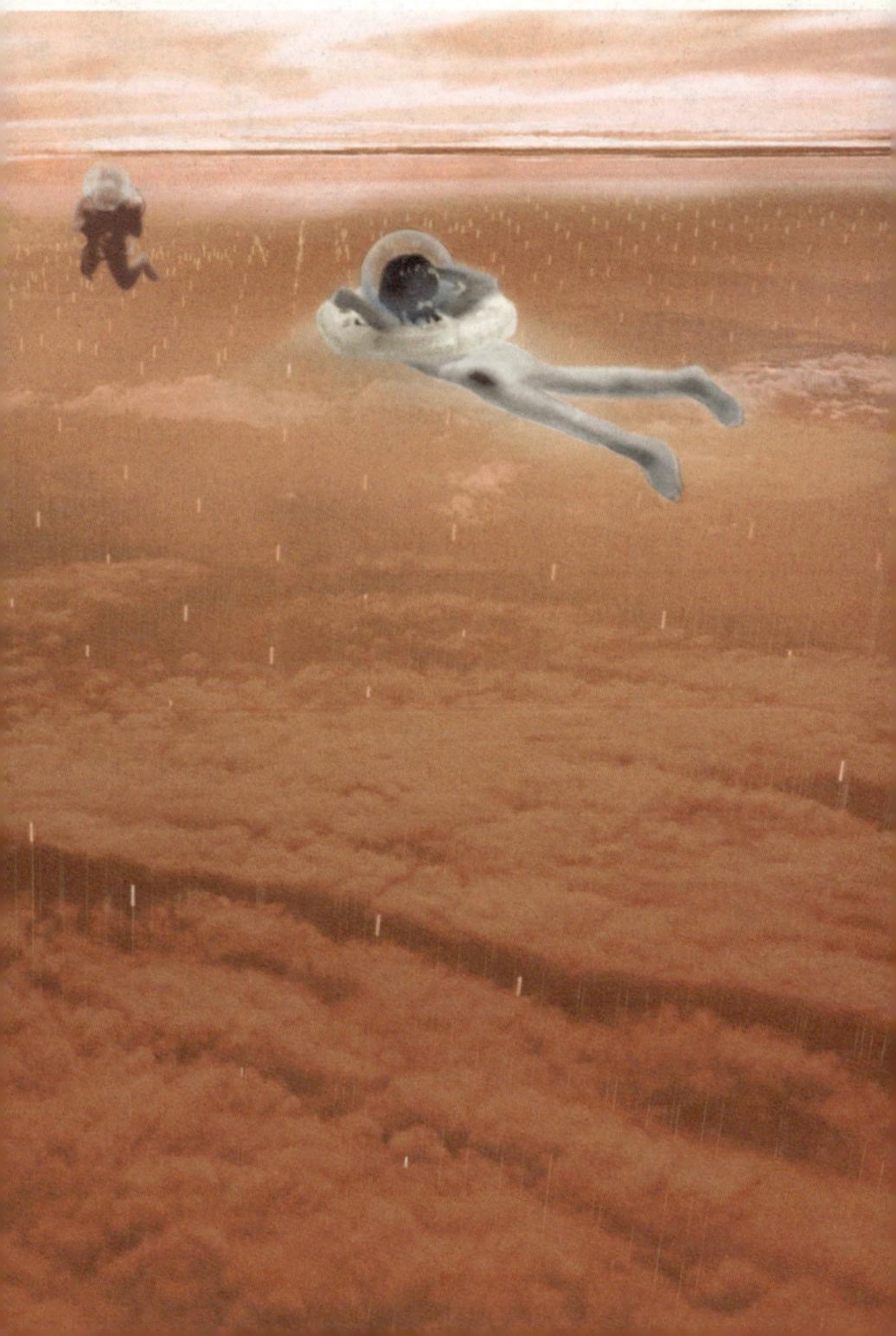

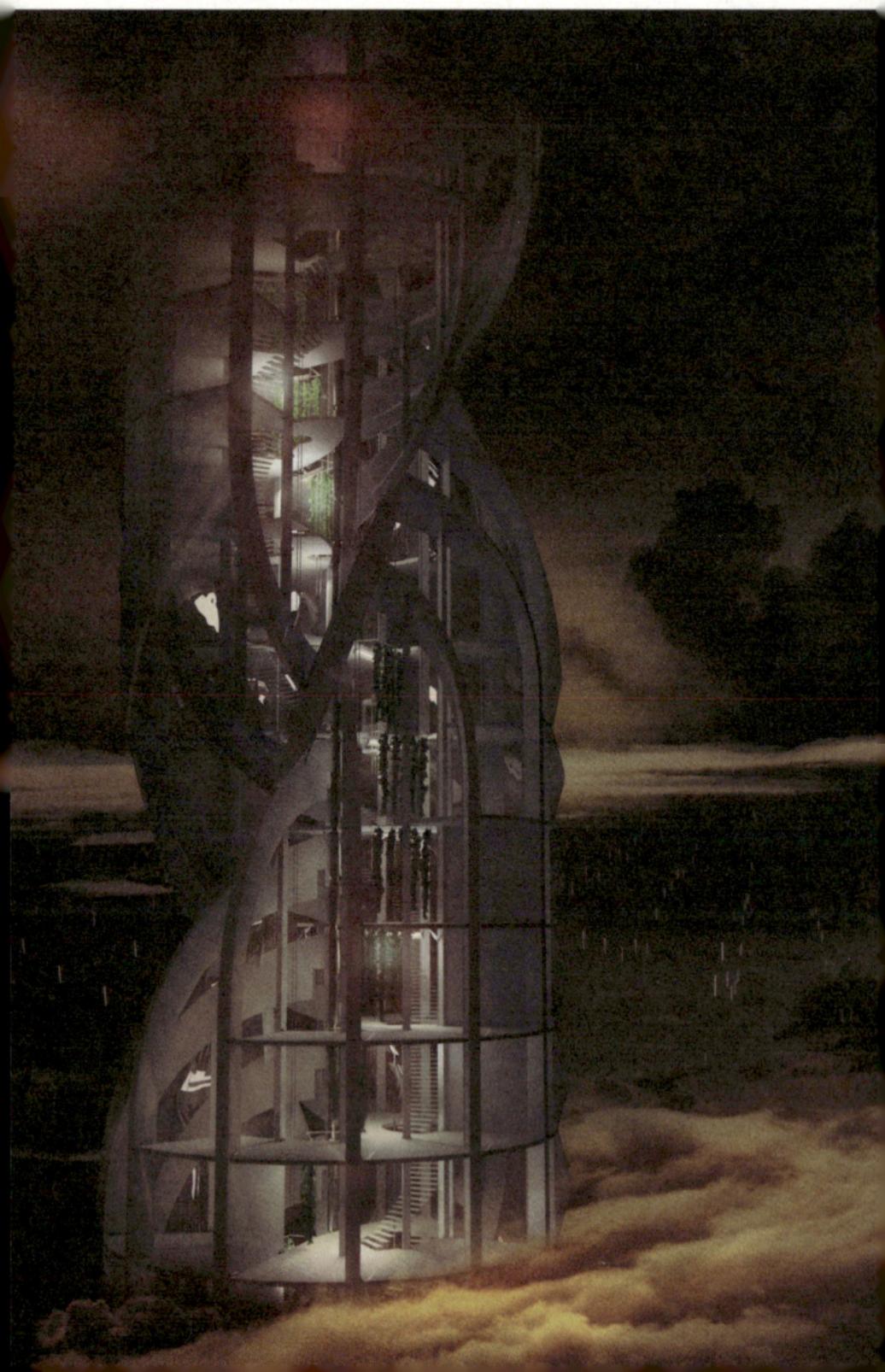
Sunset on Venus as the spiral tower emerges from cloud layers

drop the weighted cable ensuring it unrolled and landed precisely to mark the intersection. Since each cable was fixed to the same 50 km length, the top marker buoy of each cable served as an offset of the surface topography below in effect recreating a pointillist topography of the Venusian terrain. Over time more cables were dropped to increase the resolution of the doppelgänger topography. When their city passed through the endless clouds they now had a landscape to look out onto. Tall peaks were mapped and named, a system of landmarks devised to help orient the swinging and hanging colony.

Overall it appeared that Aeneas City was functioning well despite being cut off from Earth for decades. People seemed to have adapted to their new environment and were already showing signs of slight biological mutations to further acclimate to Venus. Their self-sufficient city is a testament to the persistence of humanity and our quest to survive in the most extreme conditions.

ABOUT AENEAS CITY

The city was originally designed in a vertical arrangement with successive partial levels each rotated 30° in plan, within a spiral configuration, its overall volume defined by a transparent inflatable membrane stretched over carbon fiber ribs clipped onto a vertical cable in the center of the city's interior. This central cable was to extend upwards approximately 30,000 km where it would fan out into a series of four dozen attachment points anchored into the bedrock of a C-type asteroid. This asteroid would be manually placed into an aphrodiocentric orbit allowing the spiral city below to be suspended 50 km above the surface of Venus. The orbital mechanics and masses were calculated to allow a stable orbit with a period of approximately 72 hours approximating Earth's diurnal cycle to support the occupants' natural circadian rhythms. Conditions at 50 km above Venus are remarkably earthlike with an

atmospheric pressure of one atmosphere (14.7 psi which is equivalent to sea level on Earth) and warm temperatures in a manageable range of 25° to 70° C. The air on Venus is made up of 96.5% carbon dioxide, 3.5% nitrogen and trace amounts of sulfur dioxide, argon and water vapor. The clouds are composed of sulfuric acid, so the city's inhabitants would need only wear an insulated chemical suit with respirators to go outside. Since there is no pressure differential tears and leaks would not be catastrophic, with gases diffusing slowly between layers allowing plenty of time for mending the barrier membrane. The exterior of the city would be clad in materials resistant to chemical corrosion such as transparent mylar film and glazed coatings over rigid components.

Each vertical section of the city was designed to house approximately 200 people, deployed from a single 10m × 30m launch payload, its entire structure and cladding manufactured and assembled on Earth. Engineered to expand like a paper fan and unfold like a jackknife, the ribs would clip onto the space fabricated carbon nanotube supporting cable. Housing units ranged from 50m² to 75m² and were arrayed radially along the perimeter of the spiral surrounding a central void space for vertical circulation: a continuous spiral staircase connecting all levels and six small elevators.

Chapter 4

"Currently we have seven billion people on Earth and zero on Mars. I want to make Mars seem possible, make it seem as though it's something that we can do in our lifetimes. But why go there in the first place? I believe there are really two fundamental paths along which history is going to bifurcate: One path is that we stay on Earth forever but eventually face extinction. The alternative is to become a space-faring civilization and a multi-planet species."

Elon Musk
Based on Elon Musk's presentation at the 67th International Astronautical Congress in Guadalajara, Mexico on 27th September, 2016.

Mars and Beyond

The Martian

Andy Weir

CHAPTER 1

LOG ENTRY: SOL 6

I'm pretty much fucked.

That's my considered opinion.

Fucked.

Six days into what should be the greatest month of my life, and it's turned into a nightmare.

I don't even know who'll read this. I guess someone will find it eventually. Maybe a hundred years from now.

For the record… I didn't die on Sol 6. Certainly the rest of the crew thought I did, and I can't blame them. Maybe there'll be a day of national mourning for me, and my Wikipedia page will say "Mark Watney is the only human being to have died on Mars."

And it'll be right, probably. 'Cause I'll surely die here. Just not on Sol 6 when everyone thinks I did.

Let's see… where do I begin?

Pale Blue Dot.
Home Sweet Home

Ulrich Köhler

Flee; flee from here quickly, away from planet Earth. It's high time—because we only have another two, three, or maybe four billion years left at most. Then things will get uncomfortable! Our life-giving Sun will expand, becoming a death star as its fuel, hydrogen, is gradually used up and converted into helium. In its final days, the hot, bright ball of gas at the center of our planetary system will grow and grow so much that first tiny Mercury, then Venus—our sister planet, already heated to an unbearable 500 degrees Celsius by a tremendous greenhouse effect—will vanish into the fiery, swirling outermost layers of gas.

This does not bode well for Earth, which by then will be following a tight orbit above the glowing hot plasma of the corona surrounding the Sun. Its oceans will begin to boil and all water will evaporate. The polar ice caps will have long been gone by this point. And as for life, it will no longer be possible on this once beautiful planet, celebrated in Carl Sagan's wonderful book *Pale Blue Dot*.

So we have to leave this planet, whatever the cost—and sooner rather than later. Or at least we need to start planning now. So says Stephen Hawking, the renowned astrophysicist from Cambridge.

But, where to?

Mars? Or... even further?

Mars sounds good, although it won't be of much use—that much we already know. Basically, in the last 400 years, we

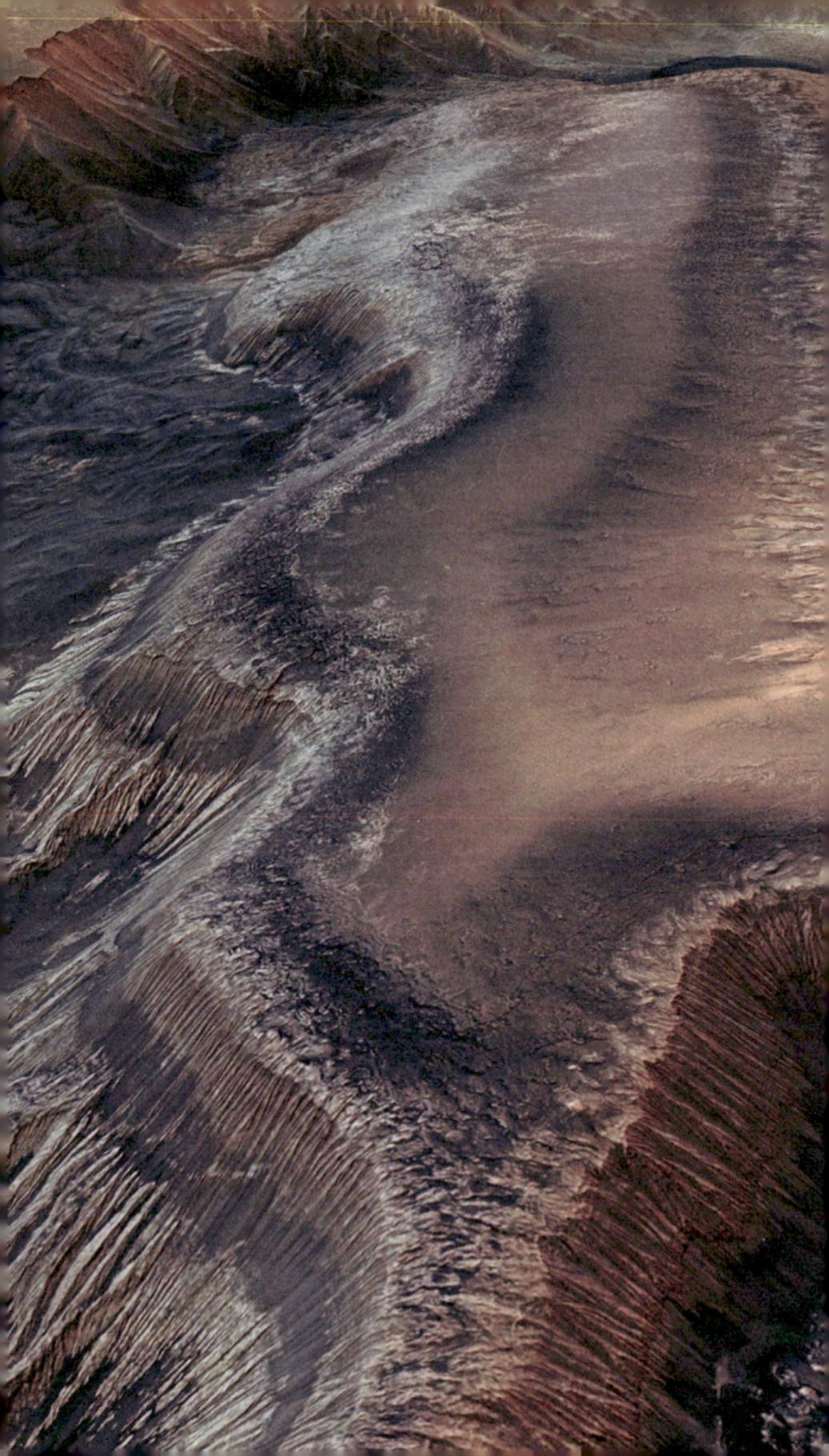

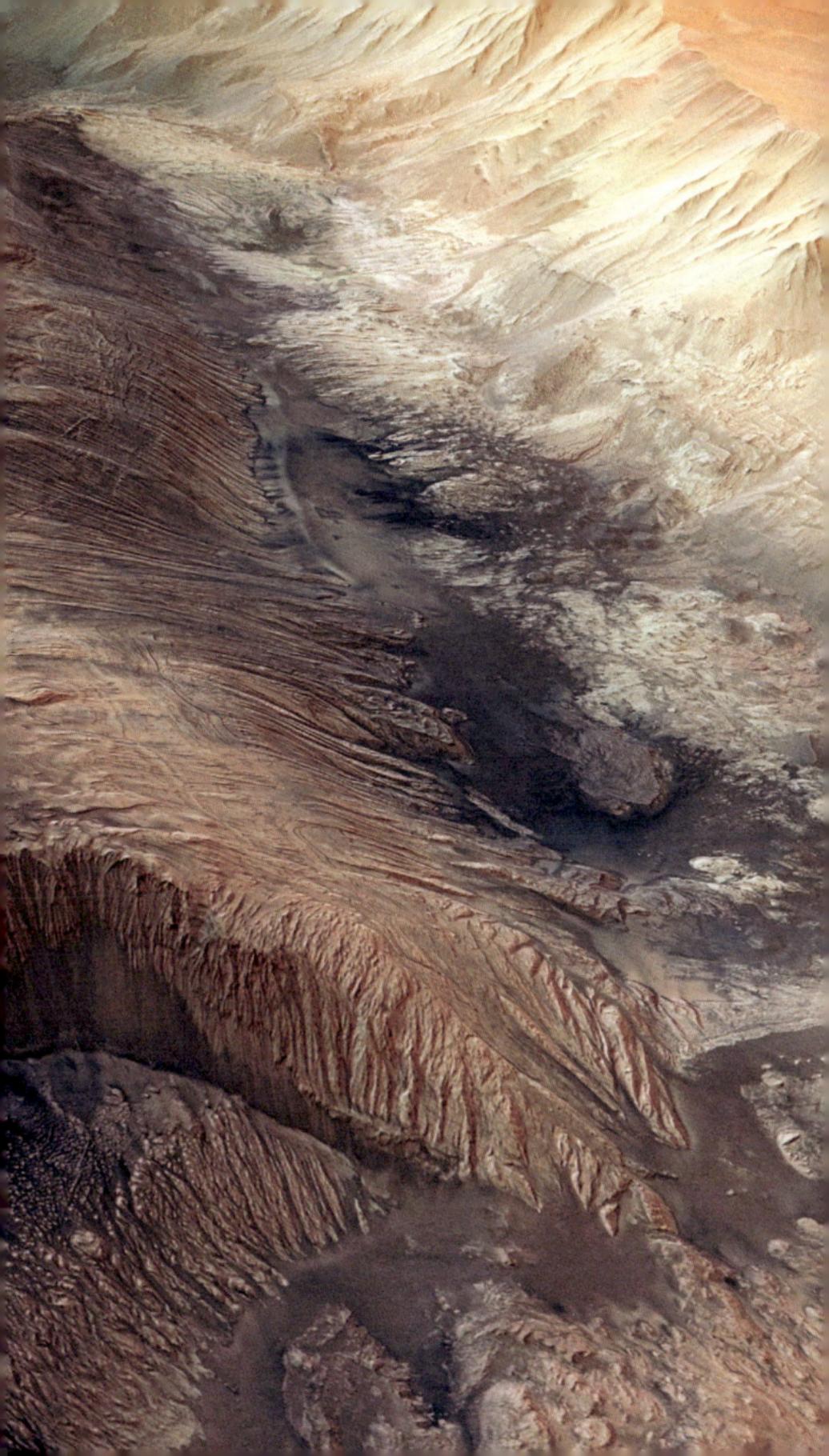

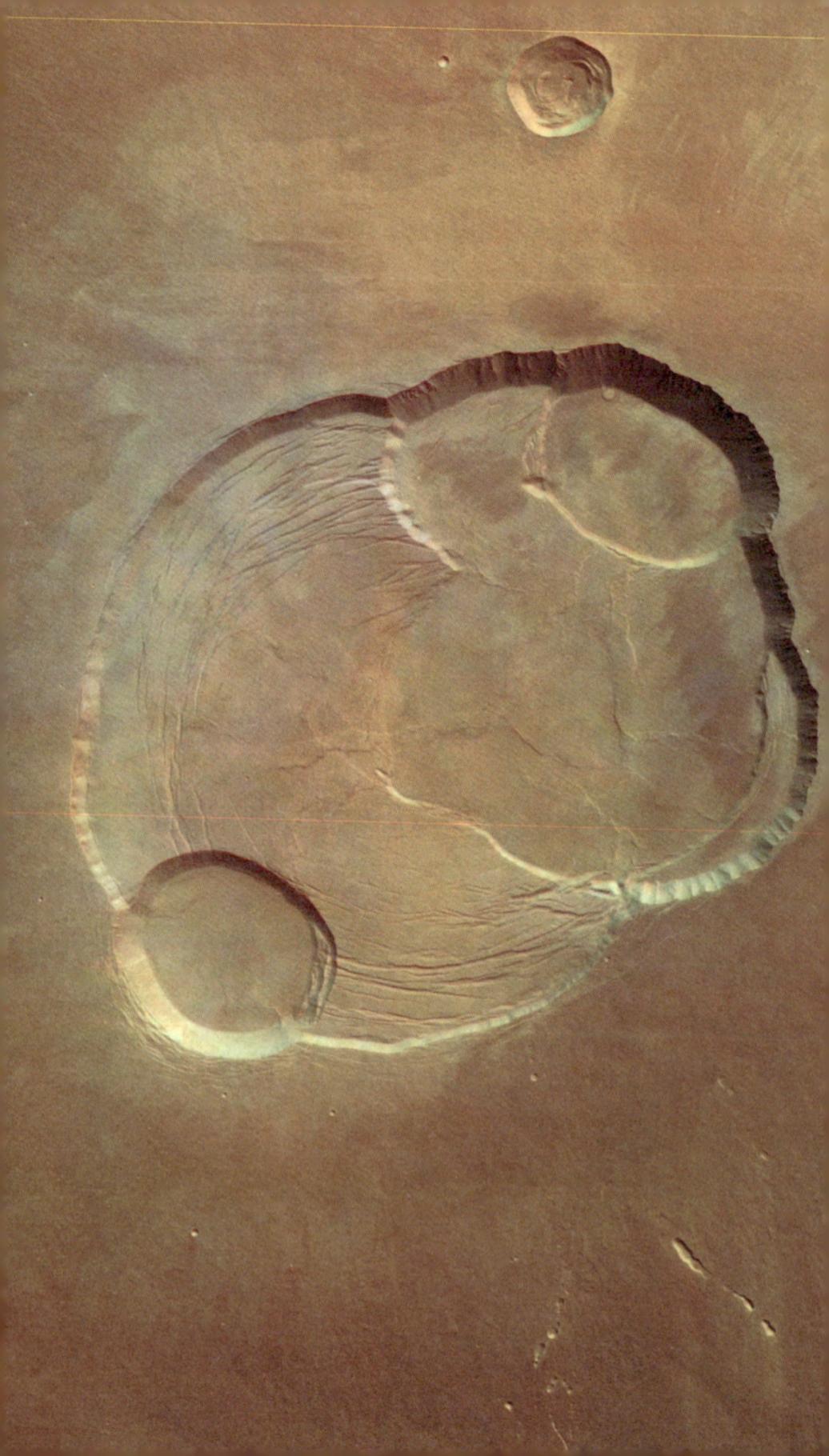

have managed to take stock of our place in the Universe: first by using more and more powerful telescopes, then, for slightly more than half a century, by sending small robotic probes out into space. First to the Moon, then to our neighbours Venus and Mars, and finally to the furthest reaches of the Solar System—a planetary system based on the universal law of gravitation (universal in the truest sense of the word) and that a certain Sir Isaac Newton summarized in a mathematical formula some time ago.

Newton's law simply states, firstly, that all matter exerts a mutual force on all other matter and, secondly, that a large mass has a greater attractive force than a small one. This is why the planets orbit the Sun—where almost all of mass is now concentrated in this bubble of material formed from the remains of stellar explosions more than four and a half billion years ago—and it is also why Moons in turn orbit planets. The fact that they do not fall into the Sun, despite the attractive force of its two quadrilliard ton mass, is the result of the angular momentum these small worlds of rock, ice and gas acquired when they formed in the gigantic disc of dust and gas rotating around the young Sun.

Starting from the Sun, there are five spheres of rock and ice (we are making an exception by including the Moon in this planetary family because it is a permanent and similarly formed companion of Earth). Next is a terrifying, apparently random section full of rocky debris—the asteroids, a rather chaotic zone partially brought under control by the nearest and most massive planet, Jupiter. We earthly beings, who are today thinking about the next place to call home, have this giant of gas with (presumably) some rock and ice in its interior to thank for our existence. Its gravity ensures that the "sky only rarely falls on our heads" and that a bullseye by one of these boulders, which can be up to several hundred kilometers wide, does not bring about our doomsday (which is what the Gauls were terrified of 2000 years ago! And not without reason, as the thousands of

circular craters on the Moon and many a hole down here are solid proof that asteroids struck Earth. Just ask T. Rex's family!).

But let's not talk about the extinction of the dinosaurs; let's look to the future. What about life on Jupiter? No way! It's a poisonous sphere of gas with a gravitational force that would crush us and with not a single homely place to offer. But wait! Jupiter has more than 50 Moons, four of which are as big as ours. These worlds are, as Mr. Spock would say, *"fascinating."* But unsuitable for life as we know it. They have no atmosphere to provide us with air to breathe. Instead, they have an icy crust much colder than the coldest regions of Siberia in winter.

Under their icy crusts, two of these Moons—known as Europa (how promising!) and Ganymede (thus reminding us of the frivolous instincts of the Father of the Gods, Zeus), harbour a massive, deep ocean with—*surprise!*—warm, mineral-rich water. If anywhere, that is where life would exist, or would have existed. Only very simple life, but at least everything required for life is there—water, volcanic heat, mineral nutrients. Researchers are still scratching their heads about this. Meanwhile, in these depths, it is total pitch black—so it's not the sort of place that humanity might migrate to—even though we might have seen something of the sort at the cinema in a James Bond film.

The rest of our planetary options can be quickly covered. Beyond Jupiter are another three very big icy worlds of gas. They also bear mythological names from the Greco-Roman pantheon of antiquity. Saturn (who—can you imagine?—ate his child! There are few paintings that exude as much fearsome savagery as Francisco Goya's grim work in the Museo del Prado in Madrid, which shows this god of prosperity and crops devouring one of his children). Uranus (the primordial ruler of the sky who, for whatever reason, hated his numerous descendants so much that he

hid them in the Underworld before Gaia, the Earth Mother, decided to have him castrated with a sickle). And finally Neptune (god of flowing water and the seas—a rather kind old man who at least sported a trident).

These three planets most certainly are not a haven for life either. Neither are their Moons, even though the largest of them, Titan, like Earth, has a thick but cold atmosphere, somehow similar to Earth's. It even rains on this Saturnian Moon, and there are lakes and rivers. What flows in them, however, is not water, but methane and other poisonous substances that are only liquid at these unspeakably cold temperatures. It is too unbearably cold here for oceans and any form of life.

To conclude our preliminary expedition on the hunt for a second utopia, we need to make a final loop back and visit the outsider, Pluto, demoted from the category of planet to dwarf planet by "old, white-bearded men." When we measure its temperature, we can see that it's not much above absolute zero, the point at which the last molecule and the last atom stop vibrating.

We are now five, six, seven billion kilometers from the Sun (around which Pluto has a very elliptical orbit). This is a distance of some six or seven light hours. So how about quickly passing through the cloud of comets surrounding the Solar System and (theoretically) venturing on a trip to the nearest star system—a double star? Alpha Centauri and Proxima Centauri are the names of these stars, "just" four light years away. Only there are an awful lot of light hours in a light year! Space is damn big, and it starts right on our doorstep. It's a bit like "neighbouring" farms in the Canadian prairies. If the nearest star is an unimaginable 4.2 light years away—that is an astounding four times 365 days times 24 hours times 60 minutes times 60 seconds times 300,000 kilometers—the distance that light travels in one second. If you follow me, you'll get an idea of the

distance because there is a calculator on your mobile phone—and it will be displaying a very long number: about 40 trillion kilometers.

After completing their missions, *Voyager 1* and *Voyager 2*, two space probes launched to explore the outer Solar System, carried on flying out of the Solar System and into the depths of space. Today they are between 20 and 22 billion kilometers from the Sun. And they are travelling even further away, at around 50,000 kilometers per hour. If they were on course for Alpha Centauri (use your calculator app to help again), it would take them about 90,000 years to get there. And whether or not stellar neighbours are hospitable to life—that is, whether or not they have planets—is an entirely different story. It is an issue in this Universe—the story of space and time.

Coming back to our cosy Earth from this imaginary journey, we may soberly take stock: if anywhere, it has to be Mars. That has not changed. Anything else is nonsense.

So why not? Earth's outer neighbour is solid, still has a little water—albeit in the form of ice—and an atmosphere that, yes, is composed of gases that differ from the fresh air that helps us wake up when we open the window in the morning. And, most of all, Mars is at best a ludicrous 60 million kilometers away from us. Three and a half light minutes—radio traffic almost in real time. A stone's throw away in cosmic terms.

For years and years, visionaries have been saying, "So what? Let's colonize this pleasant planetary neighbour!" But, first of all, Mars would need to become a grandiose tourist attraction for the billionaires here on Earth in the coming centuries (St. Tropez is a bore anyway, n'est-ce-pas?). And as we said at the outset, in the long run there's no way around it.

Only I am afraid that nothing will come of this.

And so it might be helpful to drop in a couple of uncomfortable truths.

First: no human being has ever been to Mars. This will happen fairly soon, though. Here on Earth, we will receive images that greatly remind us of the heroes of my childhood—the Neil Armstrongs, Buzz Aldrins, and Gene Cernans of the Apollo era (and, of course, the list must include the great first Shuttle pilots, John Young, and Dave Scott!). That was a time in which some people were prepared to take mad risks to fly to the Moon, to spend just a few hours or days in a very hostile environment—just to show "someone" (the Soviet Union) that the free Western world could do it. They accomplished it wearing suits with a helmet and visor, bringing along air to breathe, and concentrated orange juice that Commander John Young, Apollo XVI, absolutely refused to drink: "We got wind like a buffalo," he said to us as students, with a grin, at a BBQ at his modest house near Houston, as can be read in the once inaccessible NASA documentation of radio communications.

It will be hardly any different on Mars: air from a can (the orange-juice problem should be controlled...), freeze-dried food and drink. Add to that the invisible cosmic radiation that will cause our future heroes to seek protection under the red soil—in caves or dug-in habitats—most of the time to avoid damaging their genetic material or developing cancer. Although the pioneers will have major problems to deal with, they are all solvable. But above all, they will be happy to return to Earth, after at least two years—if only to be able to bite into a fresh, crisp apple.

Second: what was just described will happen, because humankind has gone everywhere—the North Pole, the South Pole, the summit of Mount Everest, down to the

depths of the Mariana Trench and out to the Moon. The visionaries of a Martian settlement have big plans: huge, reusable spaceships, transporting hundreds of passengers, shuttle flights, the slow but accelerating development of a permanent colony on Mars. This is where scepticism comes in, in my opinion, even though history teaches us that progress moves forward at an exponential rate. The whole venture is orders of magnitude greater to build than expensive electric cars. The Moon is "right on our doorstep;" however, in an ideal configuration, Mars is 150 times further away, and sometimes a whopping 1000 times further away! A biosphere on Mars? It's not impossible, but describing it as "very expensive" is rather inappropriate. There is water, if only in modest amounts. Rocket fuel, made of hydrogen and oxygen, could be literally drilled from the rocks—in theory. Nobody has done it, and anyone who knows what a coarse, dirty, heavy-duty mechanical business mining on Earth is will frown at the thought. Occasionally, a heavy wrench is necessary to hit a seized-up component with brute force so that the stone in the works can be freed. Has this "housekeeping" role been considered in the visionaries' plan—a Hercules of the 25th century?

Despite all the possibilities, it's an extremely inhospitable environment, and nothing can be done about it. During night on Mars, the temperature drops to as low as minus 80—and even lower at the poles. Warming the planet via an artificially induced greenhouse effect (at least we can demonstrate what we have "learnt" on Earth!) and creating a thicker atmosphere from which rain falls and water feeds rivers and fills lakes (and water that would not immediately evaporate, as it does today) is all in the realms of fantasy and is as far removed from a realizable vision as, well, Mars is from Earth. The same applies to notions of using rotating masses of iron around the 20,000 kilometer long equator to generate an artificial, protective magnetic field. Impossible. Full stop.

Third—and this is the key issue: the evacuation of the global population to Mars due to the threatening demise of our blue-green living planet. How many "people" will inhabit Earth in two or three billion years? Ten billion? More? Or fewer, because in the meantime some "unfortunate" event has occurred that has decimated humanity? Will there still be an "us"? Darwin's theory of evolution shows that changes in biological diversity on Earth—be it plants or animals, and thus people—happen quite quickly. I wouldn't put any money on betting that there will still be any farmers or agriculturers (or for that matter, football players). Would there still be humans at all?

And lastly: we Germans are well prepared, planned and organized—for everything. This is sometimes annoying in creative discourse, but a question remains that must still be asked of all beautiful "visions": Mars has the same surface area as all of Earth's continents combined. So up there, things will be a bit "cosy." The logistical effort seems unimaginable. Never mind that every single inhabitant of Earth will want or need to go on the journey, or at least, a great majority of them. Will that even be possible using spaceflight? I cannot see it. Can Mars accommodate billions of humans, offer the necessary resources, and provide everyone with a plot of land with a little front garden? I just cannot see it, and right now we do know the planet well enough. Harvesting a few hundred kilograms of potatoes like Mark Watney did in the (very realistic) film *The Martian* should not be a problem. But hundreds of thousands of tons, including proteins and vitamins and, on holidays, some hops and malt for the microbrewery The Red Planet, that's popular with established residents? My imagination cannot stretch that far.

But I digress, because the most difficult question has not yet been posed: who will be on board the Mayflower II on the long journey across the cosmic Atlantic Ocean? Not all earthlings—the capabilities for doing so will not exist.

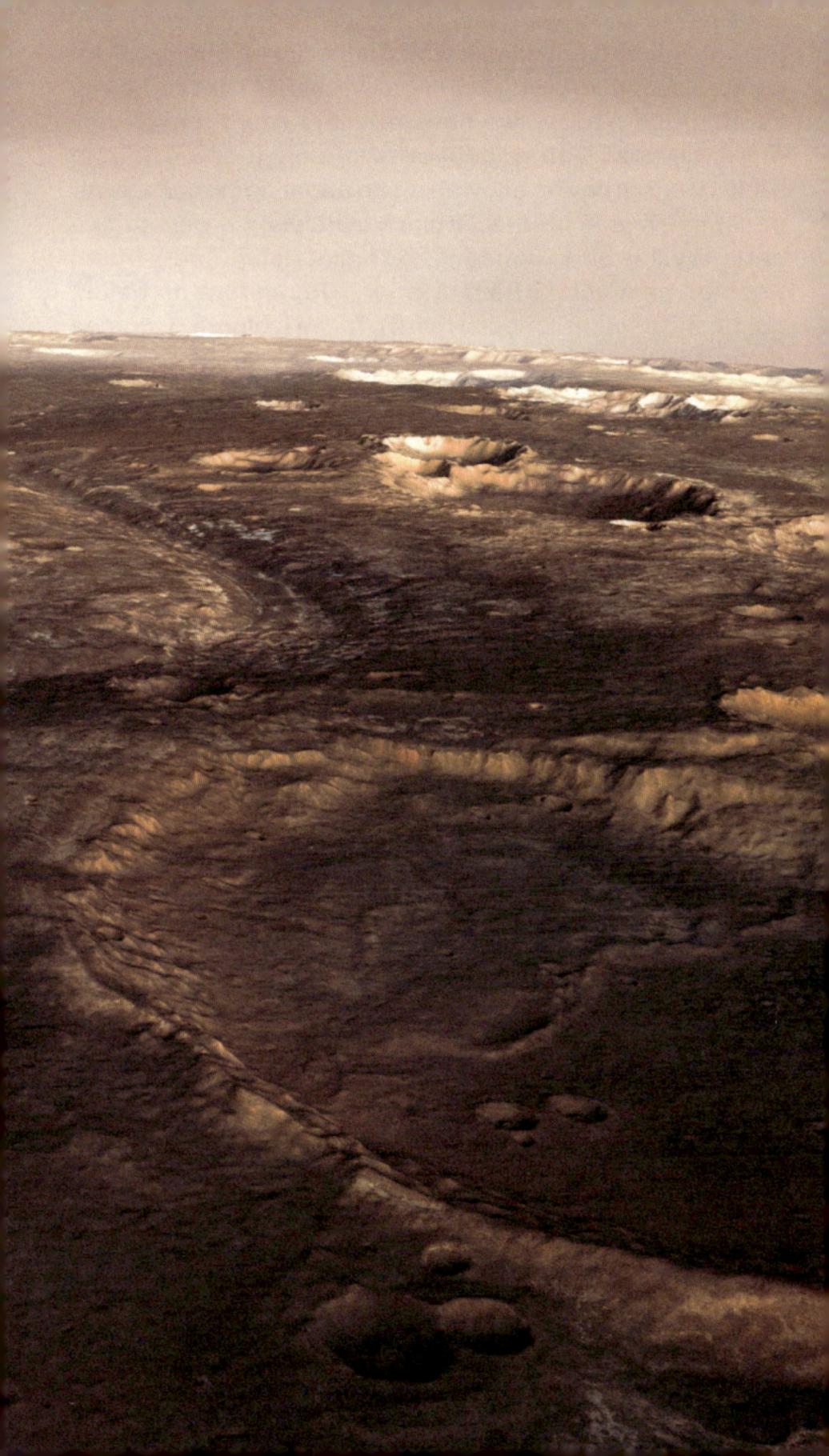

So who ultimately decides who gets a ticket, and how? An equitable, peace-loving world government? That also says: "Well, good people, we have no more room for you any more, farewell and goodbye!" Will only those who can afford the journey be allowed on an upper deck and a lower deck, like it was on the Titanic? Who will be part of this crew? Will it be Europeans, or more Asian and African people? Skin color? Rich or poor? Dependent on belief, political affiliation or social merit? To put it bluntly: it comes down to survival on Mars or death on Earth. This is a thought I do not want to dwell on as it leads to an unspeakable outcome.

Put even more bluntly—will we have a selection ramp? Where those on the left live and those on the right are left to die?

So, with great disillusionment, we must conclude that fleeing to Mars because in three billion years we will all be sunburnt and have nothing to drink in the fridge is not really an option. All the more so because, when the Sun has consumed its last reserves of hydrogen, the lights will go out on Mars as well.

So, ultimately, we will have to look far beyond the parapet towards the horizon. Will we make our way out into the galaxy and perhaps find a new home there? The discovery of seven Earth-like planets around Trappist 1, a small star just 40 light years away (that will continue emitting light for many billions of years) awakens the hope that we might indeed be able to traverse the depths of space—like in a revamped Noah's Ark—to secure our future existence.

But be sceptical. Even though the father of rocketry, Konstantin Eduardovich Tsiolkovsky, rightly predicted in 1928 that, "It's true that Earth is the cradle of humanity, but mankind cannot stay in the cradle forever," we must once more pour cold water on the visions of humans

departing Earth. Or is it common-sense to imagine that we will ever be capable of building huge space cruisers that can reach the speed of at least one tenth of the speed of light (then it would only take four or five years to get to Trappist 1), and that this could happen with the necessary armada of thousands of human freighters? Dear reader, I leave the answer to you.

At this point, on a mundane note, an altogether unvisionary but substantial (and perhaps very Teutonic) argument might be brought into the debate: what would all this cost? If it is about life and death, it may cost "the Earth." But if we just look at the fairly harmless present, we can see that bringing together the necessary, but nevertheless available, means for humankind's first giant leap to Mars is anything but easy. For now, all we can say is: visionaries have dreams. And we do not want to take your dreams away.

So what do we do?

Sure, there will be better, less expensive rocket engines someday. We can use them to fly to Mars— in this century, if nothing horrible happens. And hopefully we will be in a position to say to the first people on Mars, that we will return them safely to Earth, as US President John F. Kennedy said in 1962 on occasion of his "vision" of the Moon Landing. There will presumably be basic Mars habitats. But large colonies? I personally do not believe so (granted, "belief" falls into the same category as "visions").

Here is a useful suggestion: let us stay here for now and put all our innovative energy into a few large-scale expeditions into the rich kingdom of the Solar System—return to the Moon, visit Mars and a couple of asteroids. Perhaps at least touch down on the Moons of Jupiter. Hey, that's plenty of "vision!" Why go through all the trouble? With its intuition and imagination, humankind will continue to be superior to any robot in the foreseeable future and these expeditions

do not "cost the Earth." But one thing is for sure: we will return to this blue jewel with new knowledge, every single time. If we don't let that happen, we will be letting down pioneers like Alexander von Humboldt. Ultimately, all astronauts have been fascinated—even overwhelmed—by the view of Earth from space, by what a fantastically beautiful, inhabited oasis it is in the apparently endless black desert expanse of the cosmos. With all the ingenuity inherent in humanity, is it not an interesting vision to make this planet a bit—no, not a bit, a lot—more worth living on? With the knowledge gained from exploring other planets?

Home sweet home—planet Earth! Yes, of course we can take a quick look over the fence into our neighbour's garden, pick a couple of cherries and nibble on them. But let's face reality: we will continue to live here for the time being.

Destination Mars.

Exploring Martian Speculations, Aspirations, and Imaginations

Lukas Feireiss

"The Earth is the cradle of humanity, but mankind cannot stay in the cradle forever."

Konstantin Tsiolkovsky

The vision of colonizing our neighboring planet Mars has long been more than a mere fantasy. Technical developments have progressed so far that the American space agency NASA and private spaceflight companies have set their sights on the red planet and are eagerly promoting its settlement. Mars fever is rampant. And although many puzzles remain to be solved, our visions of Mars have long since become reflections of earthly hopes and fears. But how do politics, science, literature and film convey this vision and stimulate our imagination?

FROM MOON TO MARS

For centuries mankind has been fascinated by space travel and exploring other planets. Today this ultimate flight of fancy for the human imagination—of reaching nearby planets—is technologically possible. Almost half a century ago, men had already walked on the surface of the Moon. Yet to support the creation of a permanent, self-sustaining human presence on another planet, many long-term technical challenges still need to be solved. Nonetheless, imagining humans as a multiplanetary species is not a mere fantasy anymore.

During the golden age of space travel in the mid-20th century, the Moon—our nearest astronomical neighbor—served as the primary testing ground for ideas about space travel, ultimately culminating in the feat of landing men on the Moon. The importance of these lunar explorations was largely neglected in the following decades but now, at the beginning of the 21st century, it's another celestial body that stirs our imagination: Mars. This terrestrial planet—a rocky body about half the size of Earth—has clearly taken the top spot away from Earth's natural satellite, the Moon, filling its place in the popular imagination. Reaching Mars within our lifetime now seems possible. "Mars has become a kind of mythic arena onto which we have projected our earthly hopes and fears," said astronomer, cosmologist

and popular scientist Carl Sagan, who even recorded a message dedicated to future explorers and settlers of Mars, a few months before he died in 2012.

MARTIAN ASPIRATIONS

Significant events regarding mankind's Martian ambitions are currently underway. On September 27, 2016 at the 67th International Astronautical Congress in Guadalajara, Mexico, Elon Musk—chief executive of SpaceX and co-founder of PayPal and Tesla—shared his vision of colonizing Mars within the next decade by sending humans there with methane-fueled reusable spaceships and the largest rocket ever built. Only a week later, on October 5, Boeing CEO Dennis Muilenburg took on the challenge and declared at

the "What's Next?" tech conference in Chicago that "the first person to set foot on Mars will arrive there riding a Boeing rocket." Then on October 11, US President Barack Obama fittingly delivered a speech about the future of space exploration that was reminiscent of John F. Kennedy's historic "We choose to go to the Moon" speech which kick-started NASA's Apollo program in 1962. Speaking at Kennedy Space Center in Cape Canaveral, Florida, Obama proclaimed that "sending humans to Mars by the 2030s" is "a clear goal vital to the next chapter of America's story in space." At the same time the European Space Agency (ESA) and Russia's Roscosmos had the stationary lander Schiaparelli scheduled to touch down on Mars on October 19, to search for past and present Martian life and habitability on the planet. Even though this mission failed, these episodes merely mark the beginning.

WATER ON MARS

Named after the Roman god of war, the red planet—which was regarded as a symbol for destruction and aggression across different cultures for thousands of years—still holds many mysteries to be solved. Chief among them is indeed whether Mars, with its seasons, polar ice caps, volcanoes, canyons and weather, ever had the right conditions to support advanced life forms. Scientists believe that Mars experienced huge floods about 3.5 billion years ago. Though it is still unknown where the ancient floodwater came from, how long it lasted or where it went, numerous missions to Mars—from NASA's Mars Odyssey orbiter to the Mars Exploration Rover mission, with Spirit and its twin Opportunity—have uncovered intriguing hints. Most recently, NASA's Curiosity rover has even revealed groundbreaking details about actual flowing saltwater on the surface of Mars, which caused downright hysteria about the planet. Unraveling the story of water on Mars is so important because it could unlock the planet's climate history and would actually help us to understand the very

evolution of all planets, since water is an essential ingredient for life as we know it.

MARS FEVER

Speculation over Mars's habitability, and indeed its potential for carrying water, is, however, far from a contemporary phenomenon. It has its roots in the late 19th century, long before humankind ever made it close to the planet. In 1877, the Italian astronomer Giovanni Schiaparelli—after whom Europe's current stationary lander and planed rover are named—unintentionally incited an enduring kind of Mars craze by observing deep trenches meandering across the planet's surface in a dense network that he called "canali." Schiaparelli's "canali," however, went completely viral because of a simple mistranslation. Instead of its literal meaning of marks or grooves, "canali" in English became "canals" suggestive of water, life, and intelligent intervention in the Martian landscape. Inspired by Schiaparelli's telescopic observations, books on the subject by American businessman, author, mathematician, and astronomer Percival Lowell further fueled speculation that there were canals on Mars and popularized the long-held belief that these markings showed that Mars sustained intelligent forms of life. Moreover, the books put forward the notion of Mars as a drying, cooling, dying world with surviving ancient civilizations constructing irrigation works. Many other observations and proclamations by notable personalities of the time added to what has been termed "Mars Fever." Even the ingenious Serbian-American inventor, physicist and futurist Nikola Tesla believed that Mars was inhabited by an intelligent civilization. After observing signals in 1899 that he thought were coming from Mars (while investigating atmospheric radio noise in his Colorado Springs lab), Tesla spent the next 50 years of his life trying to find a way to communicate with our planetary neighbor. In 1901 an article in the *New York Times* by Edward Charles Pickering, director of the Harvard College

Observatory, seemed to confirm that Mars was trying to communicate with Earth.

Despite the fact that communication attempts from Mars were never proven and scientists and astronomers concluded that the famous channels were actually mere optical illusions, speculation and folklore about the possibility of intelligent life on Mars remained entrenched in the public mind for the first half of the 20th century, inspiring a corpus of works of classic science fiction whose influence can be traced in very different forms in popular culture.

MARS ATTACKS

Among the first of the many fictional explorations amid the turn of the century hype around Mars was the 1897 science fiction novel *The War of the Worlds* by English author H. G. Wells, about a Martian invasion of Earth. It remains one of the most commented on works in the science fiction canon. Famously adapted in 1938 by Orson Welles as a Halloween radio play with simulated on-the-scene radio reports about aliens advancing on New York City to enliven the story, the broadcast notoriously caused a mass panic when many listeners mistook it for the truth. The first of four film adaptations was released in 1953 and went on to influence other science fiction films. The latest in the series of cinematic adaptations of the H. G. Wells story was Steven Spielberg's 2005 film with Tom Cruise as the lead actor. H. G. Wells' *The War of the Worlds* surely set the standard for representing Mars as being populated by malevolent aliens bent on fighting humans. One such example is the science-fiction-themed trading card series *Mars Attacks*, first released in 1962, that was later adapted by Tim Burton in his 1996 comedy science fiction film of the same name. Both tell of the invasion of Earth by cruel, hideous Martians. Beyond the idea of the ill-willed Martian, the serialized stories around the heroic adventurer John Carter of Mars, which first appeared in 1912 and were written by the

American novelist and creator of jungle hero Tarzan, Edgar Rice Burroughs, also constitute a prominent Martian adventure from the first half of the 20th century. It was adapted as a feature film in 2012, marking the 100th anniversary of the character's first appearance. In 1948, another significantly less sinister Martian was introduced by Warner Bros. in their *Looney Tunes* series, with Marvin the Martian, a childlike adversary to Bugs Bunny, who has continued to the present as part of popular culture.

MARS COLONIZATION

The fascination with Mars in popular culture continued unabated in the following years and extended to the idea of human colonization of the red planet. Among the many publications on the subject during this period, two in particular stand out for me: *The Martian Chronicles* by Ray Bradbury and *We Can Remember It for You Wholesale* by Philip K. Dick.

In *The Martian Chronicles*, a collection of loosely woven stories published in 1950, Bradbury imagined the colonization of Mars by mankind fleeing from a troubled Earth that is ultimately ravaged by atomic devastation. Punctuated by two catastrophes—the near extinction of the Martians by chicken pox, apparently acquired from one of the human expeditions on Mars, and the parallel near-extinction of the human race—the narrative also chronicles the conflict between aboriginal Martians and the new colonists. In the fourth chapter, entitled "And the Moon Be Still as Bright," Jeff Spender, the crew archeologist, is humbled by the great Martian civilization and troubled by mankind's intentions and interests in the colonization of Mars. He sarcastically comments on the death of almost all the Martian race: "We earth men have a talent for ruining big, beautiful things."

Equally dark in his visions of the future, Philip K. Dick

explores philosophical, sociological and political themes in his typical manner in the influential 1966 short story *We Can Remember It for You Wholesale*. Situated in a not too distant future in which Mars is already colonized by human-kind, the story opens with a short, clear sentiment: "He awoke—and wanted Mars." In its powerful simplicity, the statement is slightly reminiscent of Franz Kafka's master-ful opening phrase in *Metamorphosis:* "As Gregor Samsa awoke one morning from uneasy dreams he found himself transformed in his bed into a gigantic insect." In a fusion of reality with false and real memory, Dick tells the complex story of a construction worker who is having troubling dreams about Mars. In Paul Verhoeven's cinematic adap-tation of Dick's short story in the 1990 blockbuster *Total Recall*, starring Arnold Schwarzenegger, Mars also served prominently as the setting. With its amazing depiction of Martian landscapes and human colonies, it is considered by many to be one of the best Mars movies ever. Like no other author, Dick's works have been the basis for many of Hollywood's all-time best science fiction films. Despite their scientific inaccuracy, *Total Recall* was also one of the first films to portray terraforming on Mars—the process of purposely modifying a planet to make it similar to the environment of Earth so as to make it inhabitable by Earth-like life.

DESTINATION MARS

Indeed, Mars—about six months away by rocket—remains the only planet on which humans could one day settle, making it a place of hope as well as trepidation. At the same time, Mars has been historically unfriendly to Earth's attempts to visit it. More missions have been attempted to Mars than to any other place in our solar system except the Moon, and about half of them have failed. Since the late 1990s, however, Mars exploration has undergone a renaissance. Data from orbiters and landed missions have spawned a revolutionary new view of Mars as an Earth-like

world with a complex geologic history—a view that has currently reached its peak in terms of scientific progress, artistic imagination and public aspirations throughout all disciplines.

Against this backdrop, American artist Tom Sachs, for example, staged a four-week mission to Mars as an immersive 55,000 square foot installation in 2012. As the artist's description states: "Using his signature bricolage technique and simple materials that comprise the daily surrounds of his New York studio, Sachs engineers the component parts of the mission—exploratory vehicles, mission control, launch platforms, suiting stations, special effects, recreational amenities, and Mars landscape—exposing as much the process of their making as the complexities of the culture they reference."

Funded by NASA's Human Research Program, the Hawaii Space Exploration Analog and Simulation (HI-SEAS) project represents a completely different analog habitat for human spaceflight to Mars. Located in a remote position on the slopes of a Hawaiian volcano, HI-SEAS aims to determine what is required to keep a space flight crew happy and healthy during an extended mission to and on Mars. The site has Mars-like features and an altitude of 2,500 meters above sea level. While the first HI-SEAS study was in 2013, the fourth and longest mission to date, lasting exactly one year and ended on August 29, 2016. In the confines of a solar-powered dome 11 meters wide and 6 meters high, the six international team members lived together for 365 days to simulate what it might be like for astronauts journeying to Mars and how people will respond to the isolation that would likely accompany such a mission.

"Mars is a barren wasteland and I am completely alone here. I already knew that, of course. But there's a difference between knowing it and really experiencing it" notes Mark Watney, the protagonist in Andy Weir's 2011 science fiction

THIS TEXT BY LUKAS FEIREISS WAS ORIGINALLY WRITTEN FOR AND PUBLISHED BY ARCHITHESE. SCHRIFTENREIHE. SCIENCE-FICTION (2.2016), ZURICH, 2016

novel *The Martian*—in which Watney is an American astronaut who finds himself stranded and alone on Mars in 2035. The eponymous film adaptation, directed by *Aliens* director Ridley Scott, was released in 2015. Seeing potential in promoting space exploration and putting Mars on the map, NASA decided to assist the filmmakers with depicting the science and technology portrayed in *The Martian*. In the film, the "Hab"—an artificial habitat—gives a certain degree of comfort to the stranded astronaut. The mere presence of this man-made structure of industrial canvas that protects against electromagnetic waves seems to remind Watney that there's a home waiting for him.

It's such homes that are currently of particular interest to NASA. Together with its partners, NASA is holding a $2.5 million competition to build a 3D-printed habitat for deep space exploration, including the agency's journey to Mars. This multiphase challenge is obviously designed to advance the construction technology needed to create sustainable housing solutions for Earth and beyond. The first phase of the competition called on participants to develop state-of-the-art architectural concepts that take advantage of the unique capabilities offered by 3D printing. More than 165 submissions were received. The first-place award went to the team of SEArch+ (Space Exploration Architecture) and Clouds AO (Clouds Architecture Office) for their design, Mars Ice House. Second place was awarded to Team Gamma and third place was awarded to Team LavaHive. The second phase is now ongoing and challenges competitors to demonstrate a recycling system that can create structural components using terrestrial and space-based materials and recyclables: "We are seeking the technology to reuse the materials we will already be carrying," said Stephen Jurczyk, associate administrator for NASA's Space Technology Mission Directorate, "and combine them with what is already available at our destination, which is, in this case, soil. We recycle here on Earth—why not on Mars?"

BEING MARTIAN

Going to Mars might actually be a late homecoming. In the last three years, evidence has been building in the scientific community that Earth life might have originated on Mars and was brought to this planet aboard a Martian meteorite that carried some chemicals essential to forming life that were likely available on Mars but not yet present on Earth. The reemergence of the panspermia theory—a hypothesis that rocks expelled from a planet's surface by impact serve as transfer vehicles for spreading biological material from one planet to another within the same solar system—is intertwined with the long-term scientific quest to find out how life began on Earth. Even though scientific signs are beginning to point in that direction, it's still more a matter of increased probability than scientific proof. Could we all be Martians after all?

"Science is no more than an investigation of a miracle we can never explain, and art is an interpretation of that miracle."

Ray Bradbury

Lukas Feireiss

The Girl from Altair IV

Fabian Reimann

Miranda and Prospero on the unnamed island

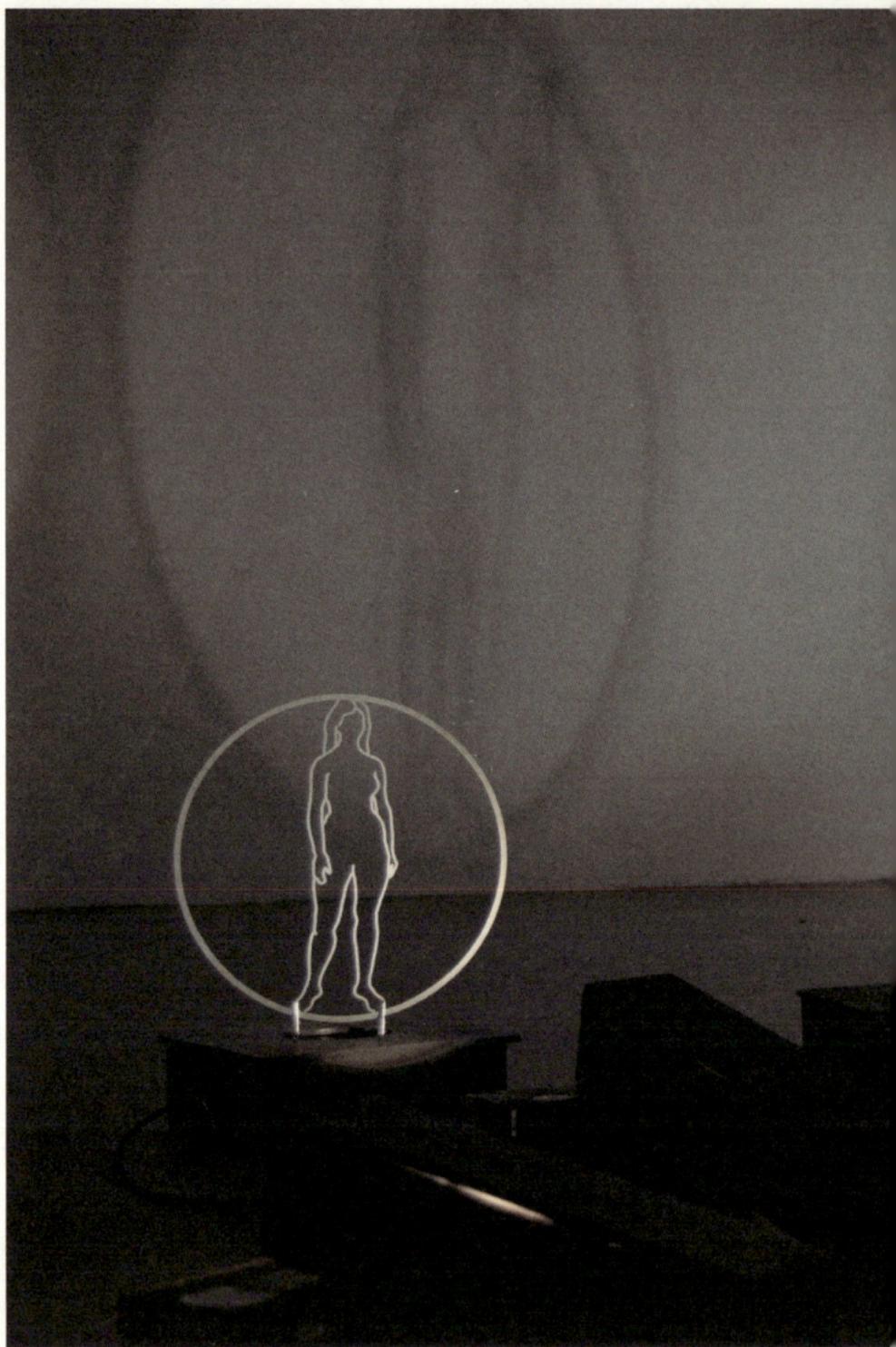

Installation view *Flat Earth*, Fabian Reimann, 2014

Fabian Reimann

Dr. Morbius shows the power of mind in his laboratory on Altair IV, 1956

Anne Francis, starring Altaira Morbius, warderobe still, 1955

Male paradise bird from New Guinea, before 1935

Fabian Reimann

In Mars We Trust

Thore Bjørnvig

As the spaceship slowly approaches Mars its captain is overcome by religious remorse. Though not particularly religious before, on the way to Mars he began reading the Bible and became increasingly convinced that the heavens are God's abode and that it is a sacrilege to breach His realm. The captain's son thinks otherwise. To him it is no coincidence that mankind is escaping the bonds of Earth just as Earth's population reaches a critical mass and resources become scarce. It was meant to be.

When the spaceship enters the Mars atmosphere in a careful breaking manoeuvre, the captain suddenly accelerates the ship, threatening to incinerate everyone aboard. His son manages to force him away from the controls but the ship crashes. On the ground the captain begins to sabotage the ship's water tanks. When his son tries to stop him, the captain shoots and wounds him. In the ensuing brawl the gun accidentally goes off and kills the captain.

The crew entrench themselves, barely survive a Martian winter, and only just make it back to Earth.

Thus the plot of the 1955 movie *Conquest of Space*.[1] Over 60 years old, its depiction of faith gone awry in outer space may seem oddly outdated. Yet, the notion that religion may pose a danger to mankind's cosmic ambitions lives on among some of those who dream about colonizing Mars.

RELIGION AND THE COLONIZATION OF MARS

Established in 2011, Mars One is a Dutch non-profit foundation that wishes to send four astronauts to Mars by 2032 (the date keeps changing) to establish a permanent colony on the planet. It aims at producing a global media spectacle funded by private donations and the sale of merchandise and reality TV rights. In 2013, anyone could put in an application to become an astronaut. According to Mars One, some 200,000 people from all over the world did apply—despite the fact that the trip will be strictly one way.[2]

Among the FAQs on the Mars One homepage is the question "What's Mars One's view regarding religion on Mars?[3] The answer is that whereas the colonization of the New World was often motivated by religious zeal, Mars One "is not based upon the idea that any particular religion should

1 *The Conquest of Space*, directed by Byron Haskin, Paramount Pictures, 1955.

2 See "Over 200,000 apply to first ever recruitment for Mars settlement," Mars One press release, September 9, 2013, at http://www.mars-one.com/news/press-releases/over-200000-apply-to-first-ever-recruitment-for-mars-settlement, accessed 20 February, 2017. For information on Mars One in general, see the organization's home page at http://mars-one.com/.

3 See http://www.mars-one.com/faq/health-and-ethics/whats-mars-ones-view-regarding-religion-on-mars, accessed February 14, 2017.

be represented in the Martian settlement." Nevertheless, Mars One encourages religious freedom—but any beliefs and activities of a religious nature are entirely up to the individual.

This is followed by the sub-question: "Is Mars colonization a religion?" Here Mars One[4] explains why the project, even though it may seem to share similarities with religion, is not a religion: whereas religion is based on belief in a divinity or spiritual being, the colonization of Mars is based on scientific knowledge and careful planning. Whereas religion is about faith, Mars One is about vision and ingenuity, and based on science and technology. And whereas religion is usually about holding something sacred, Mars One is about establishing a new society on Mars. Whether anyone will hold that project sacred is entirely up to them.

A NEW BEGINNING WITHOUT BELIEVING

In 2013, people were discussing a number of things on the "Mars One Fans Forum," a site for fans of Mars One that was not officially a part of Mars One. Most had to do with scientific and technical aspects of Mars One. A short thread (six replies, 664 views, 5 participants), however, was entitled "Mars Colonization as a religion."

It began with a fan suggesting that it might be a good idea to consider the colonization of Mars as a religion in order to win more people for the cause. This idea was soon denigrated by other fans who feared that it would have the opposite effect. First of all, the reasoning went, Mars One had nothing to do with "belief" and secondly, if Mars One was cast as a religion, people would think of its followers as static, closed-minded people.

4 The page no longer exits, but was accessed by the author during 2013 at http://marsonefans.com/.

A much longer thread, "Religion on Mars?" (267 replies, 15,662 views, some 40 participants), dealt with the question of whether religion should be brought to Mars at all, and if it was to be transported to Mars, what form it should take. Soon, the discussion became a debate on the relationship between science and religion.

The thread was opened by "illuminati1776," who suggested that it would be best to avoid sending religious astronauts to Mars, and throughout the thread he (or she) insisted that a religious worldview is incompatible with Mars colonization. On Mars people need to see reality as it is in order to survive. Religious people cannot do this and therefore are not fit to go. Mars offers humanity a chance to start over again and we should do so without religion and all its evils.

Soon a user with the screen name "Crews" joined the debate and, being a theologian who had apparently had some sort of mystical experience, he (or she) argued that science and religion can easily co-exist and religious astronauts on Mars would not pose any problems. Whereas "Crews" insisted on freedom of religion on Mars, "illuminati1776" hoped that Mars offered mankind freedom from religion. Though the uneasy co-existence of these viewpoints in a community supporting space exploration may seem strange, in fact it has a long history.

BETWEEN THE HEAVENS AND THE EARTH

In *To Touch the Face of God*, Kendrick Oliver examines the relationship between secularism and religion in the American space programs from 1957 to 1975.[5] Oliver goes against accounts of the American space program as suffused with traditional religion, or even some sort of religion

5 Kendrick Oliver, *To Touch the Face of God: The Sacred,*
 the Profane, and the American Space Program, 1957-1975,
 Baltimore: Johns Hopkins University Press, 2012.

in itself.[6] Rather, he holds out that whereas it did have some characteristics and aspects that were religious, it was just as much—and even more so—a techno-scientific secular project, which in fact was seen as a threat to traditional religious beliefs. This was exemplified by the outrage among Christian Americans when the famous atheist Madalyn Murray O'Hair tried to prevent American astronauts from expressing their religion in space through legal action.

Thus, the gist of Oliver's book is that space exploration may serve equally well as a platform for secularism and atheism as it may as a platform for religion. The same tension ran through the above-mentioned thread. Most of its participants agreed that religious astronauts on Mars would be okay, as long as they keep their religion to themselves and don't go about proselytizing and forcing their religious views on others. Some, however, feared that religious people might at some point veer into insanity and, for example, start killing off other astronauts or sabotaging the colony because "God told them so."

ATHEIST EDEN

Clearly, religious fundamentalism and terrorism were on the Mars One fans' minds and, perhaps as a consequence, quite a few argued that whereas openly practiced religion would be a bad idea on Mars, non-orthodox, "spiritual" beliefs would not pose the same kind of threat—as long as people were open to other views and truths.

Others expressed the idea that the astronaut screening process itself should weed out the overly religious, since they would hardly be able to meet the extreme demands in areas of technological and scientific expertise. Finally, some concluded that, whether you like religion or not, it would be

6 On the American space program as a religion, see for example
 Roger Launius, "Escaping Earth: Human Spaceflight as
 Religion" in *Astropolitics*, 11: 1-2, pp. 45-64, 2013.

very bad press for Mars One to deny astronauts freedom of religion on Mars and thus that this stance should be avoided.

If Mars cannot be an atheist Eden, then, what kind of religion might in fact be transplanted there? Here, the documentary *One Way Astronaut* is informative.[7] It has been promoted by Mars One, which receives half of the movie's proceeds, and in it there is not one critical remark on Mars One.[8] Thus, it is tempting to think that the four astronaut applicants interviewed in the movie have been chosen because they embody the ideals of Mars One.

SPIRITUAL SPACE

In the movie German applicant Stephan Günther is asked if he believes in God or a divine being. He answers that he believes that some kind of force is driving the Universe and has created all things with meaning—that's why everything fits so perfectly together (until humans showed up, he adds). He does not believe in God in the way the Church wants you to, but he does believe that there is much more to the Universe than we can see and understand.

When asked if he thinks he will find God on Mars he answers that this is a question of how God is defined. He believes he will experience an expansion of consciousness. Things of his past and his subconscious will be brought to his awareness in what should be a strong spiritual experience. Günther explains that the Apollo astronauts all grew spiritually through their experiences in space and through viewing the Earth from space. They learned to appreciate Earth more and felt an urge to protect it.

7 *One Way Astronaut*, directed by Kai Dieho and Peter Tetteroo, Tetteroo Media, 2013.

8 Tanya Lewis, "'One Way Astronaut' Film Follows Aspiring Mars Colonists," space.com, August 22, 2013, availabe at http://www.space.com/22483-one-way-astronaut-film-mars-colonists.html, accessed 20 February, 2017.

Günther exemplifies what I call "outer space religion," a belief system which is perhaps most clearly expressed in Frank White's pro-space classic *The Overview Effect*.[9] It is characterized by the conviction that it is humanity's destiny to colonize space and the planets, that we are driven by some sort of universal intelligent force, which has awakened in homo sapiens, spurs our evolution, and beckons us to enter into a cosmic brotherhood with other intelligent species out among the stars. According to White, the view of Earth seen from space will eventually create a global consciousness and unite the people of Earth and, in the very long run, the entire Universe.

THE PROMISE OF UNITY

Mars One also promises unification. At the very core of its branding strategy is the powerful concept of unity, the idea of becoming one. Of course, the "one" in "Mars One" is also about being the first to reach Mars, about being unique, the best, number one. But it also subtly reverberates with both a political notion of unity, as in America's "E pluribus unum" ("out of many, one," which was later replaced by "In God We Trust") and concepts of unity rooted in myth and mysticism, as for example in the notion of "unio mystica," the unification between a person and a godhead.

With Stephan Günther arguably serving as a role model of acceptable religion for Mars One, it would seem that whereas institutionalized and fundamentalist religion is not given a prominent place in the project, outer space religious "spirituality" is.

9 Frank White, *The Overview Effect: Space Exploration and Human Evolution*, Boston: Houghton Mifflin Company, 1987; second edition Reston, VA: American Institute of Aeronautics and Astronautics, Inc., 1998; third edition: Reston, VA: American Institute of Aeronautics and Astronautics, Library of Flight, 2014. See also Thore Bjørnvig, "Outer Space Religion and the Overview Effect: A Critical Inquiry into a Classic of the Pro-Space Movement" in *Astropolitics*, 11: 1-2, pp. 2-24, 2013.

RELIGION AND INTERSTELLAR MIGRATION

The relation of religion to space exploration is complicated and relevant. A recent example of the endeavour to incorporate religion into the conquest of space can be found in *Touching the Face of the Cosmos*.[10] In this collection of very different essays exploring ways in which religion may contribute to space exploration, a view of religion as an adversary that must somehow be converted to the space cause is shared among some of the contributors. Yet, religion is also portrayed as a positive potential, which inherently shares many character traits with space exploration.

The differing views of religion's role in relation to space exploration are important for at least two reasons. Firstly, they present a picture of how religion is negotiated and demarcated in face of a project seen by many as the pinnacle of religion's exact opposite: science and technology. Thus, it serves as a kind of snapshot of how religion—along with spirituality—is being reconfigured in face of the scientific and technological developments of the 21st Century.

Secondly, it offers a glimpse of how religion might fare as humanity slowly migrates towards the ever widening horizons of interstellar space. Something which currently may seem of minuscule importance but might, eventually, come to form a significant part of the history of the human species.

10 Paul Levinson and Michael Waltemathe (eds.), *Touching the Face of the Cosmos: On the Intersection of Space Travel and Religion*, New York: Connected Editions, 2016.

Biographies

Buzz Aldrin

American engineer former astronaut and explorer Buzz Aldrin was one of the first two humans to land the moon on July 20, 1969 as part of the Apollo 11 mission. Buzz was decorated with the Presidential Medal of Freedom, the Congressional Gold Medal and numerous awards all over the world. Named after Buzz are Asteroid "6470 Aldrin" and the "Aldrin Crater" on the moon. Aldrin is author o several sci-fi novels, children's books, and memoirs including *Return to Earth* (1973), *Magnificent Desolation* (2009) and *No Dream Is Too High: Life Lessons From a Man Who Walked on the Moon* (2016). Since retiring from NASA and the U.S. Air Force, Col. Aldrin calls himself a Global Statesman for Space and has remained a tireless advocate for human space exploration.

Anousheh Ansari

Anousheh Ansari is serial entrepreneur and co-founder and CEO of Prodea Systems a leading IoT technology firm. In 2006 she also became the first female civilian astronaut and the first self-funded woman to fly to the International Space Station and the first Iranian in space. Her memoir *My Dream of Stars* (2010) aims to inspire young woman around the world. The Ansari Family is also the title sponsor of the space competition Ansari X Prize, that offers $10,000,000 for the first non-government organization to launch a reusable manned spacecraft into space twice within two weeks. Anousheh has received numerous honors including the World Economic Forum (WEF), Young Global Leader and STEM Leadership Hall of Fame, to name a few. She is on WEF Future Global Council, a UNESCO Good Will Ambassador and a supporter of social entrepreneurs and organizations like Peace First to bring about positive change in the world.

Nelly Ben Hayoun

Nelly Ben Hayoun is a critical explorer, and a fearless and passionate designer. Touted by *Icon Magazine* as one of the 50 international designers "shaping the future;" Ben Hayoun is also the Designer of Experiences at the SETI Institute (Search for Extraterrestrial Intelligence), Head of Experiences at WeTransfer, and a member of the Space Outreach and Education committee at the International Astronautical Federation. Ben Hayoun previously collaborated with Beck, Sigur Rós, Bobby Womack, Damon Albarn, Maywa Denki, Bruce Sterling, and Penguin Café in a musical collaboration; the International Space Orchestra (ISO) — the world's first orchestra of space scientists from NASA and the SETI Institute. The critically acclaimed film (by the same name) was also released in 2013. Her latest feature documentary; *Disaster Playground*, was awarded The Arts Council England Exceptional Award.

Thore Bjørnvig

With a graduate background in His-tory of Religion from the University of Copenhagen, Thore Bjørnvig works an independent scholar whose main research interests lie in areas con-nected to intersections between cul-ture, spaceflight, and religion. He has co-edited a special issue of the journal *Astropolitics* on spaceflight

and religion in 2013. His current research focuses on the cultural history of space toys and LEGO's space themes, and religious aspects of the Dutch Mars One project.

Richard Branson

Sir Richard Branson is an business magnate, entrepreneur, investor, and philanthropist. He founded the Virgin group, which controls more than 400 companies. The Virgin group grew from a small record shop he founded in 1972, to become a major multinational company including interests in transport, media, and entertainment. Richard Branson is also a flamboyant character and has taken part in a number of adventure challenges and world record attempts, such as sailing across the Atlantic and taking part in around the world hot air balloon journeys. With his spaceflight company Virgin Galactic, Branson is developing commercial spacecraft and aims to provide suborbital and orbital spaceflights to space tourists and suborbital launches for space science missions.

Clouds Architecture Office

Clouds Architecture Office is an idea driven design studio based in New York City. Founded in 2010 by Masayuki Sono and Ostap Rudakevych, Clouds AO approaches projects with an intellectual and artistic rigor. Their explorations focus on the potential of the immaterial. They are interested in the experiential qualities of architecture, ways in which form and material can elicit lasting emotional or cognitive revelation. Clouds AIO goal is to create conditions that allow for a resonant experience by the synthesis of ideas through design. They worked together with SEArch (Space Exploration Architecture) on the winning concept for a frozen Mars abode in the NASA-run 3D Printed Habitat Challenge in 2015.

Pierre Cox

Pierre Cox is a an astronomer and director of the Atacama Large Millimeter Array (ALMA), a ground-based astronomical telescope in desert of northern Chile. ALMA is an international partnership among Europe, the United States, Canada, Japan, South Korea, Taiwan, and Chile. Cox is known for his research in the area of millimeter and infrared observations of star-forming regions, evolved stars, and high-redshift galaxies, and has published over 200 papers with more than 15,000 citations in total.

Xavier De Kestelier

Xavier De Kestelier is the Head of Design Technology and Innovation at international design studio HASSELL. Previously he was a partner at Foster+ Partners where he initiated and oversaw several funded research projects in the field of large scale 3D printing. He worked with NASA and the European Space Agency exploring the potential for 3D printing habitats on Mars and the Moon. He is also director of Smartgeometry, a not for profit organization that hosts an annual international conference and workshop around digital design and fabrication. Xavier has held academic positions at the University of Ghent, Syracuse University and The Bartlett School of Architecture (UCL).

Lukas Feireiss

Lukas Feireiss works as curator, writer, and art director in the international mediation of contemporary cultural reflexivity beyond disciplinary boundaries. He attained his graduate education in Comparative Religious Studies, Philosophy, and Ethnology. Feireiss is author and editor of numerous books, and curator of manifold exhibitions. He lectures and teaches various universities worldwide. One of his many interests is the

critical exploration of space in the widest sense of the term—from imaginary spaces to the physical space of our built environment and the architecture we live in, all the way to outer space and beyond. He is the author of *Memories of the Moon Age* (2016), a visual cultural history of mankind's dream of flying to the moon.

Norman Foster

Sir Norman Foster is an award-winning and prolific British architect. Foster+Partners is one of the most innovative architecture and integrated design practices in the world. Over the past four decades the practice has pioneered a sustainable approach to architecture through a strikingly wide range of work, from urban masterplans, public infrastructure, airports, civic and cultural buildings, offices and workplaces to private houses and product design. Foster+Partners completed Spaceport America the world's first space terminal for tourist in New Mexico in 2011. Foster+Partners is also part of consortium set up by the European Space Agency to explore the possibilities of 3D printing to construct lunar habitations.

Alexander C.T. Geppert

Alexander C.T. Geppert holds a joint appointment as Associate Professor of History and European Studies at New York University Shanghai and NYU's Center for European and Mediterranean Studies in Manhattan. From 2010 to 2016 he directed the Emmy Noether research group "The Future in the Stars: European Astroculture and Extraterrestrial Life in the Twentieth Century" at Freie Universität Berlin. At present, he is completing a comprehensive cultural history of outer space in twentieth-century Europe, entitled The Future in the Stars: Time and Transcendence in the European Space Age, 1942–1972.

Ulrich Köhler

Ulrich Köhler is a planetary geologist with the German Aerospace Center (DLR) in Berlin, Germany, after studies in general and applied geology at Ludwig Maximilian University in Munich, Germany, and São Paolo State University, Brazil. He has a strong interest in "comparative geology" and in answering the question why planet Earth is an obviously "privileged" place harboring life in the Solar System exclusively. Sharing the excitement of space exploration, and science, with the public is one of his major concerns: he co-authored three popular science books about the Moon, Mars, and the Solar System and curated several exhibitions for DLR.

Michael López-Alegría

Michael López-Alegría has over thirty-five years of aviation and space experience with the U.S. Navy, NASA and the private sector in a variety of roles including naval aviator, engineering test pilot, program manager, astronaut, International Space Station commander, and President of the Commercial Spaceflight Federation. He is now an independent consultant to traditional and commercial space companies, and serves on several advisory boards and committees of public and private organizations.

Greg Lynn

Greg Lynn is an architect, philosopher, science fiction author, and principal of Greg Lynn FORM. Lynn has been at the cutting edge of design in both architecture and design culture in general when it comes to the use of the computer. The buildings, projects, publications, teachings, and writings associated with his office have been influential in the acceptance and use of the advanced technologies germane to the aeronautic, automobile, and film industries

in architecture. *Time Magazine* named him one of the 100 most innovative people in the world for the 21st century and *Forbes Magazine* named him one of the ten most influential living architects. He is the author of nine books.

Michael Najjar

Michael Najjar belongs to that vanguard of artists who take a complex and critical look at the technological forces shaping and drastically transforming the early 21st century. Najjar's photo and video works exemplify and draw on his interdisciplinary understanding of art. He fuses science, art, and technology into visions and utopias of future social orders emerging under the impact of cutting-edge technologies. Najjar's work has been included over the last 20 years in many international museum exhibitions and biennials. In his current "outer space" work series he deals with the latest developments in space exploration and the way they will shape our future life on Earth, in Earth's near orbit and on other planets. As one of the pioneer astronauts of Virgin Galactic, Michael Najjar will be embarking on SpaceShipTwo on one of its future spaceflights where he will be the first artist to travel in space.

Fabian Reimann

Fabian Reimann, visual artist, designer, and editor focusses on fact and fiction in contemporary history and possible futures. His works are based on extensively artistic research and presented in several different forms such as spatial essays, narrative installations or books. In 2004 he started to publish the Freeman's Journals, the latest is *Space Colonies. A Galactic Freeman's Journal* in 2017. He was co-founder of project spaces, magazines, curated exhibitions, and symposia, and received several scholarships and awards.

Tim Smit

With a background in Archeology and Anthropology as well as a platinum and gold disc-winning career in the music industry, Sir Tim Smit is also Executive Vice Chairman and Co-Founder of the multi award-winning Eden Project in Cornwell, England. As the largest indoor rainforest in the world, the Eden Project aims to educate people about environmental matters. It consists of two buckminsterfuller-style biome-structures by Nicholas Grimshaw that contain different eco-climates; rainforest and Mediterranean. The Eden team are now creating projects in China, the USA, Dubai, and Australia with the ambition to have one on every continent.

Christiane Stahl

Christiane Stahl studied Business, French and then Art History at École du Louvre, Paris as well as the FU Berlin. She received the Erich-Stenger-Preis from Deutschen Gesellschaft für Photographie for her dissertation on photographer and documentary film-maker Alfred Erhardt. From 2006 to 2014 she was a member of the board of directors of Deutschen Gesellschaft für Photographie, and deputy chairwoman as of 2008. Christiane Stahl has been director of Alfred Ehrhardt Stiftung since 2002.

Sethu Vijayakumar

Sethu Vijayakumar is the Professor of Robotics at the University of Edinburgh, UK and the Director of the Edinburgh Center for Robotics. He has pioneered the use of large scale machine learning techniques in the real-time control of several iconic robotic platforms such as the SARCOS and the HONDA ASIMO humanoids, KUKA-LWR robot arm and iLIMB prosthetic hand. His latest project (2016) involves a collaboration

with NASA Johnson Space Center on the Valkyrie humanoid robot being prepared for unmanned robotic pre-deployment missions to Mars.
He is a Fellow of the Royal Society of Edinburgh, a judge on BBC Robot Wars and winner of the 2015 Tam Dalyell Prize for excellence in engaging the public with science.

Andy Weir

Trained programmer and software engineer Andy Weir is the bestselling author of *The Martian*, a 2011 science fiction novel. The story follows an American astronaut, Mark Watney, as he becomes stranded alone on Mars in the year 2035 and must improvise in order to survive. *The Martian*, a film adaptation directed by Ridley Scott and starring Matt Damon, was released in 2015. His upcoming book *Artemis: A Novel* is based on the moon. Weir is a devoted hobbyist of subjects like relativistic physics, orbital mechanics, and the history of manned spaceflight.

Frank White

Frank White is the author of *The Overview Effect: Space Exploration and Human Evolution* (1987), in which coined the term overview effect. He is the author or co-author of numbers other books on space exploration and the future. Together with Isaac Asimov he co-authored *Think About Space: Where Have We Been and Where Are We Going?* (1991) and *March of the Millennia: A Key to Looking at History* (1992). Other books are *The SETI Factor: How the Search for Extraterrestrial Intelligence is Revolutionizing Our View of the Universe and Ourselves* (1990), *Decision: Earth. Book One: Alone or All One?* (2003). Together with Kenneth Cox and Robbie Davis-Floyd, he also co-authored *Space Stories: Oral Histories from the Pioneers of America's Space Program* (2012).

Peter Weibel

Peter Weibel, Chairman and CEO of ZKM | Center for Art and Media Karlsruhe and professor of media theory at the University of Applied Arts Vienna, is considered a central figure in European media art on account of his various activities as artist, theoretician, and curator. He publishes widely in the intersecting fields of art and science. His career took him from studying literature, medicine, logic, philosophy, and film in Paris and Vienna and working as an artist to head of the digital arts laboratory at the Media Department of New York University in Buffalo and founding director of the Institute of New Media at the Städelschule in Frankfurt/Main. As artistic director he was in charge of Ars Electronica in Linz, Seville Biennial, and of Moscow Biennale of Contemporary Art. He commissioned the Austrian pavilions at Venice Biennale and was chief curator of the Neue Galerie Graz.

Image Index

69

Michael Najjar, *waves of mars*, 2016. Hybrid photography, archival pigment print, aluminium frame (202 × 132 cm, 79.5 × 52 in). Courtesy of the artist

70–71

Michael Najjar, *europa*, 2016. Hybrid photography, archival pigment print, aluminium frame (132 × 202 cm, 52 × 79.5 in). Courtesy of the artist

72–73

Michael Najjar, *sands of mars*, 2014. Hybrid photography, archival pigment print, aluminium frame (132 × 202 cm, 52 × 79.5 in). Courtesy of the artist

74

Michael Najjar, *moon mining*, 2016. Hybrid photography, archival pigment print, aluminium frame (132 × 202 cm, 52 × 79.5 in). Courtesy of the artist

79

Astronaut and lunar module pilot Buzz Aldrin on the Moon, 1969. Image Source: NASA

80

Astronaut and lunar module pilot Buzz Aldrin deploys Apollo 11 experiments, 1969. Image Source: NASA

86–93

Michael López Alegria performing space walks outside of the International Space Station, 2000. Image Source: Pamela Ann Melroy (NASA)

98

Image Source: University of Edinburgh's Centre for Robotics, 2017

99

Michael Najjar, *NASA Valkyrie*, 2017. Courtesy of the artist

102

Anousheh Ansari onboard the International Space Station, 2006. Courtesy of Anousheh Ansari

104–105

Horizon. Image Source: Internet

108

Anousheh Ansari on board of the International Space Station, 2006. Courtesy of Anousheh Ansari

110–111

Michael Najjar, *Eden Project*, Cornwall, United Kingdom, 2013. Courtesy of the artist

113

Collage inspired by videostill from Douglas Trumbull's science fiction film *Silent Running*, 1972. Image Source: Internet

117

Michael Najjar, *Spaceport America*, New Mexico, USA, 2012. Courtesy of the artist

118–119

Foster+Partners, *Spaceport America*, New Mexico, USA, 2014. Image Source: Foster+Partners

122 top

Virgin Galactic, *VSS Unity First Glide Flight*, 2016. Image Source: Virgin Galactic

122 bottom

Virgin Galactic, *VMS Eve cradles VSS Unity on its first flight*, 2016. Image Source: Virgin Galactic

124

Image from *Life* magazine's July, 23, 1945 issue, titled *The German Space Mirror*. Image Source: Huffington Post

126

Heinz Gartmann, "Flug in den Weltenraum," Westermanns Monatshefte 91 (March 1951), 21–28, here 27

129

Hermann Oberth, *Menschen im Weltraum: Neue Projekte für Raketen- und Raumfahrt*, Berlin: Deutsche Buch-Gemeinschaft 1957, 128

131

Inhabited satellite circling Earth. Drawing by Hans and Botho von Römer, Munich, n.d., Deutsches Museum, Archiv, LR10040

132

Still from Stanley Kubrick's *2001: A Space Odyssey* (1968). Courtesy NASA GPN-2003-00093

136

Astronaut Gerald D. Carr and William R. Pogue in Orbital Workshop (OWS) on Skylab 4, 1974. Image Source: NASA

138–142

Foster+Partners, *Mars Habitation*, 2015. Image Source: Foster+Partners

143

Rendering of Mars crew compartment. Still from *Making Humans a Multiplanetary Species*. Published on youtube.com on 27.09.2016. Source: SpaceX

144 top

Portrait of Raymond Loewy. Source: dwell.com

144 bottom

Skylab 4, television (Crew). Image Source: NASA Image and Video Library, 1973

147 top

Porthole for the Apollo space capsule. Image Source: NASA Image and Video Library

147 bottom

Skylab. Image Source: NASA Image and Video Library, 1972

151 top

Skylab. Image Source: NASA Image and Video Library, 1972

151 bottom

Skylab. Image Source: NASA Image and Video Library, 1972

152–153

The final view of Skylab, from the departing mission 4 crew, with Earth in the background. Image Source: NASA Image and Video Library

154–156

Greg Lynn, *Divide – N.O.A.H. (New Outer Atmospheric Home)*, 2014. Image Source: Greg Lynn Form

157–159

Greg Lynn, *New City*, 2014. Image Source: Greg Lynn Form

162–168

Clouds Architecture Office, *Venus Station*, 2017. Image Source: Clouds Architecture Office

175–189

The German Aerospace Center (DLR), 2017. Image Source: DLR

195

Warner Bros.' *Loony Tunes and Merrie Melodies* character Marvin the Martian, 1948. Image Source: Wikipedia

199

Detail from Alan Moore's and David Gibbon's graphic novel *Watchmen*, 1987. Image Source: Internet

205

Miranda, Prospero, Ariel, and Caliban in Act I, scene II, of *The Tempest*. Engraving is based on a painting by Henry Fuseli. Image Source: Fabian Reiman

206

Fabian Reiman, Installation view *Flat Earth*, Städtische Galerie Bremen, 2014. Image Source: Fabian Reiman

207 top

Dr. Morbius shows the power of mind in Fred M. Wilcox movie *Forbidden Planet*, 1956. Image Source: Fabian Reiman

207 bottom

Anne Francis, starring Altaira Morbius in Fred M. Wilcox movie *Forbidden Planet*, 1956. Image Source: Fabian Reiman

208

Male paradise bird from New Guinea, before 1935. Image Source: Fabian Reiman

209

Apollo 1 astronauts praying before the fatal accident that claimed their lives, 1966. Image Source: NASA

217

Frame from the movie *Conquest of Space*. Image Source: Internet

Acknowledgment

This publication has been kindly supported by

Alfred Ehrhardt Stiftung
www.alfred-ehrhardt-stiftung.de

ARTITLEDcontemporary
www.artitled.com

Benrubi Gallery
www.benrubigallery.com

Delight Rental Services
www.delight-rent.com

Galería Juan Silió
www.juansilio.com

Studio la Città
http://studiolacitta.it

Imprint

Edited by

Lukas Feireiss and Michael Najjar

Graphic Design by

Floyd E. Schulze/WTHM—Büro für Gestaltung

Project assistance by

Elisa Giuliano

Copy-editing and proofreading by

Ames Gerould

Typeface Allianz Grotesk by

Matthieu Huegi

Printing by

Ruksaldruck, Berlin

Published by

Spector Books, Harkortstrasse 10, 04107 Leipzig
www.spectorbooks.com

Distribution by

GERMANY, AUSTRIA: GVA, Gemeinsame Verlagsauslieferung
Göttingen GmbH&Co. KG, www.gva-verlage.de
SWITZERLAND: AVA Verlagsauslieferung AG, www.ava.ch
FRANCE, BELGIUM: Interart Paris, www.interart.fr
UK: Central Books Ltd, www.centralbooks.com
USA, CANADA, CENTRAL AND SOUTH AMERICA, AFRICA, ASIA: Artbook /
D. A. P., www.artbook.com
SOUTH KOREA: The Book Society, www.thebooksociety.org
AUSTRALIA, NEW ZEALAND: Perimeter Distribution,
www.perimeterdistribution.com

First Edition | Printed in Germany | ISBN 978-3-95905-191-0